Sound, Image, Silence

Sound, Image, Silence

Art and the Aural Imagination in the Atlantic World

Michael Gaudio

UNIVERSITY OF MINNESOTA PRESS

MINNEAPOLIS • LONDON

This book is freely available in an open access edition thanks to TOME (Toward an Open Monograph System)—a collaboration of the Association of American Universities, the Association of University Presses, and the Association of Research Libraries—and the generous support of the College of Liberal Arts at the University of Minnesota, Twin Cities. Learn more at openmonographs.org.

The publication of this book was supported by an Imagine Fund grant for the Arts, Design, and Humanities, an annual award from the University of Minnesota's Provost Office.

A different version of chapter 3 was previously published as "Magical Pictures, or, Observations on Lightning and Thunder, Occasion'd by a Portrait of Dr. Franklin," in *Picturing,* ed. Rachael Ziady DeLue, Terra Foundation Essays 1 (Paris and Chicago: Terra Foundation for American Art, 2016; distributed by the University of Chicago Press). A different version of chapter 4 was previously published as "At the Mouth of the Cave: Listening to Thomas Cole's *Kaaterskill Falls,*" *Art History* 33, no. 3 (June 2010): 448–65.

Published by the University of Minnesota Press
111 Third Avenue South, Suite 290
Minneapolis, MN 55401-2520
upress.umn.edu

Printed in the United States of America on acid-free paper

The University of Minnesota is an equal-opportunity educator and employer.

26 25 24 23 22 21 20 19 10 9 8 7 6 5 4 3 2 1

Library of Congress Cataloging-in-Publication Data
Names: Gaudio, Michael, author.
Title: Sound, image, silence : art and the aural imagination in the Atlantic world / Michael Gaudio.
Description: Minneapolis : University of Minnesota Press, 2019. |
Includes bibliographical references and index. |
Identifiers: LCCN 2018061118 (print) | ISBN 978-1-5179-0739-6 (hc) |
ISBN 978-1-5179-0740-2 (pb)
Subjects: LCSH: Arts, American. | Communication in art—America. |
Visual perception in art.
Classification: LCC NX503 .G38 2019 (print) | DDC 700.97—dc23
LC record available at https://lccn.loc.gov/2018061118

Contents

Acknowledgments

Many voices sound in my head as I write these acknowledgments. One of the earliest belongs to Alex Nemerov, whose graduate seminar on deconstruction and the visual arts at Stanford, twenty years ago, planted the seeds for my chapter on Thomas Cole, and indeed for the book as a whole. There are also the voices of colleagues and students at the University of Minnesota, where I have benefited from conversations made possible by the Atlantic History Workshop, the Consortium for the Study of the Premodern World, the Center for Early Modern History, and the Theorizing Early Modern Studies research collaborative and my coconspirators in that group: J. B. Shank, Juliette Cherbuliez, and Matthias Rothe. In my own department, Jane Blocker and Jennifer Marshall have listened attentively to my thoughts and generously shared their own. This project has also taken shape in dialogue with colleagues from beyond my own university: Rachael DeLue, Christopher Heuer, Matthew Hunter, Jessica Keating, Dian Kriz, Jason LaFountain, Craig Lee, Jennifer Roberts, Rose Marie San Juan, Bronwen Wilson, Angela Vanhaelen, and many others. I owe a special thanks to Tom Conley and to two anonymous readers for their insightful readings of the manuscript.

The knowledge and generosity of curators and archivists have made my research possible. I wish to thank Maggie Ragnow at the James Ford Bell Library at the University of Minnesota, Marie-Catherine Sahut at the Louvre, Jennifer Vanim at the Philadelphia Museum of Art, Josie Walters-Johnston in the Moving Image Section at the Library of Congress, Caitlyn Haynes at the National Anthropological Archives in Washington, D.C., and Mindy Besaw and Ali Demorotski at

Crystal Bridges Museum of American Art, where I completed my manuscript while in residency as a Tyson Scholar. Research for the book was also supported by two Imagine Fund grants from the University of Minnesota. Funding for digital publication has been made possible by a TOME Open Access Monograph Initiative Award. I am grateful to my editor at University of Minnesota Press, Pieter Martin, for his encouragement and for so expertly shepherding this project through publication. And finally, I wish to thank Kerry Morgan, whose voice has been the most supportive and enduring of all.

Introduction: *Soundings*

Page through a textbook on Atlantic history, or search that phrase online, and you are bound to come across a map of the ocean crisscrossed by arrows of various sizes and colors indicating the movement of peoples, goods, ideas, and pathogens: slaves from Africa to the Americas, tobacco and sugar from the Americas to Europe and Africa, Christianity and smallpox from Europe to the Americas. If there is a defining feature of the notoriously amorphous historical entity known as the "Atlantic world," it is this movement through space rather than the relatively static existence of the geopolitical entities outlined along the peripheries of the map.

This is a book about the crossing of Atlantic distances. Comprising five case studies that range over four centuries, it considers how the spatial, cultural, and socioeconomic distances of the Atlantic world were managed through the creation and dissemination of visual images: a late-sixteenth-century engraving of a Tupinambá dance, seventeenth-century landscapes of Dutch Brazil, an eighteenth-century portrait of Benjamin Franklin, an early-nineteenth-century landscape of the Catskills, and a late-nineteenth-century kinetoscope film of a Lakota dance. The very diversity of this material, however, speaks to the potential difficulties of the "Atlantic world" as a category of analysis. Lacking clear geographical or temporal parameters, and with no obvious implications in regard to style, iconography, or medium, it provides a loose sort of packaging for the art historian. Indeed, I will confess at the outset that none of the following chapters were originally conceived as being destined for publication together. What could make

a seventeenth-century Dutch landscape and an early Edison film hang together with the level of coherence one expects in a monograph?

One answer to that question might simply be the extraordinary confidence in visual representation that developed in tandem with the expanding markets and inequalities of European and American colonialism, a confidence seen in the bustling traffic in images across and around the Atlantic.[1] This Atlantic visual economy provides the inescapable context for all of my chapters, two of which consider the depiction of indigenous groups with long histories of exploitation and subjugation by colonial powers, another two of which focus on landscape painting, a representational form inextricably bound to discourses of empire in the Atlantic, and one of which considers a heroic portrayal of the great disenchanter who, for Max Weber, was the very embodiment of the acquisitive spirit of capitalism.[2] In 1938, Martin Heidegger announced that we belong to a modernity whose fundamental event "is the conquest of the world as picture."[3] Over the period addressed in this book, visual practices that include linear perspective, natural history, ethnography, exhibitionary methods, landscape painting, cartography, and portraiture helped put the world at empire's disposal. Across the distances of the Atlantic world, a representational machine emerged whose chief product was alterity: its purpose was to maintain the set of oppositional relations that Bruno Latour has called our "modern Constitution." Against the human, this machine produced nature; against reason, it produced superstition; against civilization, it produced the primitive. The imperial apogee of this process is the moment addressed in my final chapter, when world exhibitions, Wild West shows, and a nascent film industry made this "world picture" into a spectacle for mass consumption.[4]

Such an account of visual representation offers an important and necessary framework for historicizing the visual arts within the context of the Atlantic world, yet it also faces the limits that all generalizing approaches do. When viewed from above, the Modern Constitution may appear to run as a smoothly operating system, but this is only because we have missed out on what is happening at ground level. And when we do turn our attention to particulars, it becomes clear that the distances of the Atlantic world were hardly managed with ideal efficiency. Consider, for example, the scene in Robert Flaherty's well-known ethnographic film *Nanook of the North* (1922) in which a trader entertains the Inuk man Nanook with a gramophone and tries to explain to him, according to the intertitle, "how the white man 'cans' his voice." Nanook stares with fascination at the machine and laughs. The trader then lifts the gramophone disk off the player and hands it to Nanook, who proceeds to bite it in his attempt to get at the mysterious voice

inside (Figure I.1). It is a shocking moment in the film and is often cited as a typically exploitive one for its portrayal of primitive ignorance about modern technology.[5] Primitivism, however, is more than a discourse for constructing alterity. As Michael Taussig argues, it is also the discourse through which capitalist modernity articulates its own fascination with mimetic technologies.[6] Nanook's enchantment with the gramophone, an attraction so powerful he attempts to consume the disk, rehearses the early-twentieth-century spectator's enchantment with a new cinema that promised a sensuous and even mystical participation in the world through the camera lens.[7] As this filmic example suggests, the pictures that circulated around the colonial Atlantic world did not merely sustain a distanced and objectifying colonial gaze. By inviting mimetic identification with the peoples and places of this world—by enchanting their viewers—they also unsettled that gaze. The imagined tidiness of the Modern Constitution is belied by the messy and impure experience of navigating between its opposing shores. The following chapters attempt to describe this vertiginous condition of being in-between.[8]

This book might be described as a series of *soundings*, a word to which I am partial for its suggestion of an experimental testing of depths, and for its particular

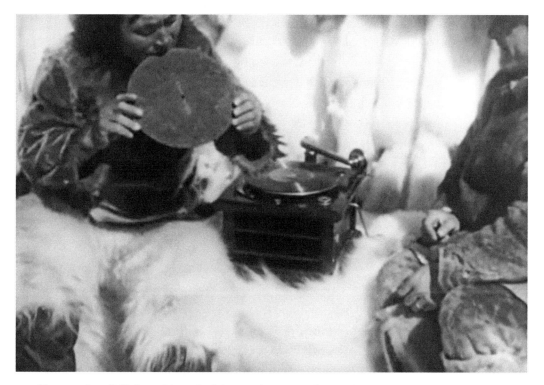

FIGURE I.1. Still from *Nanook of the North* (1922), directed by Robert Flaherty.

relevance to the crossing of oceanic distances. In her recent interpretation of John Singleton Copley's *A Boy with a Flying Squirrel* (1765), Jennifer Roberts argues that the ocean, despite its undeniable significance in the life of a painting that spent a good deal of time in transit between Boston and London, has been almost completely elided in the portrait's scholarly treatment. Only the origin and destination have mattered, the beginning and ending points of a journey over which the painting and its meanings are imagined to be delivered successfully and without loss. Roberts, in contrast, places the oceanic interval itself, with all of its obstacles and delays, at the center of her analysis.[9] It is in a similarly disruptive spirit that I offer my own soundings of the waters between the colonial production of alterity and the sensuous desire for likeness in the Atlantic world.

But there is another respect in which my chapters may be called "soundings," because this is a book about the sounds, as well as the silences, that are conjured by pictures. As I realized quite late, the common thread running through the following case studies is the disturbance of the privileged domain of vision by an appeal to the ear. The works of art discussed in each of my chapters are notable for their potential to be heard, a potential that is by no means diminished by the fact that it remains unrealized. *Nanook of the North* again provides a helpful point of reference, for it is curious that this primitivizing performance of cinema's mimetic power is staged (the scene was, in fact, entirely scripted) as Nanook's captivation by an altogether different technology, as he uses his teeth to test a disk from a machine for playing recorded sounds.[10] The difference between film and a gramophone disk is of some importance in this example, since in 1922 the voices of actors and the sounds of the film's action remained unavailable to cinema's audience.[11] The gramophone that fascinates Nanook is, in other words, emphatically silent. His attempt to eat the white man's voice belongs to a long history of similar gestures that are made from within the silence of pictures but directed toward an aural experience beyond the frame of pictorial representation. These gestures launch us into an uncertain Atlantic passage between sight and sound.

As the emergence of the field of "sound studies" in recent decades demonstrates, sound has been granted a new legitimacy as an object of historical inquiry. The story of modernity, as Leigh Eric Schmidt writes, is "almost always one of profound hearing loss in which an objectifying ocularcentrism triumphs over the conversational intimacies of orality."[12] Against this modern subordination of the ear to the eye, Schmidt and others have focused their attention on Atlantic "soundscapes" that feature the noises of Christians in the American Enlightenment, the cracking of thunder and the ringing of bells in early America, or the tumult of the

black African diaspora.[13] The present study makes its own modest contribution toward such efforts. To offer just one example, I hope to make the sounds of the religious revival more present than they have been in the literature on Thomas Cole's landscapes. But if visual images can in some measure open our ears to the sounds of the past, I am also attuned to the stubborn silences they maintain despite our demands that they speak to us. *Sound, Image, Silence,* in other words, is about the elusiveness of aural experience as an aspiration both of the visual arts and of scholarly endeavors to retrieve the past audibly for the present. If my case studies are, in part, a response to the call of sound studies to write the ear into Atlantic history, they are informed at a more fundamental level by a poststructuralist wariness of efforts to capture the voice. It is a project that is perhaps best characterized as what Michel de Certeau terms a *heterology*, a "science of the other" that illuminates the ways in which disciplines and institutions seek to assimilate the voice of the other, even as the opacity of that voice, its foreignness to representation, returns as a breach in discourse.[14] In his ignorance of the white man's technology, Nanook bites the inedible disk, and thereby inscribes himself within the disciplinary hierarchies of early-twentieth-century ethnographic documentary. But as the camera closes its own teeth on Nanook, something offers resistance here as well: voices that are in some sense registered within the film but nevertheless remain unknown to it.

What kind of sounding, then, does a silent picture require? One response to this question, as my title suggests, is that it demands we put to work an "aural imagination." This phrase is a fairly common one in literature on music and poetry, where it refers to the way musical notation or the words of a poem might stimulate an imagined experience of sound. Recently art historians, inspired by growing research on the integration and interdependence of human perceptual faculties, and desirous to counteract overdrawn modern oppositions between the eye and the ear, have begun to explore the potential of this idea in the realm of the visual arts.[15] *Sound, Image, Silence* builds on these efforts, but at the same time, it insists that the aural imagination is not a mental prosthesis for uncanning the sounds of silent pictures. Nanook, after all, who laughs during the scene with the gramophone, knows the white man's voice is not really inside the disk. The aural imagination is not about a smooth trajectory from seeing to hearing; it is about the productive friction between them.

Early film, with its grand aspirations to collapse the distance between art and life, may continue to serve as our touchstone on this point. In the 1890s, Thomas Edison dreamed of reproductions that would awaken both the eyes and the ears

of audiences, uniting sound and the moving image in an experience "without any material change from the original."[16] If the so-called "silent" cinema did not quite live up to this dream, it was nevertheless an audible art form that included musical accompaniment and sometimes live, in-house commentators who interpreted the intertitles for the audience.[17] What the silent film could not provide, however, was synchrony between the actions witnessed and the sounds heard, and it is this disjuncture between visual and aural experience that produced, in Michel Chion's words, a space for "imaginary voices that everyone could dream to their heart's content."[18] Nanook's laugh and the sound of the white man's voice produced by the spinning disk on the gramophone belong fully to the aural imagination. This is not because Flaherty's film convincingly puts those voices in our heads; it is because those voices, prior to the introduction of synchronized sound in 1927, were beyond the reproductive capabilities of cinema.

The potential that lies within this gap between image and sound is not a recent discovery. It was discussed by Greek and Roman writers and mined enthusiastically by Renaissance humanists. The dictum that "painting is mute poetry, poetry a speaking picture," attributed to Simonides of Ceos, and the Horatian simile *ut pictura poesis* ("as painting, so poetry") inspired countless commentaries written between the mid-sixteenth and mid-eighteenth centuries on the relationship between the visual and verbal (spoken) arts, which were understood to share the same end of imitating nature but to arrive there by different means.[19] It is not until the publication of G. E. Lessing's *Laocoön* (1766), however, that we encounter an effort to establish a firm critical distinction between the so-called "sister arts." For Lessing, the fact that poetry is an art in which sounds are enunciated in time, whereas painting distributes forms and colors in space, means that the two belong to fundamentally different orders of imitation and should not, therefore, be uncritically compared. *Laocoön,* as its subtitle states, is "an essay on the limits of painting and poetry." Even for recent artists and critics who question the pure aesthetic realms of modernism theorized by Lessing, the tension between seeing and hearing has remained an important tool for thought. The installation artist Fred Wilson, for example, put this tension to work at the Maryland Historical Society in 1992 when he unsettled viewers by causing the black servant in a colonial portrait to ask them: "Am I your brother? Am I your friend? Am I your pet?"[20]

My own route into the possibilities of the aural imagination is more aligned with Wilson's disruptions of the silent museum-going experience than with the modernist pieties of Lessing. With Wilson, I am inclined to ask, "how do we respond to pictures that really do want to speak to us?" There is, after all, a long

history of such pictures. Encounters with speaking paintings and sculptures were not uncommon in the Christian Middle Ages, as when Saint Francis of Assisi knelt before the *San Damiano Crucifix,* saw the lips on the painted image of Christ move, and heard them speak.[21] In seventeenth-century Rome—even as Gian Lorenzo Bernini sculpted lifelike portrait busts that art historians, steeped in the literature on the sister arts, have praised with the metaphor of the "speaking likeness"—visitors to the museum at the *Collegio Romano* encountered Athanasius Kircher's "Delphic Oracle" and actually heard a portrait bust speak.[22] Speaking pictures such as these have always existed outside the mainstream of art history. The *San Damiano Crucifix* survives for art historians as a Romanesque artifact, but its speech could only occur before the era of the image gave way to the era of art.[23] The speaking statues in Kircher's museum belong to a different scholarly world than do the canonical works of his contemporary Bernini. The speaking picture, to put it bluntly, is indecorous. It appears outside the proper limits of the visual arts: in the natural magic of an eccentric polymath; in the intense piety of the premodern imagination; or, in Wilson's case, at a moment of deep uncertainty about the purpose and priorities of the modern museum.

The following chapters are not chiefly concerned with oracles, crucifixes, and other objects endowed with literal powers of speech. The prints, paintings, and films that provide my focus can be described only as mainstream works within the canons of art and early cinematic history, which is to say that they remain more or less comfortably within Lessing's realm of silent pictures. But they are pictures that were asked to do a great deal. Their task was to deliver, often across vast distances, encounters with the native inhabitants of the Americas, with New World landscapes, and with Atlantic celebrities. By putting them into conversation with sound, by considering how these pictures put the limits of supposedly silent visual media to the test, I hope to bring into focus their engagement with an aural imagination. When these pictures do speak, moreover, it is not with the decorous voice of the poet, but through those exemplary sounds of the Atlantic world that intrude upon the hushed domain of visual contemplation as disruptions of propriety and reason, sounds that are normally kept at bay for the sake of peace and civility. They speak to us through the noise of the pagan dance, the discord of battle, the din of revivalist religion, and the sublime sounds of nature in the Americas: lightning, thunder, and the waterfall. In what ways did the visual arts conjure, but also attempt to manage, such sounds?

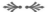

I begin with an engraving from Theodor de Bry's *America* that depicts a dance witnessed by the Huguenot missionary Jean de Léry during the time he spent among the Tupinambá Indians of Brazil in the late 1550s (see Plate 1). The image corresponds to a powerful moment in Léry's narrative account, written twenty years after his return to Europe, when he recalls the sounds of the dancers' chants still ringing in his ears across time and distance. Since the fifteenth century, artists had looked to dance as a guide for the depiction of compelling motion, and certainly de Bry's dancing figures do much to bring Léry's written account to life.[24] Yet, if this is an invitation to experience the dance in its sensory plenitude, it is a decidedly ambivalent one. For reformed Christians of the sixteenth century, the kind of circular dance depicted by de Bry was closely associated with idolatry, and especially with the Israelites dancing in pagan abandon around their graven image in Moses's absence. This engraving from a late sixteenth-century compilation of Protestant travel accounts places us somewhere in between the view that would hold the pagan dance at a safe distance and a more proximate experience that would leave the Tupinambá chants ringing in our own ears. Sounding out this intermediate space can leave us with the same sense of vertigo described in a passage from the Psalms invoked by Léry. Tossed to and fro, we are left to stagger about like drunken men, all our cunning gone.

Not all the works I consider leave us so dizzy. The landscapes painted in Brazil by the Dutch artist Frans Post between 1637 and 1644, the subject of my second chapter, do everything in their power to keep us at a quiet and stable remove from the disorienting sounds of war in the New World, as the forces of the Dutch West India Company engaged with the Portuguese up and down the Brazilian coast (see Plates 5–8). While Post accompanied these expeditions and depicted sites associated with Dutch victories, his paintings, which are often noted for their muted qualities, raise the question of landscape's relationship to the noise of historical event. The development of landscape as a genre may justly be seen as a dampening of that noise, a process of gradually pushing the painting's argument—or what Leon Battista Alberti called the *istoria*—off-stage and allowing the silence of the background to come into the foreground. But, if landscape tends to be a quiet genre, what of the voice of the historian whose purpose is to restore the landscape to its proper context? When Post's Brazilian views were etched for the history of Dutch Brazil written by the humanist Caspar Barlaeus, their powers of speech returned, at least in part, as they became sounding boards for an early and influential Atlantic history by one of Holland's greatest orators.

My third chapter shifts from the sounds and silences of the south Atlantic to the rumbling of thunder in the north, and from an Atlantic history composed by a humanist to one that was being written by natural philosophers. The subject of this northern history was the electrical fire, and at stake was the question of whether the lightning was the voice of God speaking through the thunder or a natural force at the command of the experimentalist. This is the question raised by a portrait of the Atlantic's greatest "electrician," Benjamin Franklin, whom the London artist Mason Chamberlin situates between the calm and quiet of the scholar's study and a violent electrical storm that rages outside the window (see Plate 9). Franklin has often been portrayed as a Promethean disenchanter of the heavens who stands out in relief against the religious enthusiasm of the Great Awakening, a movement whose exponents were all too prepared to hear the judgments of God in the thunder. But the sitter for Chamberlin's portrait was in fact profoundly attuned to the excessive and irrational forces of the natural world. In Franklin's electrical entertainment called "the magical picture," he does not imitate lightning simply to tame it; he invites his audience to feel its force directly in their bodies by taking hold of an electrified mezzotint. Franklin's magical pictures can help us to recognize that portraits like Chamberlin's held a capacity to shock, a potential to speak with a voice from beyond the frame, as they circulated in printed form around the Atlantic world.

If religious enthusiasm is not fully silenced in Chamberlin's portrait, its presence is felt even more strongly in my fourth chapter, where the sounds of the Second Great Awakening intrude into the landscape paintings of Thomas Cole. It is a fact of some interest that the first two items on Cole's list of over one hundred ideas for future paintings, composed in 1827 just as he was becoming a sought-after painter of American wilderness scenes, are "Preaching in the woods as is seen in the Western country" and "Camp Meeting at Night." These two paintings were probably never made, but their presence at the top of Cole's list points to an important, if unexamined, context of his early landscape art: the camp-meeting revivalism of the early nineteenth century that sought out the same settings of natural sublimity that inspired Cole's own art. For the nature-worshiping audience that financed the development of the first American school of landscape painting, the kind of worship that happened at the camp meeting was a vulgar affair associated with the noisy theatrics of the ungoverned mob. At the beginning of his career, however, Cole appears to have been imaginatively invested in the camp meeting. Revivalist religion provides the background noise to my reading of Cole's innovative early landscape, *Kaaterskill Falls* (1826), a painting in which

the shouts and hollers of camp-meeting religion are transposed into the muted tones of the cult of nature, even as the artist leaves traces of those popular sounds in the waterfall itself, a natural feature that Cole called "the voice of the landscape" (see Plate 10).

My final chapter returns to Native American dance, which, like the religious revival, was a subject of both fascination and contempt for nineteenth-century Americans who defined their own standards of taste and civility against the unruly bodies and discordant sounds of their social and racial others. My focus in this case is the Lakota Ghost Dance, a nonviolent ritual that nevertheless, in 1890, became permanently associated with the "outbreak" at Pine Ridge and the massacre of Lakota men, women, and children by government troops at Wounded Knee Creek. In 1894, when Lakota performers in Buffalo Bill's Wild West show were filmed for Thomas Edison's latest invention, the kinetoscope, white audiences across the United States and Europe were given the opportunity to witness the dance for themselves (see Figure 5.3). Distinctly war-like in its presentation, *Sioux Ghost Dance* anticipates a twentieth-century history of silencing indigenous voices through the stereotype of the "Hollywood Indian." Yet 1894 was a radically uncertain moment in the history of American film. Edison was acutely aware of the kinetoscope's lack of synchronized sound and the consequent disconnect between optical and auditory experience as viewers saw the bodies of dancers in motion but did not hear them. This sensory "shortcoming" invites us to imagine how a dance that was of profound religious and political significance for Lakota people in the 1890s eluded the representational powers of the new medium of film.

"It Seems Their Voices Are Still in My Ears"

Picturing a Tupinambá Dance in 1592

FOR TWO MONTHS DURING LATE 1557 and early 1558, the Frenchman Jean de Léry lived among the Tupinambá Indians along the Brazilian coast, near modern-day Rio, and carefully observed and recorded the details of their physical appearance, language, culture, and natural surroundings. Léry, however, had not come to Brazil with the intention of studying the native population. His initial purpose was to found a Protestant mission on a small island in Guanabara Bay, where the French had established a colony to protect their interests in the brazilwood trade. Léry and his fellow Calvinist missionaries had been sent from Geneva at the request of the colony's leader, Nicolas Durand de Villegagnon, but shortly after their arrival, the fickle Villegagnon reverted to Catholicism, banished Léry's party from the island, and eventually put three of them to death. These events meant the failure of the first Reformed mission in the Americas, but thanks to Léry's two-month exile on the mainland, they fortunately led to a remarkable work of early modern travel literature, *Histoire d'un voyage faict en la terre du Brésil* (1578). Claude Lévi-Strauss, recalling his own arrival in Rio in 1935 with Léry's book in his pocket, dubbed this vivid sixteenth-century account of Tupí culture the "anthropologist's breviary."[1]

Perhaps the most memorable moment in Léry's narrative comes in the chapter entitled "What One Might Call Religion Among the Savage Americans." Here the author describes a Tupinambá ritual performed by "five or six hundred men dancing and singing incessantly," men who produce such harmony in their chants that Léry is finally overwhelmed: "I stood there transported with delight. Whenever I remember it, my heart trembles, and it seems their voices are still in my ears."[2]

In a foundational essay on Léry's text, Michel de Certeau treats this moment as "the equivalent of a primal scene in the construction of ethnological discourse."[3] Léry, writing at a distance of twenty years and six thousand miles from his initial experience of the dance, invokes an original but irretrievable orality, a sound unavailable to his pen but nevertheless generative of the very text he creates. Hereafter, de Certeau argues, ethnological writing will be the effort to recover this lost, embodied speech. It is a compelling reading of *Histoire d'un voyage* and justifies its Lévi-Straussian nickname, but in the present chapter, I wish to ask whether de Certeau's take on Léry's text can be transposed into a visual key. To what extent might this reaching toward the voice help us to understand the efforts of Europeans to *picture* the alterity of the so-called "New World"? We are fortunate to have an image that raises the question for us, an engraving of the very dance whose sounds so powerfully moved Léry (Plate 1).

Engraved in the workshop of the Flemish printmaker and publisher Theodor de Bry for his 1592 and 1593 Latin and German editions of Léry's narrative, the illustration appears in the third part of *America*, an enormously successful series of illustrated Protestant travel accounts published by the de Bry firm between 1590 and 1634. Although the engraving is based on a woodcut from the original 1578 edition of Léry's book (Figure 1.1), de Bry's 1592 version significantly expands on his model, transforming the single figure standing in back into three, the single dancer in front into a circle of sixteen, and enclosing all of them within the interior of a grass hut. De Bry's Tupinambá dancers wear little clothing, although nearly everyone is adorned with minced feathers glued directly to their skin, a feather ornament called an *arayoye* that is worn over the lower back, and tinklers on their lower legs made by filling the dried fruit of the calabash tree with small stones.[4] All the figures in the outer ring show the same uniform stance, and the right foot of each of those on the near side is raised slightly above ground level, casting a shadow where it is about to fall. We can imagine the sound that is about to come, the thud and the rattling as they all drop their feet on the dirt in unison. "They stood close to each other," Léry writes, "without holding hands or stirring from their place, but arranged in a circle, bending forward, keeping their bodies slightly stiff, moving only the right leg and foot, with the right hand placed on the buttocks, and the left hand and arm hanging: in that posture they sang and danced."[5]

The rhythmic but stationary movement of the men is regulated by the trio at the center of de Bry's engraving, who are costumed differently than the rest. In contrast to the bald pates of the dancers, these shamans, called *caraïbes,* wear feathered headdresses. Whereas the dancers are bare but for the feathers attached

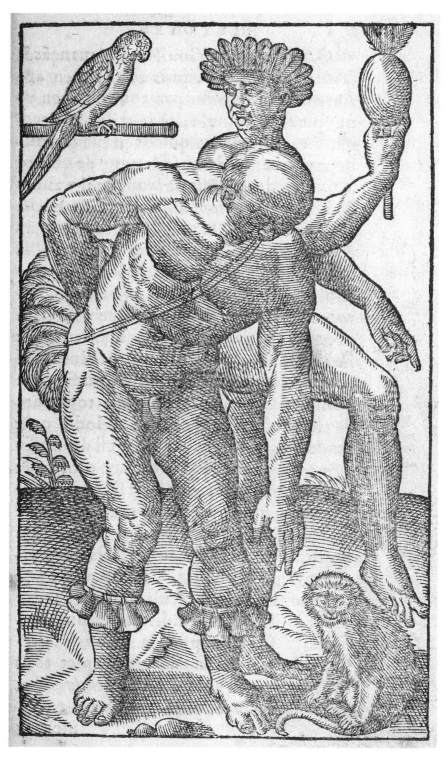

FIGURE 1.1. Jean de Léry, woodcut of Tupinambá dancers, from *Histoire d'un voyage faict en la terre du Brésil* (1578). Courtesy of the John Carter Brown Library at Brown University.

to their bodies, these men wear feathered belts and heavy feathered capes. Clearly men of authority, they wield tokens of their power. Two of them hold large tobacco cigars through which they blow puffs of smoke composed of freely swirling lines that counter the rational contours defining bodies and architecture (Figure 1.2). Léry describes how these shamans, while anointing the dancers with this intoxicating vapor, "would say to them, 'So that you may overcome your enemies, receive all of you the spirit of strength.'"[6] In addition, each of these central figures holds in his hand a large ovoid object, a dried gourd that has been attached to a stick and decked with its own feathered headdress. This they call the *maraca*, Léry tells us, and in order to make the spirit speak through it, they shake it incessantly. The anthropomorphic forms of the maracas echo the heads of the three central

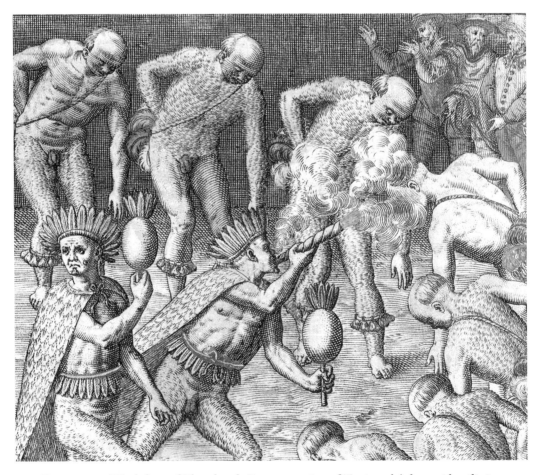

FIGURE 1.2. Workshop of Theodor de Bry, engraving of Tupinambá dance (detail), in Jean de Léry, *Navigatio in Brasiliam Americae* (1592). Courtesy of the John Carter Brown Library at Brown University.

figures, particularly that of the middle shaman, who forms the pivot of the composition. It is a formal arrangement that asks the viewer to contemplate the authority of this strange object and this strange figure, an authority that would appear to govern all that happens within the hut.

The viewer of de Bry's engraving takes all of this in from an elevated vantage point that echoes Léry's own privileged point of view. Léry explains that, when first approaching the hut, attracted to it by the sounds of the chanting men, he made an opening in its grass covering "in order to see as well as I might wish."[7] De Bry in fact includes this makeshift peephole in the upper left corner, as a reminder of how his viewer is meant to see: this is our peep show. But seeing is not enough for Léry; he wants to get closer. He is so compelled by the sound of the dance that he and his two companions, a fellow missionary named Jacques Rousseau and a Norman interpreter who had lived among the Tupinambá for six or seven years, enter the hut physically and retire into a corner, where they can observe the dance at their leisure (see Figure 1.2). Unnoticed by the Tupí men, and thus still enjoying their peep show, the three Frenchmen engage in conversation as the man on the right points to the dancers while the other two hold out their hands in gestures that signify an animated dialogue about the significance of the ritual they witness. There are no clear markers that identify the men individually, but it would be reasonable to assume that Léry is the central figure, who wears a robe that sets him apart from the two men in doublets, and who is the only one to face the viewer. Here, in the corner of the hut, stands our own authority, an eyewitness trained to look and to listen in John Calvin's Geneva, and through whose eyes and ears we experience this New World spectacle.

As Léry describes it, the dance revolves around the power of the *caraíbes* to hold the common people under their spell, making them believe that a spirit speaks to them through the maracas. In this respect, Léry is a disenchanter of the dance, an iconoclast out to expose false idols. His account of the ceremony, however, is of interest not only for its critique of religious superstition but also as a particularly evocative passage in which Léry, with trembling heart, is transported by the sounds of the chanting, bewitched by the dancers as the dancers themselves are bewitched by the sound of their speaking gourd. Directly below the illustration in de Bry's Latin edition, we encounter Léry's transcription of the chant: "Heu, heura, heura, heura, heura, heura, heura, heura, ouech," and in order to make the "measured harmonies" of these words resound in his reader's ears as powerfully as they do in his own, Léry records the chant in musical staff notation (see Plate 1).[8] Sixteen notes are arranged in a regular, descending pattern on a

single staff across the bottom of the page, in counterpoint with the sixteen bodies pictured above, arranged in their regular, circular pattern.[9]

De Bry's image leaves us in an ambivalent position. On the one hand, it presents itself as an unveiling of religious superstition in which we experience the dance as a liberation of our own senses from the smoke and false speech of the *caraïbes*. This liberation occurs both optically, insofar as we occupy the commanding perspective figured by the hole in the wall, and discursively, in the sense that we become, through our reading of Léry's text, virtual participants in the demystifying discussion that takes place in the upper right corner of the hut. The rational speech among the French observers of the dance, as Léry explains in his text, is directed toward the author's own comprehension of the chants, as he asks his Norman interpreter for clarification on their meaning. Occupying this privileged position of rationality, we come to understand our own status precisely as freedom from the dancers' condition of bewitchment. On the other hand, this eminently rational visualization of the dance enacts its own magic. Through its formal characteristics and through its correspondence to Léry's verbal effusions on the beauty of the chants, the engraving conjures the lost sound of the dance, a sound the author represents as opaque speech: the "heura, heura, heura" of the dancers. It is not going too far to say that de Bry puts his image before his viewer and shakes it, as if it were itself a maraca, so that he might leave the sounds of a Tupinambá dance ringing in our ears. If the hole in the wall is one figuration of the viewer's standpoint before the image, then the maraca at the center is a second, competing figuration: it stands for the image that speaks to us in order to enchant us with its magic.

Art historians tend to be skeptical of such sounds. Faced with an image's call for participation, we are more likely to retire into the corner in search of historical explanation. In the following pages, my aim is to unsettle this comfortable scholarly distance by focusing on the de Bry engraving's undecidability about its own status as an image of enchantment or disenchantment. My path begins with a detour through the circular dance and a recently restored painting of Native Americans completed only two years after Columbus made his first landing in the West Indies. It then comes back around to de Bry's Tupinambá dance, to the question of its sounds, and to the challenge of keeping our balance before it.

DANCING IN CIRCLES

The circular dance runs through the art of early modern Europe as a distinctly ambivalent motif. Often focused around a central object or figural group, it

makes for dynamic compositions by linking moving figures through multiple spatial planes, even as it condemns as pagan superstition this very impulse to enliven a visual image. Its paradigmatic instance is the Israelites' worship of the golden calf, witnessed by Moses after he has descended from Mount Sinai with the tablets of the law. During his descent, Moses, like Léry, first becomes aware of voices raised in song: "I do heare the noise of singing."[10] When he finally stands at the base of the mountain and sees with his own eyes that his people have broken the first two commandments—"Thou shalt have none other gods before me" and "Thou shalt make thee no graven image"[11]—he casts the tablets to the ground in his fury, breaking them to pieces. A version of the story done by the Flemish engraver Jan Sadeler (after Crispijn van den Broeck), published in 1585 in Gerard de Jode's *Thesaurus sacrarum historiarum veteris testamenti,* focuses our attention on the debauchery of the men, women, and even children who lose themselves in drink, music, and dance while worshiping the idol they have fashioned in their leader's absence (Figure 1.3). Renaissance writers interpreted the Israelites' idolatry as a reversion to the worship of the Egyptian bull deity Apis, who oversees this scene of sensual abandon from his perch atop a column.[12] The placement of the Apis bull on a column and the circular format of the dance are common elements of the subject's iconography, even though they are not mentioned in Exodus. Their origin instead lies in a pictorial formula established during the Christian Middle Ages that equates the statue on a column with the pagan idol. The sculpture in the round raised above the people is not merely an image to be seen with their eyes, but one that invites them to move their bodies around it. It promotes circular dances of the type we see in Sadeler's print, dances that lack priestly mediation and stand in contrast to the frontality associated with Christian worship.[13]

The dance around the golden calf was depicted by numerous artists during the sixteenth century, its popularity fueled by the heightened awareness of images and their dangers that accompanied the Protestant Reformation.[14] Most spectacular among these treatments is surely Lucas van Leyden's 1530 altarpiece in the Rijksmuseum (Plate 2). The foreground of the central and side panels immediately draws us in with its sensuality and lush colors, as a variety of ostentatiously dressed figures seek gratification of their carnal appetites. It is only after we have lingered over their feast that we come to discern the actual subject of the painting in the middle distance: the golden calf surrounded by a group of wildly gesticulating dancers and a second group dancing in a ring to their right. Eventually, we perceive in the background the tiny figure of Moses, standing at the foot of the smoking mountain with the tablets raised in his hands. Although

Conflato gelidis Horebi in vallibus auro, Quem colerent vitulum composuere bouem, Exod. 3 2.

FIGURE 1.3. Jan Sadeler after Crispijn van den Broeck, *Dance around the Golden Calf*, 1579. Rijksmuseum, Amsterdam.

Sadeler's composition does not push Moses quite so far into the distance, it similarly lures us in with drink and dance before we have the opportunity to absorb the story's moral. Both pictures complicate our understanding of how the pagan idol might inform the Christian viewer's response to the visual image, because, despite the nominal focus on the Mosaic prohibition on making and worshiping idols, it is precisely a pagan idol that activates these pictures. It is in relation *to* the golden calf, raised on its column, that dancers and revelers become animated and in turn animate the beholder.[15] It is not enough, therefore, to say that these pictures reference or represent pagan worship. It would be more accurate to say that they come to life around the idol and demand a response from us, if not a response of idolatry, then at least one that is emotional, embodied, and participatory. They call out our inner pagan, as it were, if only to teach it a lesson.

Should we dance in circles with the revelers, or observe at a critical distance with Moses? If the pictures by Sadeler and Lucas van Leyden do not, and perhaps

cannot, offer a definitive answer to this question, sixteenth-century reformers were quite clear about their views. John Calvin saw the devil at work in those who "hoppe and daunce like stray beasts."[16] Huguenot and Puritan critics found the circular dance to be particularly deserving of censure. Lambert Daneau, author of the *Traité des danses* (1579), compares the ridiculous motions of such dances to "a circle, the center of which is the devil, and the whole circumference his angels."[17] Morris dances were singled out in this criticism. Commonly performed in circular formats with exaggerated movements that included leaping and mock fighting as dancers beat time with instruments and wore dancing bells around their ankles or wrists, morris dances were seen by Elizabethan Puritans as relics of paganism. In the visual arts, they sometimes appear as Renaissance equivalents to the dance around the golden calf.[18] A print entitled "Dance of the World," published in Antwerp around 1600 by de Bry's contemporary Joan Baptista Vrints finds in the morris dance a metaphor for human vanity (Figure 1.4). A direct reference to the Mosaic story can be found in the lower left corner, where the tablets of the law lay neglected on the floor along with a bridle and pitchers for water and wine, symbols of temperance. At the center of the dance stands Lady World, wearing a globe on her head and holding a bubble to signify the brevity of human life, while six dancers symbolizing foolish human traits make wild gestures as they circle around their empty idol. Jean de Léry encountered such dancers in Brazil, where young men in the villages would dress up in their *araroye,* tie on their tinklers, take their maracas in hand, and go "leaping and dancing" through the village: "I was reminded of those over here whom we call 'morris dancers,' who, during the festivals of the patron saints in each parish, go about in fools' garb, scepter in hand and bells on their legs."[19]

Because of its associations with pagan idolatry and human folly, the circular dance was a favorite subject in the European pictorial response to the American encounter. The engraving of Léry's "morris dancers" surrounding the *caraïbes* is one of numerous circular compositions in de Bry's *America*. The first volume, which reprints Thomas Harriot's *Briefe and True Report of the New Found Land of Virginia,* features a large engraving entitled *Their danses which they vse att their hyghe feastes* (Figure 1.5). Harriot's *Report* was the only one of de Bry's volumes to be published in an English edition, and this plate would likely have put its English audiences in mind of the circular dances performed at Whitsun ales and May games. It also establishes a clear link to pagan precedents through the classical motif of the three graces, who appear at the center of the dance as "three of the fayrest Virgins" in the village. The young women embrace, turn about, and set the

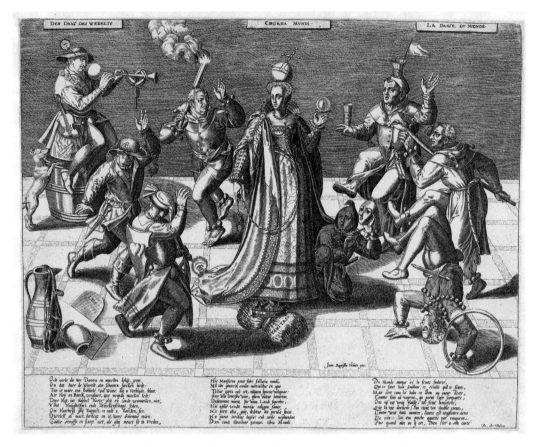

FIGURE 1.4. Peeter Baltens (attributed to), *Chorea Mundi,* c. 1600. Rijksmuseum, Amsterdam.

figures around them into motion. Among the carved posts in the outer ring, which the caption compares to "the faces of Nonnes couered with theyr vayles," the men and women of Virginia "dance, singe, and vse the strangest gestures that they can possiblye devise."[20] The format of the circular dance remained popular in illustrated works on the Americas. It appears, for example, in many of Bernard Picart's illustrations for Jean Frédéric Bernard's landmark work of comparative religion, *Cérémonies et coutumes religieuses de tous les peuples du monde* (1723–1743). In one of Picart's plates, a burning pyre serves as the focus of Bacchic revelers in New France who sacrifice their possessions to the great spirit "Quitchi-Manitou" (Figure 1.6). Picart's image stands as evidence of Bernard's thesis that the world is full of "vulgar and abject Souls" unable to "raise their Minds to what is most sublime and mysterious in Religion."[21] There can be no doubt that such depictions are intended to disenchant New World religion by exposing it as pagan superstition,

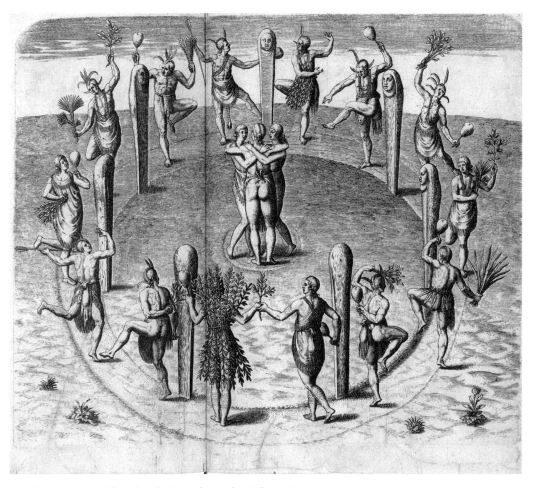

FIGURE 1.5. Theodor de Bry after John White, *Their danses which they vse att their hyghe feastes,* from Thomas Harriot, *A Briefe and True Report of the New Found Land of Virginia* (1590). Courtesy of the John Carter Brown Library at Brown University.

but with no less certainty, we can say that these lively pictures by de Bry and Picart want from us something more than our contempt.

Recent evidence suggests that Europeans associated the pagan dance with America from the moment of the earliest encounters. In 2013, a fresco in the Borgia apartments in the Vatican made the news for a previously overlooked detail. In a scene of the Resurrection in the Hall of the Mysteries of the Faith, completed in 1494 by Pinturicchio (Bernardino di Betto), the figure of the risen Christ, holding in his left hand his banner of victory over death, stands on a cloud above his empty tomb and in front of an opulent mandorla comprised of gilt stucco studs. (Figure 1.7) To the left kneels Pope Alexander VI (Rodrigo Borgia),

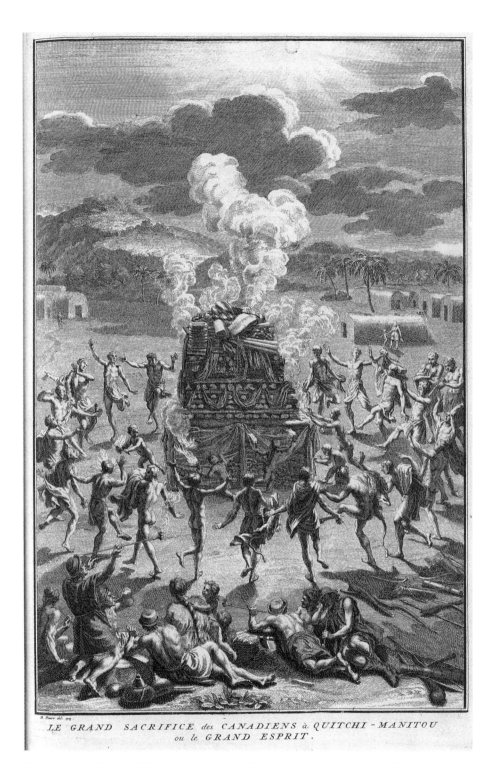

LE GRAND SACRIFICE des CANADIENS à QUITCHI - MANITOU
ou le GRAND ESPRIT.

FIGURE 1.6. Bernard Picart, *Le grand sacrifice des Canadiens à Quitchi-Manitou ou le grand esprit* from Jean Frédéric Bernard, *Ceremonies et coutumes religieuses de tous les peuples du monde* (1723). Courtesy of the John Carter Brown Library at Brown University.

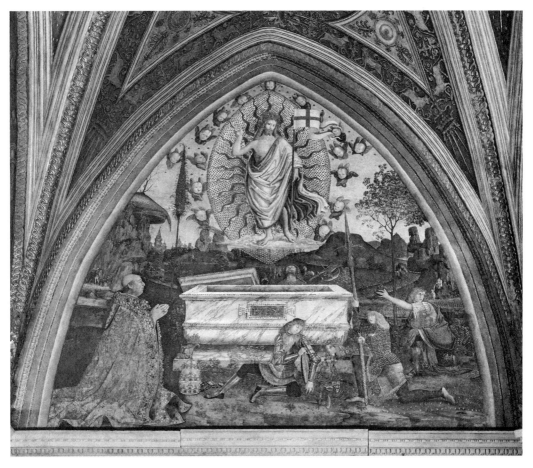

FIGURE 1.7. Pinturicchio (Bernardino di Betto), *Resurrection,* c. 1494. Hall of the Mysteries of the Faith, Borgia Apartments, Vatican. Photograph copyright Stefano Baldini / Bridgeman Images.

and to the right are the Roman soldiers who had been guarding the tomb. One of the four soldiers kneels behind the tomb while looking directly up at the risen Christ, and next to his head we can make out a group of much smaller, naked figures (Plate 3). Painted in *fresco secco,* they have faded over time and now appear somewhat translucent against the lush green landscape. At the front of the group are the two most clearly defined figures. The foremost of them faces the viewer, his arms and legs in motion, his headdress forming a crown of undulating rays around his face. The other stands in profile with his head downturned and his right arm raised so that it blocks our view of his face. In his right hand he grasps a tall spear or pike around which five or six figures seem to be moving, perhaps dancing, in a clockwise motion.

Pinturicchio's frescoes in the Borgia apartments have recently undergone extensive restoration, and even though these ghostly figures in the background of the *Resurrection* had been visible previously, the cleaning of the painting has brought them into the spotlight and prompted a new interpretation of their identity. In April 2013, the head of the Vatican Museums, Antonio Paolucci, announced their "discovery" in the Vatican newspaper, *L'Osservatore romano*: "Against the background of the Resurrection, just behind the soldier struck by the prodigious event, you see figures of naked men, adorned with feathers, seeming to dance."[22] Paolucci suggests that these figures are consistent with Columbus's description of the people he encountered in the Caribbean on his first voyage, and are thus perhaps Europe's "first pictorial representations of Native Americans."[23] In his letter on his first voyage, which was available in Latin, Spanish, and Italian editions by 1494, Columbus does describe the natives as all going "naked, as their mothers bore them, men and women alike."[24] We also know that Alexander VI took an interest in Columbus's voyage. There are good reasons, therefore, to agree with Paolucci's assessment.

These revelations about Pinturicchio's fresco were widely reported in the press with a certain breathlessness and a tendency toward free association. A reporter for National Public Radio, for example, who was not especially interested in the fact that it was the Taíno people Columbus encountered in 1492, noted that one of the figures "seems to sport a Mohican [hair]cut."[25] Even Paolucci's identification of "men adorned with feathers" is a questionable leap, since Columbus's letter, which was the only published account of his voyage at the time Pinturicchio was painting, does not mention feathers. The *ottava rima* edition of the letter by the poet Giuliano Dati does describe the natives as carrying spears and having well-adorned hair and beards, and despite the absence of beards among Pinturicchio's figures, the painter may well have been influenced by Dati's translation.[26] But it is likely that Pinturicchio's figures owe at least as much to another European discovery of the early 1490s as they do to Columbus: the *Domus aurea* of Nero with its *grotteschi,* the Roman ornaments composed of hybrid human, animal, and vegetal motifs that sparked a Renaissance revival of antique decoration. Pinturicchio was one of the first painters to take inspiration from these ornaments, as is evident, for example, in a detail from the ceiling of the Piccolomini Library in Siena Cathedral (Figure 1.8).[27] The headdress of palmettes atop a hybrid creature's mask-like face, a common element in *grotteschi* and one that became a Renaissance signifier of the exotic, closely resembles the crown of "feathers" surrounding the mask-like face of the central nude figure in the Vatican

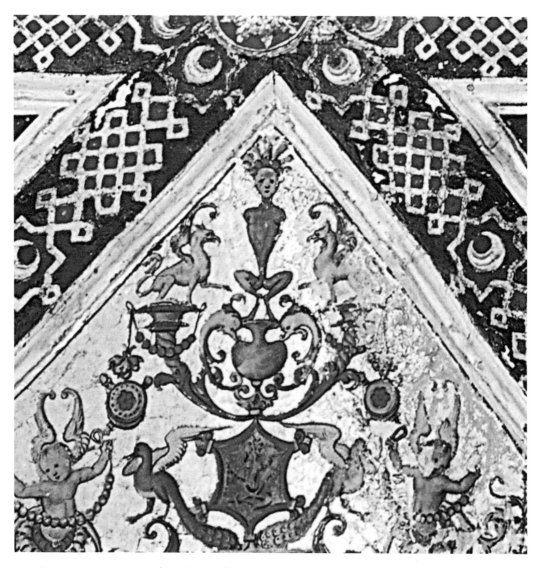

FIGURE 1.8. Pinturicchio (Bernardino di Betto), grotesque ornament, 1502–3. Ceiling of Piccolomini Library, Siena Cathedral. Scala / Art Resource, N.Y.

fresco.[28] The point here is not to reject the influence of Columbus on Pinturicchio, but to suggest that Pinturicchio would have imagined the New World through his knowledge of pagan antiquity.

Such a pagan lens on the New World would be very much in keeping with the theological and humanist program of the Borgia apartments, which is based on typological relationships between Egyptian myth and Christianity.[29] Next door in the Hall of the Saints, for instance, the ceiling shows the myth of Osiris and his

living reincarnation, Apis. It is impossible to miss the connection between this sacred pagan bull and the golden Borgia bull, the family's heraldic symbol that appears throughout the apartments, including in Pinturicchio's ornamental band around the *Resurrection* (see Figure 1.7). These typological relationships establish the legitimacy of the Borgia papacy while enfolding pagan antiquity within the triumph of the Christian faith. Similarly, the inclusion of a "pagan" dance below Christ's risen body amounts to an assertion that the New World must be known through its enclosure within Christian revelation, the central truth of which is Christ's resurrection. The Christian status of the lands discovered by Columbus was a matter of concern to Alexander VI, and he made his position on it clear in his papal bull issued in May 1493, *Inter caetera,* in which the Pope calls for conversion of the natives. Desirous that "the name of our Savior be carried into those regions," he writes to Ferdinand and Isabella, "we exhort you very earnestly . . . that . . . you purpose also, as is your duty, to lead the peoples dwelling in those islands to embrace the Christian profession; nor at any time let dangers or hardships deter you therefrom."[30] Understood in these terms, Pinturicchio's painting is theologically consistent with other early images of New World peoples, like the *Adoration of the Magi* by the Portuguese painter Vasco Fernandes (Figure 1.9). Dating from 1501–2, this panel is one of eighteen that together make up an elaborate altarpiece for the cathedral in Viseu, Portugal. Here, the central king, a dark-skinned figure in European clothing but in Tupinambá headdress and carrying a large arrow or spear, advances with fluttering sleeves and tassels in a pose strikingly similar to Pinturicchio's foremost dancer as he carries his gift of a silver-lined coconut shell toward the Christ child. A figure of New World difference, he moves toward sameness as he seeks incorporation within the body of Christ.[31] Both Fernandes and Pinturicchio put the inhabitants of the New World into motion as details within larger theological programs that court paganism only to subordinate it to sacred history.

Yet the very depiction of these figures in a state of arrested movement has the potential to disrupt their tidy incorporation within a settled, Christian order. Aby Warburg showed in his 1893 dissertation on Sandro Botticelli that the Winckelmannian ideal of "noble simplicity and quiet grandeur" fails to explain the visual and emotional volatility of pagan antiquity's afterlife in fifteenth-century Italian art. In response to Leon Battista Alberti's call for artists to convey movement through draperies that "fly gracefully through the air" or hair that "waves in the air like flames, twines around itself like a serpent, while part rises here, part there," artists like Botticelli and Pinturicchio drew on antique pictorial formulas to

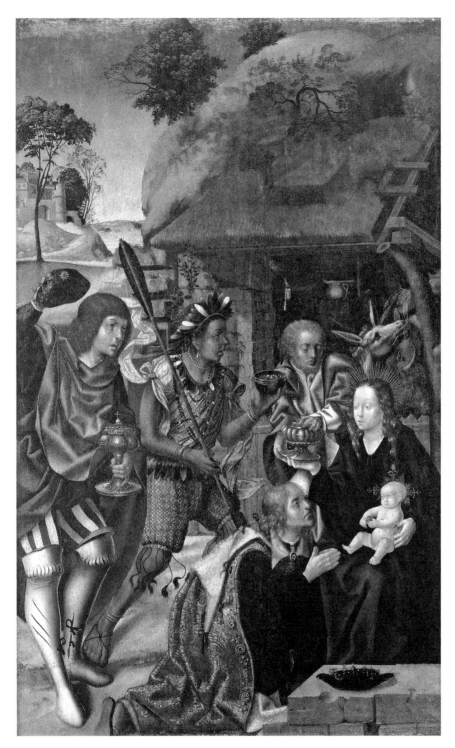

FIGURE 1.9. Vasco Fernandes, *Adoration of the Magi*, 1501–2. Panel from the chancel altarpiece, Viseu Cathedral. Oil on panel, 131 × 81 cm. Museu Nacional Grão Vasco. Direção-Geral do Património Cultural / Arquivo de Documentação Fotográfica. Photograph copyright José Pessoa.

depict outward "accessory" motion, putting the limits of their static medium to the test.[32] One suspects Alberti would have approved of the flame-like tendrils rising from the head of Pinturicchio's pagan dancer. In a fresco that is possibly the earliest European painting of the inhabitants of the Americas, and that is perhaps inspired by the recently unearthed ornaments from the *Domus aurea,* an ancient paganism is resurrected in a manner not unlike the resurrection of Christ himself. To include the dancing figures immediately above the empty tomb and below Christ, with the foremost figure's pagan headdress echoed in the agitated, golden rays of light emerging from the resurrected Christ, is to make an assertion about what painting can do through the depiction of movement and gesture. Who can look at such figures and not see in them an art that aspires to reanimation? If a primary theological message of the Borgia apartments is the triumph of the Christian faith, Pinturicchio's dancing figures call us back to a moment before painting becomes theology, to a moment of pagan revelry before Moses arrives on the scene and brings the dance to an end.

EXPERIENCE VERSUS KNOWLEDGE

In his influential book *The Power of Images* (1989), David Freedberg maintains that we should attend more closely, both theoretically and historically, to the psychological and behavioral responses that visual images elicit from viewers. In Freedberg's view, this is a topic inadequately addressed in Western writing on art, which has typically treated such responses as embodied conditions that need to be overcome in favor of a proper critical stance: they are thought to be "unrefined, basic, preintellectual, raw," in short, "primitive."[33] The pagan dance, as Freedberg himself shows, holds an especially fraught place within this long history of discomfort over visual response, for despite its manifest visual interest, much was at stake for Christian viewers in achieving a distance from its allurements.[34] As I have suggested in the preceding discussion of Pinturicchio's *Resurrection* fresco, the experience *of* the dance does not easily give way to knowledge *about* it. The same may be said about de Bry's engraving of the Tupinambá dance. It is the product of an author and publisher who, though committed to achieving a critical perspective on their subject, place an equally high value on the immediacy of our sensory experience.

Histoire d'un voyage is very much a text about the challenge of extracting stable knowledge from individual experience. In his preface, Léry alerts us that what follows will be a definitively first-person account:

If someone finds it ill that hereafter, when I speak of savage customs, I often use this kind of expression—"I saw," "I found," "this happened to me," and so on (as if I wanted to show myself off)—I reply that not only are these things within my own subject but also I am speaking out of my own knowledge, that is, from my own seeing and experience; indeed, I will speak of things that very likely no one before me has ever seen, much less written about.[35]

Léry then immediately plunges us into a turbulent world of new experience as he and his companions sail out of Honfleur and into a stormy Atlantic: "Putting into practice what is said in Psalm 107, all of us, our senses reeling, staggered about like drunkards; the vessel was so shaken that no sailor, however skillful, could keep himself on his feet."[36] Psalm 107, which figures importantly in Léry's text, as it does in Calvinist thought more generally, teaches that the many vicissitudes of this world are not to be attributed to the fickleness of fortune, but to God's providence. "They that go downe to the sea in shippes," writes the Psalmist, "are tossed to and fro, and stagger like a drunken man, and all their cunning is gone. Then they crye vnto the Lord in their trouble, and he bringeth them out of their distress."[37] The waters that batter Léry at sea will indeed be pacified, but he will soon lose his footing again when he encounters the Tupinambá, who are at one moment a joyous people who laugh with Léry and welcome him into their society, but at the next, are cannibals cursed and abandoned by God. The sense of vertigo evoked in the Psalm's imagery of shipwreck and deliverance is the leitmotif of *Histoire d'un voyage,* which never permits the reader a point of view outside the "I" of the author's own tumultuous experience. Léry's poise, writes Janet Whatley, "is the dynamic poise of one who can keep his balance on a rolling, pitching platform, who is supple enough to stagger and not fall, who is willing to be momentarily out of control."[38] To read the narrative is always to be in search of this balance, whether on the ocean or in a Brazilian hut where, repulsed and delighted, we reel with Léry between the rattling of maracas and the chanting of the Tupí dancers.

Léry's narrative is a microcosm of the larger compilation in which de Bry published it, a heterogenous collection of texts that can induce a similar sense of vertigo in its reader. There is no single narrative or author standing behind de Bry's *America,* nor do its thirteen volumes represent a single language or nationality: the first four volumes alone, published between 1590 and 1594, include narratives by English, French, German, and Italian voyagers. *America* is itself a sea of differing perspectives on the New World, and its pictures, the most distinctive

feature and primary selling point of the publication, ask us to see through the eyes of its varied authors. Amidst all this visual evidence, we often find ourselves without secure footing. The texts in de Bry's *America,* moreover, bear a complex relationship to the pictures, which do not merely reflect, but often jostle against the narratives. For example, the plates of the first volume, Harriot's *Briefe and True Report,* which are based on original watercolors by the English painter John White, are notable for their careful articulation of a sovereign New World society, complete with its own "Cheiff Lordes" and "Chieff Ladyes." Harriot's text, however, is an advertisement inviting European readers to invest in an English colonial venture to a country ripe for settlement. How are we to reconcile these competing claims of pictures and text? The question must remain open because the many fragments of text and image that constitute de Bry's *America* offer no omniscient voice that would resolve it. De Bry's approach stands in contrast to histories of the Americas written under the patronage of the absolutist Spanish monarchy, such as Antonio de Herrera's *Historia general* (1601–1615). Distilled from primary sources into a single master narrative and minimally illustrated, the *Historia general* suppresses all potentially competing claims to the sovereign authority of the Spanish crown.[39] Even in Pinturicchio's Vatican fresco, despite the experiential tug of its pagan dance, Christian doctrine and the transcendent authority of the Borgia papacy offer us a royal route to certain knowledge. For de Bry and Léry, however, the grand program of Christian salvation remains veiled and mysterious behind the fragmentary sights and sounds of the individual confronting the sensory evidence of the New World.

It is this emphasis on experiential encounter that makes de Bry's *America,* at its core, a *Protestant* publishing venture. It has recently been argued that the anti-Catholicism of de Bry's publications has been overstated, that de Bry did his best to tone down the antipathies toward Spain and Rome he surely felt as a Protestant exile from the Spanish Netherlands working in Frankfurt.[40] And it is true that *America,* for the most part, is not a polemical text. The Léry volume, for example, plays down the author's more stridently anti-Catholic passages and forgoes easy equations between Catholics and American idolaters in favor of a more generalized opposition between Christianity and an idolatrous New World paganism. This is surely a strategic decision on de Bry's part that is intended to give his volumes wide, cross-confessional appeal. De Bry was also clearly attuned to doctrinal differences between the readerships of his two editions: a largely Protestant audience for the German translation, and for the Latin translation, a wide and scholarly European readership that included many Catholics. The full text of

Psalm 107, for example, appears at the beginning of de Bry's German edition of *Histoire d'un voyage* but is not included in the Latin.[41] De Bry was an astute businessman, to be sure. Yet, despite this selective catering to confessions, the basic insight Calvinists found in Psalm 107 underwrites the whole of de Bry's *America*, German and Latin editions alike. In this collection of texts that privilege an experiential confrontation with the verbal testimony and visual evidence of a hitherto unknown continent, the finding of a stable vantage point is a struggle left to the reader and to God's providence.

In the Léry volume, this experiential groping toward knowledge involves both our eyes and our ears. Psalm 107 is introduced in de Bry's German edition with the Latin motto "Plus videre quam habere."[42] "Better to see than to have" would be a literal translation of the phrase, but below the Latin, de Bry provides a German translation that does some interpretive work: "Erfahrung ist besser dann Gelt und Gut," or "experience is better than money and goods." The conflation of vision and experience in de Bry's translation is significant. As a prelude to Psalm 107, the motto suggests that the evidence of our senses, and especially our eyes, can lead us, if we are wise, to a deeper knowledge of God's judgments in the world. This is more than a principle reflecting Léry's own commitment to direct observation; it stands as a justification for de Bry's engravings, which serve as valuable experiential aids to our understanding.

Appearances, however, can be deceiving, and vision is therefore no substitute for the more noble sense that triggers Léry's recollection of the Tupinambá dance. Protestant reformers took to heart the Pauline lesson that "faith is by hearing, & hearing by the worde of God."[43] For Martin Luther, Christ's kingdom is a "hearing-kingdom" and not a "seeing-kingdom." "The beginning of true doctrine," writes Calvin, is "a prompt eagerness to hearken to God's voice."[44] Hearing thus has the potential to transcend the uncertainties of visual experience. But hearing, because it too is a form of sensory experience, cannot always be trusted: there is the voice of God that is heard in the heart, and then there is "the outward voice of men."[45] For Léry, the maracas belong to the latter category. The chants of the dancers, on the other hand, open onto something more, onto an experience of alterity that resonates deeply within Léry, even though he cannot fully articulate it.

Although the chants remain elusive, Léry does attempt to decipher them with the help of the Norman interpreter. When he asks about their meaning, he is told that "at the beginning of the songs they had uttered long laments for their dead ancestors, who were so valiant, but in the end, they had taken comfort in the assurance that after their death they would go join them behind the high

mountains, where they would dance and rejoice with them."[46] Léry is here re-
ferring to—and he remains an important source of anthropological knowledge
about—the Tupinambá belief in a so-called "Land-without-Evil," which was a
central component of Tupí-Guaraní religion.[47] Going from village to village, the
caraíbes would lead massive rituals in which they called on people to give up their
sedentary, agricultural existence and undertake arduous migrations in search of
a mythic paradise, the Land-without-Evil. The *caraíbes* did this, moreover, not
through proselytizing or doomsaying, but through a poetic speech they called *ñe'ë
porä,* or "beautiful words." These were a combination of unspoken melodies,
chanted speech, and spoken words; they are the words that appear below de Bry's
engraving, translated into musical notation; they are the sounds that transport
Léry "with delight." And to reiterate a point made earlier, this musical speech
should be understood in contrast to Léry's own speech within the hut, when he
talks with his interpreter so that he might master the dance through discourse,
and thus transform it into an object of knowledge. Such an instrumental use of
language is quite different from the language that bewitches Léry as opaque, *felt*
sound, a sound whose power inheres not in its signification, but in its resonance.
And, indeed, this is precisely the effect beautiful words were supposed to have.
These were words fundamentally about their own sound. They constituted an
entirely metaphorical speech, the purpose of which was to restore bonds between
human beings and their mythical ancestors, and they did this wholly through
their enunciation, not by designating or communicating in any ordinary way. As
the anthropologist Hélène Clastres writes, they are words "intended for chant,
not for knowledge."[48]

The sounds of the ceremony we witness in de Bry's engraving, however, involve
more than just beautiful words. The cult of the maraca is also central to the reli-
gion of the Land-without-Evil, and thus the maraca's incessant sound, while far
from beautiful to Léry's ears, demands our attention as well. The significance of
maracas within Tupinambá society had been noted since the earliest European
accounts. Hans Staden, a German soldier taken captive by the Tupinambá for
nine months in 1554, was the first to mention them. His *Warhaftige Historia,* or
True History, was first published in 1557 and subsequently went through many edi-
tions, including those of the de Bry firm, which placed Staden's narrative along-
side Léry's in the third part of *America.* The original edition of *Warhaftige Historia*
was illustrated with simple woodcuts and includes the first European depiction of
a maraca (Figure 1.10).[49] Although Staden is sufficiently aware of the importance
of this object within Tupinambá religion to give it its own illustration, he mistakes

FIGURE 1.10. Maraca, from Hans Staden, *Warhaftige Historia und beschreibung eyner Landtschafft der Wilden Nacketen* (1557). Courtesy of the John Carter Brown Library at Brown University.

its actual function, stating that "they believe in a thing, which grows like a pumpkin," a claim that reflects Staden's belief that the maraca is itself a god for the Tupinambá, rather than a mediator that effects communication between a human and spirit world.[50] The maraca was used by shamans during ceremonies such as the one we see in de Bry's engraving, and for other purposes as well, whenever it was necessary to call on the spirit world. It resembled a human head with feathers for hair, as well as other features. As Staden notes, and as his illustration shows, they "cut a hole in it like a mouth; then they put in small pebbles so that it rattles" (the maracas carried by the *caraïbes* in de By's engraving have feathers but no visible mouth). It could even have ears and eyes, and it sat atop an arrow that took the place of a neck. The *caraïbes* would breathe tobacco smoke through it so that it came out the orifices, and they would also speak through it; when they did this, it was understood that a spirit was speaking through the maraca.[51]

In his account of the Tupinambá, the Calvinist Léry claims that the *caraïbes* use maracas to dupe the people, making them believe these objects are living beings that require food and drink. In a passage that de Bry expurgated from both of his editions, presumably so he would not offend any potential purchasers who favored Rome, Léry likens the *caraïbes* with their sacred rattles to itinerant indulgence

sellers in Europe: "You could find no better comparison than to the bell-ringers that accompany those impostors who, exploiting the credulity of our simple folk over here, carry from place to place the reliquaries of Saint Anthony or Saint Bernard, and other such instruments of idolatry."[52] The maraca also makes a notable appearance on de Bry's title page for Léry's narrative, where it sits atop the architectural façade that provides our entry into the text (Figure 1.11). Here it becomes the centerpiece of a savage, and therefore inverted, social order, with Tupinambá dancers on either side falling prostrate before it in idolatrous devotion, a man and woman to either side devouring human limbs, and a cannibal feast over the *boucan* visible through the arched opening. Léry may fall under the spell of the "beautiful words" of the Tupinambá, and this is understandable in a Protestant who locates truth in the ineffable Word that reverberates beyond the outward evidence of the senses. Neither Léry nor de Bry, however, have any tolerance for the base speech of the maraca.

Like the iconoclast who demands of an image that it speak and then mocks it when it fails to respond, Léry and de Bry seek to silence the speaking images of Brazil, to show that they are gourds and nothing more. The ambivalence of this Protestant ethnography lies in its harnessing of the visual image to accomplish its work. De Bry's engraving of the Tupinambá dance, invested as it is in disenchanting New World idols, seeks to debunk claims about the lifelikeness of one image by exploiting the power of another. The impulse behind the illustrations for de Bry's *America,* after all, is to enliven the New World. The main title page to the Latin edition describes the engravings of Brazil as being *ad vivum expressis,* literally "expressed to the life." The phrase *ad vivum* had become a common one by the second half of the sixteenth century. It described a picture (often a portrait, natural history illustration, or chorographic subject) that could claim a special epistemological authority based on an observer's direct encounter with the object. It provided a standard of trustworthiness in an era when print was making visual information more accessible to broad audiences who wanted assurances of reliability.[53] But in that stock phrase *ad vivum* is a suggestion of something more than a cool judgment on a picture's veracity. Through the preposition *ad,* it signals a motion toward the thing itself. The naturalistically rendered image has the capacity to *move* us closer to a condition of lifelikeness.[54] De Bry's title page prepares us for a book in which images will take us as close as we can hope to get to the inhabitants of Brazil, so palpably that we can almost hear the chants of the dancers and the rattle of the maracas. But, once there and confronted with the folly of putting too much faith in mere images, we are distanced from the very life that

NAVIGATIO
IN
BRASILIAM AMERICAE
Qua Auctoris Navigatio, quæ memoriæ
prodenda in mari viderit, Brasiliensium vic
tus & mores à nostris valde alieni, animalia
etiam, arbores, herbæ, & reliqua singularia
nostris penitus incognita describuntur:
adiectus insuper Dialogus eorum
lingua conscriptus.

A IOANNE LERIO BVRGVNDO
Gallicè primùm scripta, deinde latinitate donata
Varijs autem figuris illustrata per
Theodorum de Brÿ Leo:

Venales reperiütur in officina
Theodori de Brÿ.

FIGURE 1.11. Workshop of Theodor de Bry, title page to Jean de Léry, *Navigatio in Brasiliam Americae* (1592). Getty Research Institute, Los Angeles. Digital image courtesy of the Getty's Open Content Program.

the image made *ad vivum* would conjure. The experience of looking at de Bry's engraving is a vertiginous, circular dance unto itself.

A QUESTION OF PERSPECTIVE

To see the dance from a distance is to see it from the Mosaic viewpoint, that of the lawgiver in Sadeler's print as he looks down upon the dance from his superior position on the mountain. We are asked to occupy this same position in de Bry's engraving. Located above the dance, we are able to perceive its circular form, and thus bring to bear on it all the meanings that form carries with it. This is a commanding perspective into which we might read a good deal about vision and modernity. Its inaugural and epoch-defining moment occurs at the summit of Mount Ventoux in 1336, as the great humanist Francesco Petrarch takes in the sweeping view across the Alps from his Olympian perch.[55] Its pictorial foundation is the *costruzione legittima* codified by Alberti in 1435 and later, at the moment of art history's disciplinary founding, theorized by Erwin Panofsky as the symbolic form of the post-Renaissance world. Its significance within modernity is at once optical and ontological. It grants the individual visual control over the world while predicating that control on a self who exists at a distance from reality, who experiences the world as if seen from the outside, as a picture.[56]

This point of view may also be described, when it enters the service of European colonialism, as an imperial gaze. Walter Mignolo has recently characterized de Bry's *America* in these terms:

> At the center of an expanding imperial Europe, as if standing upon a hill like future British travelers surveying the interior of Africa and South America, De Bry's visual narrative complements contemporary world maps. . . . This world is a triumphal spectacle laid out before the viewer's eyes; it is a confirmation of the superiority of Western Europe in the process of building its own imperial identity. De Bry's gaze is the gaze of *humanitas* that looks across the world to observe the otherness of *anthropos*.[57]

For Mignolo, de Bry is the bellwether of a colonial modernity grounded in Renaissance humanism and perspectivalism, and the consequence of this "logic of coloniality at work, hidden behind the triumphal rhetoric that De Bry's engravings transmit," is "a silence imposed upon the Other."[58] One might counter, however, that *America* offers only silence and unequivocal triumph if we insist on

remaining atop the hill where de Bry initially places us, at a distance and out of earshot. Approached more closely, his engravings can be loquacious, cacophanous even, particularly when read in light of narratives and captions that invite multiple voices. There can be no question that de Bry's *America* is entangled in what Mignolo calls a "colonial matrix," one that was very much in-the-making in the 1590s, but the meaning of de Bry's illustrations is far from settled within this matrix, and the generalizing concept of an "imperial gaze" driven by a power-hungry humanism cannot account for their ambivalent wavering between distance and proximity. The challenge, then, is not to expose a presumed imperial tyranny hidden behind de Bry's *America,* but to seek our balance on this rocking ship while attending to the voices conjured by its words and pictures.

In Léry's case, the desire to approach the dance more closely is manifest in the palpable sense we have that the hole in the wall, and therefore our optical distance as viewers, is not enough. As Léry explains in his narrative, he and his companions are not satisfied with it and go through the wall to enter bodily into the hut and stand amidst the performers. De Bry invites us to join them through his modifications to the original woodcut from the 1578 edition of *Histoire d'un voyage.* By multiplying the single dancer in the foreground of the earlier woodcut sixteen times and gradually rotating his body so we can see it from every angle of vision, de Bry counteracts our distanced gaze and asks us to experience the dance in the round. There is a well-established art-historical language for addressing such efforts to shift between two- and three-dimensional media, or between different modes of sensory experience. One could, for example, invoke the Renaissance comparison between painting and sculpture to explain de Bry's efforts to render up a figure in three dimensions: by showing identical figures from multiple sides in a single composition, the artist produces an effect of *relievo* that outdoes the sculptor by revealing the full dimensionality of the dance all at once. The addition of color to de Bry's engraving, which is not uncommon in surviving copies of *America,* including the example from the John Carter Brown Library illustrated in Plate 1, enhances this effect of lifelikeness by transcending the black-and-white of print or the coldness of stone. One might also invoke the comparison between painting and poetry to understand the way in which de Bry's picture competes with language's capacity (in this case, the chants of the dancers) to speak to us. It is not difficult, however, to see the limitations of such *paragoni,* concepts that are so caught up in the efforts of Renaissance humanism to rescue painting from the mechanical arts that they fail to account for the strangeness, and one might even argue the magic, of a Renaissance pictorial naturalism

that was one of the chief means by which Europeans sought contact with the inhabitants of the Americas.

A more helpful language would be to think of de Bry's picture not as a "representation," a concept that reduces the copy to a second-order status in relation to the original, but rather as an act of "mimesis." Mimesis is not to be understood here in the limited and general sense of illusionistic imitation in the visual arts, but as the specifically "primitive" form of imitation theorized by nineteenth-century anthropologists like Edward Tylor:

> Man, in a low stage of culture, very commonly believes that between the object and the image of it there is a real connexion, which does not arise from a mere subjective process in the mind of the observer, and that it is accordingly possible to communicate an impression to the original through the copy. We may follow this erroneous belief up into periods of high civilization, its traces becoming fainter as education advances.[59]

Mimesis, conceived in these terms, refers to the way the senses penetrate into the world in order to inhabit its otherness. It is a kind of knowing that refuses reflective distance and instead insists on an intrinsic and corporeal connection, often understood in terms of occult sympathies, between an imitation and the thing it imitates. The maraca can stand as one obvious example: by giving the gourd hair, a mouth, and eyes, the Tupinambá endow it with a life of its own; it speaks and eats.

Although mimetic behaviors of this sort appear throughout de Bry's *America* in the idolatrous practices of New World pagans, our perspective on mimesis is not always that of Mignolo's *humanitas* looking out upon its primitive anthropological other. In the illustrations to the second part of *America,* which is an account of the short-lived French Huguenot colony in Florida during 1564–1565, mimesis becomes a subject for reflection and cultural comparison. The engravings for the volume are based on drawings by Jacques Le Moyne de Morgues, a Huguenot artist who had been part of the expedition to northeast Florida and carefully observed the customs of the indigenous Timucua people. Le Moyne's images occasionally juxtapose European and Timucuan behaviors, and just as Michel de Montaigne, in his essay "Of Cannibals," finds in Tupinambá anthropophagy an occasion to reflect on European barbarism, Le Moyne appears less interested in establishing firm hierarchies across the Atlantic than in prompting his viewer to contemplate both variety and similarity in human customs. In one instance, he

offers up his own artistic practice for such contemplation (Figure 1.12). In a plate entitled *Cervorum venatio* ("The Hunting of Deer"), Timucuan hunters approach their prey while disguising themselves in deerskins. As Le Moyne's caption explains, this practice, one "which we had never seen before," has the practical function of allowing the hunters to sneak up on the deer.[60] The wearing of the skins also suggests the animalistic nature of the savage. But Le Moyne complicates the otherness of this New World practice in the reflections that appear in the stream running through the center of the composition, where the hunters and prey, whom we initially see as different (deer and men dressed as deer), become identical with each other. Surely Le Moyne is asking us, through this watery metaphor of art as a mirror of nature, to reflect on the similarity of his own imitative art to that of the Timucuans. To enter into this image, in other words, is to put

FIGURE 1.12. Workshop of Theodor de Bry after Jacques Le Moyne, *Cervorum venatio,* from René Laudonniere, *Brevis narratio eorum quae in Florida Americae Provincia Gallis acciderunt* (1591). Rijksmuseum, Amsterdam.

it on like a second skin in our desire to be *like*. De Bry's *America* is full of such invitations to clothe ourselves in New World difference.

The desire to put on the New World, rather than merely to represent it, was occasionally pursued with a striking literalism in early modern Europe. One of the more notable instances occurred in September 1550, as King Henri II of France and his queen, Catherine de' Medici, made their royal entries into the city of Rouen. Such events were great mimetic spectacles. As the monarch traveled in a lavish procession that evoked a Roman triumph, an elaborate pageantry that included works of painting, sculpture, and *tableaux vivants* reanimated the past to establish the legitimacy of the sovereign in the present. In Henri's entry, for example, his genealogical affiliation with the Trojan hero Hector, legendary founder of the French royal line, took the form of a "living" statue standing fifteen feet tall, from whose body spouted a plume of blood that created Henri's insignia of a triple crescent. The most unusual aspect of Henri's procession, however, was the living tableau that awaited the king when he reached the banks of the Seine on the outskirts of the city. There, he encountered a large meadow planted with natural and artificial shrubs and trees to look like a Brazilian forest, home to exotic birds, monkeys, and squirrels. Two villages of huts made from tree trunks had been constructed in the forest, and the whole scene was inhabited by fifty captive Tupí men and women who had been brought to France on merchant ships, along with another 250 Frenchmen who were as naked as the native Brazilians and participated in their activities. They ran after monkeys, fired arrows, rested in hammocks, chopped "brazilwood," and carried it to the river to trade with French sailors. Amidst all of this, a battle broke out between two Brazilian tribes, and after furious fighting with arrows and clubs, the victors burned one of the villages to the ground. In an encore performance held the next day for the queen's entrance, the second village was burned. Mock combats had traditionally been part of royal entries, but nothing like this had ever been seen previously. The king, it was reported, showed his enjoyment openly.[61]

The king watched these events unfold from a scaffolding that had been set up to provide the best possible vantage point. Fully encompassed by Henri's view, the entirety of this elaborate spectacle reflected back on the king as confirmation of his own sovereign authority. Most of France, of course, was not present for the royal entry in Rouen, and for this reason, a festival book was published in 1551 that sought to convey the king's perspective to a wider audience. The volume, which includes detailed verbal descriptions and numerous woodcuts, presents the entry as an opulent but orderly affair glorifying Henri at every turn. One of

the most elaborate woodcuts is a two-page panorama entitled *Figure des Brisilians,* in which the Brazilian forest is presented as at once Edenic, pagan, and violent (Figure 1.13). Among the many figures populating the scene are a man and woman reminiscent of Adam and Eve standing to the right, five nude figures dancing in a circle to the left, and the two tribes waging war on each other in the foreground. Numerous tiny figures throughout the forest are engaged in the various pursuits described in the text as the two Tupinambá villages burn in the distance. In short, there is much for the beholder to take in, but the power of the sovereign's panoptic view lies precisely in its ability to manage this excess. Still, the overabundance of the scene prompts speculation on what a more proximate experience might have been like. If the woodcut places us at an imperial distance from the object of the king's magisterial gaze, the performance itself aimed for a "real connexion" to its object by eliminating any distance whatsoever between sixteenth-century Brazil and a meadow along the banks of the Seine. Clothing themselves in the New World, the participants closed this distance with such fervor that they reduced

FIGURE 1.13. *Figure des Brisilians,* from *C'est la deduction du sumptueux ordre plaisantz spectacles ...* (1551). Courtesy of the John Carter Brown Library at Brown University.

their stage to ashes in the very pursuit of lifelikeness. As the author of the festival book describes the event, "it seemed to be real, and not simulated."[62]

The insatiable desire for likeness that animated the king's entry into Rouen in 1550 suggests that we should question the primitivizing of mimesis by anthropologists like Tylor. And, indeed, writers such as Walter Benjamin and, more recently, Michael Taussig have taken mimesis out of Tylor's nineteenth-century evolutionary framework by treating it as a universal human faculty that is no less at work in everyday language and modern technologies than in ancient dance or pagan ritual.[63] Rarely, however, does historical scholarship entertain the ways in which this mimetic magic remains operative within a presumably disenchanted Western modernity. Yet, what is Léry's own verbal mimicry of the Tupinambás' beautiful words but a moment of ecstatic, sonorous alterity, a becoming-of-the-other from which he returns but that he also never forgets? And what is de Bry's engraving but an effort to recover this sound through its invitation to enter into another's skin and experience an alien world so fully we can hear it? Responding to this mimetic impulse does not, of course, mean that we should put all critical faculties on hold to pursue a fantasy of presentness existing outside of determining historical factors. Mimetic desire is hardly free from the violence of the colonial matrix. But it does mean that, when we look upon a sixteenth-century depiction of a Tupinambá dance from the critical distance of art history's disciplinary scaffolding, we should be prepared to lose our balance.

Frans Post's Silent Landscapes

A LBERT ECKHOUT'S *Tapuya Dance,* painted in the early 1640s on a canvas nearly ten feet wide, is a notable successor to the Tupinambá dance engraved in the de Bry workshop fifty years earlier (Plate 4). The painting features eight male dancers based on Eckhout's studies of indigenous inhabitants of the coastal areas of northern Brazil, where the artist was in the employment of Count Johan Maurits van Nassau-Siegen, the governor of the Dutch colony. Naked and dancing in a circular formation, the men raise their right legs and brandish spears high in their right hands, while in their lowered left hands, they carry war clubs. Two women stand at the far right of the canvas behind an armadillo, each cupping a hand over her mouth and humming in accompaniment to the dancers. By placing the nearly life-sized figures as close as possible to the picture plane, Eckhout brings their movements and sounds astonishingly close to us, an effect enhanced by the rightmost dancer, the only one not holding a spear, who looks directly at the viewer. The painting has received much praise for its liveliness and accuracy. Hugh Honour, for example, writes that Eckhout "broke completely free from all formal and other conventions or stereotypes and succeeded in conveying a vivid and accurate impression of [their] gestures, . . . as well as the frantic rhythm of the war dance."[1]

One may take issue with the idea that Eckhout freed himself from all conventions, and scholars have done so by articulating the cultural rules within which this seventeenth-century Dutch painter worked. They have argued convincingly that this painting, along with Eckhout's depictions of Africans, mestizos, mulattos, and other indigenous Brazilians, belongs to a pictorial cycle intended for the

walls of Johan Maurits's primary residence in Brazil, Vrijburg palace in Maurit-
staad (now Recife). At Vrijburg, Eckhout's paintings put on display a hierarchy of
human civility—the dancing Tapuyas being the most savage—that glorified the
count and underpinned Dutch justifications for colonial rule.[2]

Yet it is important not to dismiss Honour's observation that Eckhout is reach-
ing for something beyond convention. As the painting draws us into the dance,
we sense that the artist is reaching beyond the limitations of his medium: toward
the motion of the dancers, toward the sound produced by the two women, and
toward the response to that sound in the rhythmic movement of the men's feet
and the clattering of their spears. We sense that the artist is aiming for the kind
of shock that an audience at the Mauritshuis felt in August 1644 when, at a cele-
bration for the newly returned Johan Maurits, and with Eckhout's paintings serv-
ing as the backdrop, the sights and sounds of the *Tapuya Dance* were brought to life
in a performance by actual Brazilians. "Count Maurits brought back savages who
performed dances while completely naked," wrote Constantijn Huygens, secre-
tary to the stadtholder, Frederik Hendrik, to a friend. Many reacted to the dance
with laughter, while "the ministers, who with their wives were watching, thought
it unpleasant."[3]

The conceit of the painting or sculpture that is experienced by a beholder with
such vividness that it becomes animated, and indeed audible, is an enduring one.
In medieval narratives, the weak-minded are seduced by the alluring speech of
pagan statues, while the faith of saints is testified by their readiness to hear the
voice of Christ spoken by a crucifix or the voice of the Virgin in an icon.[4] Renais-
sance humanists were fond of composing epigrams that praised portraitists for
representing all but the sitter's voice; in doing so, they were pointing not only to
the limitations of a mute art, but to the artist's aspirations to exceed those limits.[5]
Erasmus of Rotterdam, for example, eulogized Albrecht Dürer for depicting "the
whole mind of man as it shines forth from the appearance of the body, and almost
the very voice."[6] Erasmus's words point to an aural imagination that informs the
new pictorial naturalism of the Renaissance, an imagination that Eckhout, de Bry,
and others put to work across the geographical distance between Europe and the
Americas in their efforts to enliven the New World through dance, to make it speak.

In the present chapter, my aim is to show that this aural imagination is not
only about a picture's capacity to speak to a beholder; it is also about a beholder's
own need to speak *for* pictures. Stories and epigrams about speaking images, after
all, are just that: stories and epigrams. When Erasmus praises Dürer, it is not
the artist's portrait that speaks directly to us; it is Erasmus who speaks for the

portrait. Art historians, by the same token, are skilled ventriloquists who put their own imaginations to work in the effort to restore mute objects to the past so that, across temporal distance, those objects might speak back to us as history. If we feel that a picture has a special agency, that it may indeed want to be heard, it is still the art historian's vocation to provide its voice. It is this scholarly need to make pictures speak that I propose to explore in the context of Dutch Brazil as I make the case that works of art created under the governorship of Johan Maurits are indeed saying something to us. Some pictures, however, frustrate such efforts, and the works that will be my focus in the following pages present a particular challenge: the landscapes created by the Haarlem painter Frans Post during his seven years in Brazil, from 1637 to 1644. Far from noisy depictions of Brazilian dances, these paintings are among the most insistently silent early modern depictions of the New World.

THE SILENCE OF FRANS POST'S BRAZIL

Post, like Eckhout, worked under Johan Maurits, who was appointed governor general of Dutch Brazil in 1636 by the West India Company (WIC). Founded in 1621, the WIC was both a commercial and a military instrument of the Dutch Republic: it carried the war with Spain to the Americas, where it sought to wrest control of the Brazilian sugar trade from Spanish-ruled Portugal. During the 1620s and 1630s, the WIC made inroads into northeast Brazil and gradually gained substantial control of the coastal regions, but the cost of this success was internal conflict in the company and the accrual of enormous debt. The WIC therefore turned to Johan Maurits, grandnephew of the stadtholder, to restore order and solvency and further extend Dutch holdings in Brazil. The count's noble pedigree, his humanist education, and his recent military accomplishments in Europe all suggested he could be an effective governor and bring an end to the bickering that plagued the WIC government. To an extent, Johan Maurits did accomplish these goals, strengthening Dutch presence in Brazil while securing a labor force for sugar production by expanding WIC involvement in the Atlantic slave trade. Dutch preeminence in northeast Brazil nevertheless proved to be short-lived, and during the decade after Johan Maurits's return to the Netherlands, the WIC gradually lost all of its holdings to the Portuguese.[7]

While Dutch military and commercial success in Brazil was limited, as a knowledge-making enterprise, the governorship of Johan Maurits was unprecedented in its breadth and influence. The count assembled a team of artists and

scholars to carry out a systematic description of the Brazilian landscape and its flora, fauna, and peoples. Chief among this group were the physician Willem Piso, the astronomer and naturalist Georg Marcgraf, and the painters Eckhout and Post. Several recent scholarly studies have been dedicated to reproducing their substantial body of textual and pictorial work, but already by the late 1640s, a significant portion of their production had made it into print thanks to Johan Maurits's dedication to promoting the research of his scientific team and his own legacy as governor general.[8] Piso's and Marcgraf's work on the *materia medica* and natural history of Brazil, along with woodcuts based on the drawings of Eckhout, were published in *Historia naturalis Brasiliae* (1648), the most authoritative study in its field until the early nineteenth century.[9] The etched maps and landscapes of Marcgraf and Post appeared in *Rerum per octennium in Brasilia ... historia* (1647), a history of the governorship of Johan Maurits written by the Dutch humanist Caspar Barlaeus. Still an essential source on the history of Dutch Brazil, it is a book about which I will have more to say. A third volume, the *Mauritiados* (1647), which has fared less well in its reputation, is a lengthy Virgilian epic about the count written by his chaplain, Franciscus Plante. It includes many of the same plates by Marcgraf and Post that appear in the Barlaeus volume.[10]

Post was twenty-four years old and at the beginning of his career when he arrived in Brazil. He had most likely received his training under his older brother, Pieter Post, a member of the Guild of St. Luke in Haarlem and a prominent Dutch architect who designed Johan Maurits's residence in the Hague, the Mauritshuis.[11] It was surely through Pieter's influence that Frans entered into the count's service in 1636. Barlaeus writes that Johan Maurits "engaged the services of the best artists" in order to display "the villages, regions, and cities that he conquered, to show to his fellow citizens in the Republic overseas."[12] In other words, at the time Johan Maurits was appointed governor general, he was probably already envisioning a publication that would serve as a record and celebration of his military and administrative accomplishments in Brazil, and he recognized the importance of employing skilled artists in this endeavor. It was not by accident, moreover, that he found the best landscape artist for his purposes in Haarlem, where painters in the Guild of St. Luke worked alongside architects, mathematicians, and surveyors. During the early decades of the seventeenth century, Haarlem painters and printmakers like Esaias van de Velde, Jan van Goyen, and Salomon van Ruysdael absorbed the spatial lessons of nautical science and military surveying and developed a new kind of landscape painting that was focused on the panoramic sweep and topographical features of the Dutch countryside.[13] Frans Post carried this new art to Brazil.

Post painted eighteen landscapes for Johan Maurits while accompanying the governor general on his various expeditions along the northeastern Brazilian coast. These paintings, all of which measure approximately two feet by three feet, eventually left the count's collection in 1679, when he presented them as a gift to Louis XIV.[14] In subsequent centuries, most of them disappeared, and currently only seven are located: four remain in the Louvre, while a few have resurfaced in other collections. *View of Itamaracá,* which entered the Rijksmuseum collection in the late nineteenth century, bears the earliest date of any of the surviving paintings: November 3, 1637 (Plate 5).[15] Most of the canvases include the artist's signature followed by the year, month, and day, an indication of their attachment to particular locales visited by the artist. Itamaracá, an island just off the coast that had a fort and fourteen operational sugar mills, was a site of strategic importance for the Dutch, and for a brief period, Johan Maurits considered establishing a city there, a fact that explains why Post would have chosen it as a subject for a painting.[16] The foreground includes a European man on horseback in "the Portuguese mode of riding," according to a seventeenth-century label attached to the back of the painting.[17] With him are two black slaves, one carrying a basket and the other tending to the horse of a second European man who has dismounted and directs our attention across the harbor to a tiny settlement and the Dutch fort on the distant island. Like the other landscapes painted in Brazil, *View of Itamaracá* served as the basis for one of the plates in Barlaeus's *Historia.* The paintings themselves were probably hung alongside Eckhout's paintings on the walls of the count's residential palace at Vrijburg, where they showed the main localities in Brazil under Dutch dominion. But, if their purpose was to declare Dutch presence in the New World, they did so with remarkable understatement. What strikes one about these landscapes is how quiet, empty, and reserved they are.

It is instructive to compare the works completed in Brazil with those painted after Post's return to Holland in 1644. Capitalizing on his early transatlantic travels, Post continued to specialize in Brazilian landscapes throughout his career, but his later works cultivate an exoticism that is mostly absent from the landscapes executed for Johan Maurits. A typical late landscape, dated 1662 and substantially larger than the earlier works, shows a view of Olinda Cathedral as a group of Portuguese men and women leave mass, their slaves awaiting them outside the church (Figure 2.1). The lush foreground is filled with Brazilian flora and fauna: pineapples, melons, an anteater, a sloth, an armadillo, a monkey, an iguana, and more. Post's later reimaginings of the Brazilian landscape, even if based on a particular site such as the ruined cathedral at Olinda, are no longer tethered to the

FIGURE 2.1. Frans Post, *View of Olinda Cathedral,* 1662. Oil on canvas, 107.5 × 172.5 cm. Rijksmuseum, Amsterdam.

specific locales and events that occupied the artist's attention during his seven years in Brazil. They appeal instead to a generalized taste for New World differ- ence. The landscape's foreground, chock full of Brazilian curiosities, is a cabinet of wonders for our consumption. *View of Olinda Cathedral* announces to viewers the availability of its tropical *naturalia,* which, like the painting itself, stand ready to be swept into the Dutch Republic's growing trade in art, knowledge, and exotic commodities.[18]

Post's view of Fort Ceulen, in contrast, painted in Brazil in August 1638, is mostly a painting of nothing (Plate 6). Three-fifths sky, it would seem to justify David Freedberg's description of Post's early Brazil landscapes as "arguably the airiest in all Dutch art."[19] There are, however, several figures occupying this emptiness, situated more or less at the center of the composition. Three Tapuya Indians gather on the shore, one seated and wearing a scarlet headdress, his club and arrows laid to rest by his side; two more stand facing each other, one of them in a similar bright headdress and wearing on his lower back the same type of feathered ornament worn by de Bry's Tupinambá dancers. "Tapuya" is a word of Tupi origin, but it was used pejoratively by the Dutch to refer to the indigenous groups in Brazil they deemed especially savage: cannibals who lived in the wild

rather than on the European mission settlements, or *aldeas*.[20] Other artists in the employment of Johan Maurits also depicted the Tapuya, not only Eckhout, as we have seen, but also the count's quartermaster, Zacharias Wagener, who kept a sketchbook that includes a watercolor of a Tapuya dance (Figure 2.2). In the text on the reverse, Wagener writes "the Tapuya dance around in a circle, entirely naked, letting out terrifying cries."[21] In contrast to the central event of Wagener's watercolor, at the center of Post's landscape, nothing happens. It would be a stretch even to call these figures the "subject" of the painting, since they engage in no activity and appear as just one more topographical feature of the landscape, human extensions of the earthen ledge against which the arrows and clubs of the seated figure rest.

One might say that the Indians in Post's *Fort Ceulen* appear bored, and perhaps we even become a little bored looking at them. The potential for boredom, that subjective state of indifference often experienced by viewers of seventeenth-century Dutch landscapes, still lifes, portraits, and genre scenes, has long been acknowledged by astute interpreters of this art.[22] Alois Riegl, for example, in the preface to his classic study of Dutch group portraiture, dwells on the lack of action in Dutch realism and notes that "there is always just enough activity to distract us from noticing how little is really going on."[23] Riegl's comments should

FIGURE 2.2. Zacharias Wagener, watercolor of Tapuya dance, from Wagener's "Thierbuch," 1634–41. Copyright Kupferstich-Kabinett, Staatliche Kunstsammlungen Dresden. Photograph by Herbert Boswank.

not be understood as a negative evaluation, however. When Dutch paintings take us to "boredom's threshold," as Angela Vanhaelen puts it, and yet maintain just enough internal activity to solicit our attention, they produce that inner state of distanced and calm attentiveness that was for Riegl the proper mood of modern aesthetic experience.[24] Post's Brazilian landscapes push this kind of viewing, which Riegl called "distant vision" (*Fernsicht*), to its limits by removing nearly all of those small but distracting signs of activity. Consider the fourth figure in *Fort Ceulen,* for example, who rows a dugout canoe. Is he rowing toward the other three figures, or is he beginning to row away from shore? A static indifference reigns even here. It is characteristic of Post's landscapes that even the subtle suggestions of movement are stilled. There are other indications of movement in the painting, notably the breakers that hit against the far shore to the left of the fort, but their motion and sounds are swallowed into the picture's emptiness. The sense of distance is overwhelming. Post offers the New World to his viewer, clarifying it visually so that we can discern the tiniest details, but he does so by putting this world beyond the reach of any sense *but* vision.

Erik Larsen, author of a monograph on Post published in 1962, argued that, in order to achieve this sense of distance, the artist must have been looking through the wrong end of a Galilean telescope. The argument is far-fetched and has been subjected to well-earned criticism, but Larsen did have a point.[25] If the reversed telescope fails to hold up as an account of Post's actual practice, it does offer an apt metaphor for the distancing effect of his landscapes. This effect surely owes much to a general awareness of optics among seventeenth-century Dutch artists, although it is perhaps more helpful to consider it in relation to one of the key spatial practices of the Dutch expedition in Brazil: cartography. The surveyors and mapmakers working under Johan Maurits represented vast, continuous spaces in scaled-down cartographic representations projected from a distant bird's eye perspective. The map of Itamaracá in Barlaeus's *Historia,* for example, shows us the southeastern corner of the island, the harbor, and the adjacent coast—the same landscape depicted by Post in his painted landscape of Itamaracá (Figure 2.3; see Plate 5). The painting differs from the map, however, in accommodating the distance of impersonal cartographic projection to a human point of view. As our gaze follows the gesture of the European man who points across the harbor, we gain a subjective experience of distance, one that could be likened to, if not explained by, the experience of looking through the wrong end of a telescope.[26]

In another of Post's early pictures, a view across the São Francisco river, there are no human figures at all to mediate our experience of spatial distance (Plate 7).

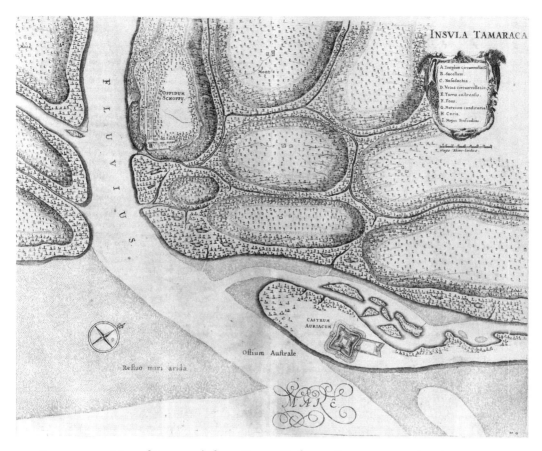

FIGURE 2.3. Map of Itamaracá, from Caspar Barlaeus, *Rerum per octennium in Brasilia . . . historia* (1647). Rijksmuseum, Amsterdam.

On the near shore we see samples of the natural history of Brazil: a large cactus, other types of tropical vegetation, and the world's largest rodent, a capybara, which grazes on some plants at the edge of a rocky bluff overlooking the river.[27] Opposite this natural history diorama wedged into the left foreground, we can discern on the far shore architectural structures, a road, and three small boats along the bank, all signs that humans do indeed inhabit this landscape (Figure 2.4). But one feels a need to turn the telescope back the right way around to get access to this remote world, a world that seems all the more distant because of the river that divides the composition in two and appears to our vision as a kind of void that, in reflecting the sky, draws that sky's overwhelming emptiness and silence into the heart of the painting so that this landscape seems only just to hang together.

Many have remarked on the quietness of the landscapes Post made during his Brazilian period. The historian J. H. Elliott has described them as a "fresh, if

FIGURE 2.4. Frans Post, *São Francisco River,* 1639 (detail). Copyright RMN-Grand Palais / Art Resource, N.Y.

somewhat muted, image of the New World during his stay in Brazil." "Muted" is one of the more popular adjectives found in descriptions of these paintings. It refers to visual tonalities that stand in contrast to the lush colors of the artist's later paintings, but it also suggests the capacity of these landscapes to suppress any form of sensory experience other than vision.[28] Other common descriptors include "quiet," "calm," "serene," "reserved," "tranquil," and "placid."[29] All of these words underscore the silence of Post's Brazilian landscapes, and one dwells all the more on this silence when it is remembered that they were created amidst a great deal of *noise,* amidst the noisy and tumultuous historical events that occurred in these landscapes, indeed whose very occurrence is the occasion for these land-scapes (Post's landscapes are, in a sense, history paintings), but which neverthe-less do not seem to be *of* these landscapes. The occasion for Post's *São Francisco River,* for instance, was a rout in which Johan Maurits drove the Portuguese out of the town of Openeda and then had his own fort, Fort Maurits, built in the same location. The walls and buildings of the Dutch fort are barely visible across the river at the top of the bluff. At the foot of the bluff are a few additional structures, possibly built by the Dutch or perhaps survivals from the original Portuguese set-tlement. The fort and the small boats visible along the far shore serve as reminders

of Dutch presence, yet there is no military event, nor any other sort of event for that matter, depicted in this landscape.

Post's *Fort Ceulen* similarly records the site of a Dutch victory. The structure shown in the painting, well-positioned at the mouth of the Rio Grande, was originally called "Forte dos Reis Magos" ("Fort of the Three Magi") and garrisoned Portuguese soldiers. In 1633, it was captured by a Dutch force under the command of Matthias van Ceulen, one of the WIC's directors, and renamed after him. According to Barlaeus, the fort was taken "after ferocious fighting on land and at sea."[30] A sign of past conflict can be detected behind the fort, in the details of a gallows and, next to it, a gibbet for the display of the executed (Figure 2.5). A narrow white form appears to hang from the gallows, but it is impossible to determine if this is a human body: these details exist at the very limits of visibility. The gallows and gibbet are not direct signs of military engagement, to be sure, and perhaps they were not even put to use during the battle for the fort and its aftermath. They are simply reminders for the viewer that this is a landscape in which violent events have played out. Yet because of the vagueness of their reference, and because of their almost indiscernible size, that history seems to be swallowed by the stillness and silence of the landscape.

FIGURE 2.5. Frans Post, *View of Fort Ceulen,* 1638 (detail). Copyright RMN-Grand Palais / Art Resource, N.Y.

The author of the recent *catalogue raisonné* on Frans Post maintains that the land-scapes of the artist's Brazilian period evoke an environment "in which the peaceful conviviality encouraged by Nassau between the different religions, nationalities and even races appears to have been as remarkably harmonious as possible, in view of the striking differences between them."[31] Post's proclivity for topograph-ical exactitude and minute details does make it tempting to explain his paintings as a faithful pictorial response to the conditions he encountered in Brazil, and since the nineteenth century, Dutch realism has often been characterized as an art that shed the formality of convention to follow the leads of nature and everyday life.[32] It strains credulity, however, to explain Post's landscapes in this way, since "everyday" Dutch Brazil under Johan Maurits was dominated more by violent acrimony than by "peaceful conviviality." The Dutch were in Brazil to drive out the Portuguese, and it was on military raids up and down the coast against these political and religious foes that Post encountered the sites depicted in his paint-ings. Nor is "harmony" the right word to describe Dutch relations with the indig-enous and slave populations of Brazil. While some indigenous groups were allied with the Dutch, many Tupí-speaking Indians from the *aldeas* took up arms with the Portuguese in guerrilla warfare against the armies of Johan Maurits. The enslaved Africans of Brazil, whose numbers were fed by increased WIC involve-ment in the slave trade beginning in 1636, fought with the Portuguese, but at the same time, they presented both the Portuguese and Dutch with the constant threat of revolt.[33] In short, the fact that Post's paintings exude tranquility hardly means they were painted in the midst of tranquility, and in this respect, they are very much in keeping with a general tendency of seventeenth-century Dutch art to efface political and religious conflict. The golden age of Dutch realism, after all, coincides with an eighty-year Dutch revolt against Spain (1568–1648) and the pan-European devastation of the Thirty Years' War (1618–1648). Very little of this conflict, however, makes its way into the pacific interiors, still lifes, and land-scapes that, far from reflecting the turmoil of seventeenth-century Dutch society, often leave us on the threshold of boredom.[34]

For Karel van Mander, author of the foundational text on Dutch painting and painters, the *Schilder-Boeck* (1604), landscape in particular is a place for relaxation and pastoral retreat, and recording the lives of its chief practitioners is, for van Mander, a happy alternative to writing historical chronicles of what he calls "our Netherlandish bloodstained theatre."[35] Although van Mander did not write about the sweeping panoramic view with low horizon that was just beginning to be developed in his own city of Haarlem around the time of his death in 1606, it

too offers peaceful refuge to the beholder, and perhaps a bit ironically, given how much its conceptualization of space owes to military surveying practices.[36] Johannes Vermeer's *View of Delft,* which bears a striking compositional similarity to Post's *São Francisco River,* is an exemplary work in this topographical tradition (Figure 2.6). The span of the city's skyline, the harbor with its dream-like reflections of buildings and clouds, and the conversing figures on the near shore are all enveloped by the quietness of the distant view. In a moving essay published in 1995 in *The New Yorker,* Lawrence Weschler, while covering the hearings of the Yugoslav War Crimes Tribunal, writes about traveling back and forth in the Hague between the tribunal and the gallery in the Mauritshuis that holds Vermeer's *View of Delft.* There, in the very house built for Johan Maurits while he was undertaking his military campaigns in Brazil, and to which he returned with Post's paintings in 1644, Weschler finds an escape from the stories of unspeakable wartime violence

FIGURE 2.6. Johannes Vermeer, *View of Delft,* c. 1660–61. Oil on canvas, 96.5 × 115.7 cm. Mauritshuis, The Hague.

in Bosnia that he hears at the tribunal as he takes in Vermeer's "image of unalloyed civic peace and quiet." Yet he also reflects on the fact that, when Vermeer made his painting, "all Europe was Bosnia."[37] Weschler's essay is entitled "Inventing Peace." The peace and quiet one finds in Vermeer's *View of Delft* is an invention of Dutch landscape painting, a creative act of silencing history.

LANDSCAPE AND *ISTORIA*

If I have made much of the quietness of Post's landscapes, it is because there is a quality that belongs not only to these particular works, but to landscape in general as it developed as an independent genre of painting in sixteenth-century Europe, that warrants this attention to silence. I am referring to an aspect of landscape painting that goes beyond a merely figurative muting of the din of war and historical event, beyond van Mander's pastoral retreat. I am referring, rather, to landscape's capacity to silence a beholder, making it difficult to find the words that would transform it into history.[38]

It is this tendency to stifle speech that distinguishes landscape from the type of picture that had been praised in humanist commentary on the visual arts since Leon Battista Alberti's *De pictura* of 1435. For Alberti, a good painting is like a good oration. Oratory was central to the identity of early Italian humanists, who typically used the word "orator" to describe themselves, rather than "humanist." Their ideal was to stand before an audience making a case in polished classical Latin, and Alberti, whose advice to the painter is often modeled on Cicero's and Quintilian's advice to the orator, carried this privileging of speech into his thinking about painting.[39] His suggestion that every bodily member be depicted so as to express appropriate emotional content, for example, must be understood in light of the orator's overriding concern with making a compelling argument through affective gesture.[40] Such strategies enabled the painter to tell more effectively the *istoria* (or *historia*), a central concept for Alberti that refers to the disposition of bodies in a painting in such a way that they compose a harmonious and persuasive narrative presentation, one that moves the beholder in the same way that a well-told history moves a reader or listener. "I look at a good painting," Alberti writes in his *De re aedificatoria*, "with as much pleasure as I take in the reading of a good *istoria*. Both are the work of painters: one paints with words, the other tells the story with his brush."[41]

The idea of the painting as *istoria* is a powerful one because it binds the sensual experience of a picture to its translation into words, and indeed into the

humanist beholder's own eloquent speech. A scene from the predella of the San Zeno altarpiece by Andrea Mantegna, an artist who knew Alberti's book on painting and was advised in the making of this altarpiece by the learned humanist Gregorio Correr, can serve as a model of the Albertian picture (Figure 2.7). For, even though we cannot help but be impressed by the descriptive attention the artist has lavished on the view of Jerusalem in the distance and the wispy clouds that punctuate the azure sky, these landscape elements remain secondary to the painting's unmistakable *istoria*: the crucifixion of Christ. All of the standard figures one expects in this subject—Christ and the two thieves, John, the Virgin Mary and the women who accompany her, and the various Roman soldiers—occupy their appropriate places in the foreground in the bright light of midday. All their gestures, moreover, are eminently readable, from the grief expressed by John's clasped hands, to the Virgin's swoon, to the attentive gaze of the centurion on horseback who looks up and recognizes Christ's divinity, to the soldiers who cast dice for Jesus's clothes and remain oblivious to the gravity of the event. Knowing

FIGURE 2.7. Andrea Mantegna, *Crucifixion,* from predella of the San Zeno altarpiece, 1456–59. Tempera on panel, 76 × 96 cm. Scala / Art Resource, N.Y.

the story of the crucifixion from the Gospels and from a host of stories and commentaries going back to late antiquity, and affected by Mantegna's powerful narrative presentation, we should be able to find the words to express the painting's impact on us. Certainly the Renaissance humanist viewer, with his oratorical training, would have been prepared to give voice to Mantegna's *istoria*.[42]

But if Alberti and, later, Giorgio Vasari conceived of painting as a stage for the *istoria,* landscape painting leaves us instead with an empty and silent stage. Independent landscape emerges in the sixteenth century as the exclusion of the event, the *istoria.* The word Renaissance writers used for landscape was *parergon,* which means an accessory work, equivalent to the now-obsolete English term "by-work." It was adopted from the *Natural History* of Pliny the Elder, who had used it to refer to small drawings of battleships that the painter Protogenes added to the background of one of his famous mythological subjects.[43] Though conceived as a supplement, the landscape as *parergon* achieved independence during the Renaissance in the work of the German artist Albrecht Altdorfer, in small views of terrain devoid of any identifiable subject matter. These are "complete pictures, finished and framed," as Christopher Wood describes them, "which nevertheless make a powerful impression of incompleteness and silence."[44] Landscape thus originates in the early sixteenth century as a precarious kind of painting, an independent genre that lacks content, and it never sheds this supplementary status in relation to the *istoria.* In 1656, the English antiquary and lexicographer Thomas Blount included the Dutch word "Landskip" in his *Glossographia,* a compilation of "all such hard words . . . as are now used in our refined English tongue." According to Blount,

> All that which in a Picture is not of the body or argument thereof is *Landskip, Parergon,* or by-work. As in the Table of our Saviors passion, the picture of Christ upon the *Rood* (which is the proper English word for *Cross*) the two theeves, the blessed Virgin *Mary,* and St. *John,* are the Argument: But the City *Jerusalem,* the Country about, the clouds, and the like, are *Landskip.*[45]

Understood in these terms, an independent landscape like Post's *São Francisco River* is a picture that lacks an argument, a painting that no longer speaks. Perhaps we could consider the cactus and capybara as a kind of argument, but there is no narrative and certainly no tradition of commentary that would prepare us to give voice to what is seen here. These incidental elements are the stuff of the *parergon*; background has simply become foreground. Thus, it is in the very nature of

landscape painting to frustrate the would-be interpreter, for we stand dumb before the painting without an *istoria*.

Van Mander, the chief early-modern theorist of Dutch painting, attempted to resolve this uneasy relationship between landscape and *istoria* in his verse essay on art theory, *Den Grondt der Edel vry Schilder-Const* (*The Foundation of the Noble Free Art of Painting*), which constitutes the first book of the *Schilder-Boeck*. As an artist trained in Flanders who spent the bulk of his career in the city of Haarlem, van Mander was intimately familiar with the descriptive northern tradition in which landscape achieved independence as a genre. As an artist and humanist who spent four years in Italy, he was also strongly influenced by Italian writing on art, particularly Vasari's *Vite* (1550), in which the *istoria*, expressed through the artist's command of the human figure, was understood to be the defining element of a picture. Van Mander's response to these two pictorial alternatives was to search for balance. In the compositional model set forth in the *Grondt*, figural arrangements that express the content of the *istoria* remain essential to van Mander's concept of the painted history, but landscape now assumes equal importance. The skilled painter does not rely on the action of figures alone to tell a story, but also on the action of the eye as it is guided pleasurably through the distant spaces of the composition. In his chapter on the ordering and invention of histories, van Mander writes that a composition will delight our senses if, beyond the large foreground figures, "we allow there a place of penetration or a vista, with small background figures and a landscape at a distance, into which the vision may plunge."[46] But it is important to recognize that, even though van Mander unsettles the Italian hierarchy of figure over setting, there nevertheless cannot be an *istoria* without figures. Van Mander does not reject the Italian model; he integrates it into his landscape-centered art theory. But what of the landscape without figures, or the landscape with figures whose action is unclear, like the motionless Tapuyas in Post's *Fort Ceulen*? Even when approached through Van Mander's northern reformulation of the *istoria*, Post's landscapes remain stubbornly silent.

A more recent theorist of Dutch painting, Svetlana Alpers, has taken van Mander's rethinking of the *istoria* a step further. In her now-classic study of seventeenth-century Dutch painting, *The Art of Describing* (1983), Alpers rejects any accommodation of Alberti's humanist and rhetorical mode of historical narration to Dutch practice. Where van Mander sought balance between Italian and northern ways of seeing, Alpers sees a clash of incompatible systems. Building on Riegl's awareness of the dominance of the eye over action in Dutch art, she argues

that "the new testimony of the eye challenged the traditional authority of history."[47] In their landscapes and in their maps, the Dutch created a record of their history based on place, not narrated actions and events. Alpers finds in Vermeer's *Art of Painting* the consummate expression of Dutch art's displacement of the Italian model of rhetorical persuasion in favor of a descriptive mode (Figure 2.8). For, even though the artist's nominal subject is a female model dressed as Clio, the muse of narrated histories who holds the trumpet of fame in one hand and the book of recorded events in the other, she is dwarfed by the meticulously painted map of the northern and southern Netherlands, shown prior to their political division, that hangs behind her on the wall like an immense painting.[48] Like this emblematic map in the studio of Vermeer's painter, Post's Brazilian landscapes belong to a particularly Dutch mode of recording history, an art of describing.

There can be no doubt that Alpers provides a compelling model for linking quiet topographical landscapes of the kind made by Post to the historical events they do not depict. However, her argument does leave us, as it left some of the early critics of *The Art of Describing,* with the question of what happens to the humanist, rhetorical mode of persuasion in Dutch art and culture.[49] One could argue, without calling into question the usefulness of the descriptive model articulated by Alpers, that the recasting of history as place need not imply the irrelevance of the Albertian *istoria* for Dutch art. The desire to make the painting speak remains. It lingers at the margins of the artworks themselves—in the gallows behind Fort Ceulen or in the moored boats on the far side of the São Francisco river—as the specter of actions and events that have been pushed off the stage. It lingers also in the writing of the seventeenth-century Dutch humanists who continued to champion the Albertian view that the painter's duty, like the orator's, was to tell a persuasive story.[50] And it lingers for the present-day scholar (even for someone like Alpers herself) who needs the history of Dutch landscape painting to be something more than what is seen; who needs the object to *speak.*

If a descriptive impulse lies behind seventeenth-century Dutch painting, one that, as Alpers acknowledges, "does not offer us an easy verbal access," an Albertian impulse nevertheless underwrites the discipline whose task is to find words adequate to these pictures.[51] An *istoria* must lie somewhere in the background, concealed behind the picture's muted surface, and it is the historian's task to pull it into the foreground. Art history stands opposed, therefore, to the silences of landscape painting. This is perhaps most apparent in the well-developed materialist critique of eighteenth- and nineteenth-century British landscape. Numerous studies have explored the work of ideological erasure in the rustic idylls of

FIGURE 2.8. Johannes Vermeer, *The Art of Painting*, c. 1666–68. Oil on canvas, 120 × 100 cm. Erich Lessing / Art Resource, N.Y.

Thomas Gainsborough, John Constable, Richard Wilson, and others, paintings created amidst social conflict in the countryside as rural laborers were displaced by the enclosure of lands once held in common.[52] In Constable's *Hay Wain,* for example, the labor of peasants is integrated peacefully into their environment (Figure 2.9). Two men, presumably returning to the fields after delivering their load of hay, unhurriedly ford the River Stour in their empty cart. One must look closely at the painting to pick out the figures from the landscape itself, particularly the angler in the bushes on the far shore and the haymakers in the distant field. Absorbed as they are into the fabric of their world, Constable's figures cannot offer us any argument about that world because they are the landscape itself; they are "tokens of a calm, endless, and anonymous industry, which confirm the order of society."[53] We critique a landscape like the *Hay Wain* because its recasting of history as place is a means of naturalizing culture. Beneath its outward calm, we discover an *istoria* about class conflict.

In the literature on seventeenth-century Dutch art, scholars have found a voice for landscapes in hidden symbolic meanings and in the political and religious

FIGURE 2.9. John Constable, *The Hay Wain,* 1821. Oil on canvas, 130.2 × 185.4 cm. Copyright National Gallery, London / Art Resource, N.Y.

associations that audiences likely brought to these pictures.[54] Materialist critiques like those common among historians of British landscape have had less purchase in this historiography, although it requires no stretch of the imagination to detect an ideological erasure akin to that of Constable's *Hay Wain* in Post's *Ox Cart,* a work from the artist's Brazilian period in which three enslaved African men, one of them seated in the cart and playing a flute, leisurely guide their team of oxen along a road outside the settlement of Vila Formosa de Serinhaém (Plate 8). Post's later *View of Olinda Cathedral,* moreover, has recently prompted Julie Hochstrasser to argue that the real story behind these quiet and overgrown ruins is the torching of the city of Olinda by the Dutch in 1631 (see Figure 2.1). Hochstrasser concludes her essay with a call for historians to sound Clio's trumpet in the face of such tight-lipped pictures: "Art can open our eyes to some of history's silences, but art, too, has its silences, which history in turn can help us to address."[55]

Reading landscape in opposition to its silences, however, eventually runs up against the limits of its own explanatory power. Such an approach can tell us much about the motivations for the production or consumption of paintings, but it tells us little about landscape itself, since it bypasses the question of meaning posed by the genre. Hochstrasser's critique of Post's *View of Olinda Cathedral* begins with the assumption that landscape means something for the viewer ("on its surface this seems to be a proud account of the Dutch colony in Brazil"[56]) and then shows that it does not signify in the way one might at first have suspected. What seemed to be innocent in Post's painting is in fact a fantasy of tranquility masking a history of colonial violence. What seemed to be nature is really culture. The historian thus temporarily outflanks the silence of landscape, but this is a battle that can never be won: landscape will always be generating the question of meaning that the historian will always be attempting to resolve. Indeed, this very question is thematized in Post's *São Francisco River.* On the near side of the river, nature dominates. On the far side, receding from our vision and almost invisible, are signs of human habitation and therefore a possible story we might attach to the Brazilian landscape as depicted in the foreground. There is even a certain amount of visual rhyming between the two shores, such as the vertical forms of the cactus and reeds echoing the tiny masts of the boat. In between them, however, is the daunting blankness of the river, which bisects the composition and stands as a challenge to the historian who would reconnect setting with subject matter. Post has staged neither a historical event nor its erasure. He has staged, rather, the very problem of attaching landscape to history.

BARLAEUS SPEAKS FOR BRAZIL

It is therefore of some interest that, a short nine years after Post painted *São Francisco River,* a renowned Dutch humanist and historian, Caspar Barlaeus, attempted to repair the rend between Brazil as a mute place and Brazil as a narrated event, stitching together the two sides of the painting, as it were, so that it might speak to us as history. In 1645, shortly after he returned to the Netherlands, Johan Maurits arranged for Barlaeus to write the history of Dutch Brazil, a task that was completed in 1647. Published at the presses of Amsterdam's preeminent printer, Joannes Blaeu, Barlaeus's *Historia*—its full title in English is "The History of the Recent Activities in Brazil and Elsewhere over a Period of Eight Years under the Governorship of Count Johan Maurits of Nassau"—is a great celebration of Dutch endeavors in the New World. Printed in folio and embellished with fifty-six maps, plans, and views, all of them printed across two leaves or as larger foldouts, it is also one of the finest and most richly illustrated books published in seventeenth-century Holland. Post created thirty-one drawings for it, many of them based on his painted landscapes executed in Brazil, that were then etched by the artist Jan van Brosterhuyzen.[57] These etchings include the plate entitled *Fort Maurits on the shore of the São Francisco River,* which is based on the painting of the São Francisco river, but with important alterations to the original composition (Figure 2.10). In the version for the *Historia,* Post has done away with his capybara so as not to distract our attention from the tiny figures of the Portuguese who now flee across the river toward the near shore. The plate relates directly to a long quotation in the text that Barlaeus extracted from a letter written by Johan Maurits to the stadtholder, Frederik Hendrik, shortly after the event. The count explains in the letter: "[The Portuguese] seemed terrified of pursuit and did not linger, so as not to expose remnants of their army to danger. They crossed the river without troubling themselves about their equipment and supplies, which they left behind on this side of the river."[58] In Post's revised composition, historical event begins to reappear on the previously empty stage as the terrified Portuguese, pushing and stumbling over one another, ford the São Francisco river. History begins to reappear as Post's landscape finds its voice in one of the greatest humanists of seventeenth-century Holland.

A similar reintroduction of event into the Brazilian landscape occurs in the etched version of the view of Fort Ceulen (Figure 2.11). While the etched landscape remains as open and expansive as the original, it has dispensed with the nonevent at the center of the painting and replaced it with a delegation of Tapuya

FIGURE 2.10. Jan van Brosterhuyzen after Frans Post, *Fort Maurits on the São Francisco River,* from Caspar Barlaeus, *Rerum per octennium in Brasilia . . . historia* (1647). Rijksmuseum, Amsterdam.

Indians meeting with Johan Maurits himself in 1638 during the count's visit to the province of Rio Grande. Barlaeus describes the event:

> While Count Johan Maurits was camped at the Rio Grande River, representatives sent by the king of the Tapuyas approached him carrying gifts such as bows and arrows and exceptionally beautiful ostrich feathers, which they wear when they are on the warpath. The Count accepted these in a proper fashion, as tokens of peace and a pledge of goodwill. He received the ambassadors in a dignified and splendid manner, and after agreeing to a treaty of friendship, gave them gifts in turn.[59]

This account occurs just after Barlaeus has reminded his reader that the fort providing the background for this exchange, when it was still under the dominion of the Spanish king, "was named for the Three Magi."[60] As the representatives of the

FIGURE 2.11. Jan van Brosterhuyzen after Frans Post, *Fort Ceulen on the Rio Grande*, from Caspar Barlaeus, *Rerum per octennium in Brasilia . . . historia* (1647). Rijksmuseum, Amsterdam.

Tapuyan king bear gifts to the Christian count and pay him their respects, we detect a subtle reference to the gift-bearing kings mentioned in the Gospel of Matthew, and through whose iconography (which, in an early sixteenth-century Adoration by Vasco Fernandes, as we saw in the first chapter, had already recruited an indigenous Brazilian into the ranks of the magi) Christian Europe envisioned its global reach. Through biblical reference and Barlaeus's narration of the deeds of Johan Maurits in Brazil, Post's view of Fort Ceulen begins to speak to the reader of the *Historia*.

Although Barlaeus had not been to Brazil, he was a logical choice to write its history given his reputation for eloquence and his prominence in Dutch letters. He was a professor at the recently established Amsterdam Athenaeum Illustre; his nominal field was philosophy, but he was best known to his contemporaries as a skilled and sought-after Latin poet. He had established a reputation for composing national martial epics and panegyrics celebrating the victories of the stadtholder,

Frederik Hendrik, over Spain, and it was in this same vein that he wrote *Mauritius redux,* a poem in praise of Johan Maurits's victories in Brazil that was published immediately after the count's return.[61] When he chose Barlaeus as the author of the history of Dutch Brazil, undoubtedly on the basis of this poem and on the recommendation of their mutual friend Huygens, Johan Maurits was making a conscious choice to achieve fame and glory through the voice of a humanist. In the *Historia,* the count's military exploits are compared to those of the ancients. "Whoever reads this," Barlaeus writes, "will recall those commanders of antiquity who invaded the enemy's territory to turn back the tide of war from their own land." Just as a great commander like Scipio Africanus pursued his Carthaginian enemies across the sea, so too did Johan Maurits pursue his Spanish enemies across the sea. But the Dutch have not simply emulated the ancients in their conquests: "We have far surpassed the Romans, for the regions to which we go are immensely distant, and the men we fight are far more savage and uncivilized."[62]

As a historian, Barlaeus thus places himself within a tradition of ancient historians like Livy and Tacitus, who wrote about the history of Rome and its conquests. Since the fifteenth century, humanists had cultivated the ancient art of writing history. As professional orators, many early humanists held positions as chancellors and secretaries, and in these roles, they celebrated and justified the deeds of their patrons by composing histories out of older chronicles, as well as from more recent sources.[63] It is not surprising, therefore, to see a growing reflectiveness on the art of writing histories over the course of the sixteenth and seventeenth centuries, resulting in numerous treatises on the *ars historica* ("art of history"). One of these was written by Barlaeus's good friend and next-door neighbor, Gerardus Joannes Vossius, who, along with Barlaeus, was one of the two inaugural professors at the Amsterdam Athenaeum in 1631. Vossius was a prolific historian and his *Ars historica* (1623) was the most highly esteemed book on this subject written in the seventeenth century.[64] History, according to Vossius, is a knowledge of particular facts whose memory allows people to "live well and happily."[65] To achieve this beneficial end, facts must be provided with effective narrative form, and Vossius allowed considerable leeway in this matter, even arguing that, in order to preserve the stylistic coherence of a history, an author could compose speeches for the characters without necessarily having evidence for them.[66] Historical accuracy was important, of course, but the humanist needed to couple accuracy with *eloquentia.* This was the orator's skill in creating a harmonious union between wisdom and style, and its pursuit was a defining characteristic of Renaissance humanism.[67]

The writing of history, in other words, was more than setting down facts on the page, just as the painted *istoria* was more than descriptive brushwork alone. Both of them looked toward the oration and its performative power to move the auditor as their model. It is this underlying oratorical model, moreover, that permits such apparently dissimilar creations as Mantegna's *Crucifixion* and Barlaeus's history of Dutch Brazil to be encompassed under the single genus *istoria / historia*. The flexibility of the humanist concept of history can be seen in the writing of Vossius himself, author not only of an influential *ars historica* but also of a book about the four arts of writing, gymnastics, music, and painting entitled *De quatuor artibus popularibus* (1650), in which he declares that painting "not only equals or exceeds poetry, but may also make a companion of *historia*."[68] To count both the compositions of the painter and written accounts of famous deeds within the category of *historia* may seem to make the word so vague as to lose all its critical purchase, but this would be to ignore what humanists sought in common across a range of cultural production: the capacity of a well-expressed story to affect and improve its audience.

Barlaeus, in pursuit of eloquence, follows his friend's advice to incorporate speeches into his history. Not only does he quote extensively from Johan Maurits's correspondence, but in multiple instances, he puts speeches into his mouth, particularly on those highly performative occasions when the count stands before his men and incites them to take up arms against the enemy, as when he addresses his admirals and captains on January 1, 1640, in the harbor at Pernambuco: "You will fight bravely, doing your utmost on this occasion presented you by heaven. Nowhere can the Spaniards be conquered more surely than along these shores."[69] One might even describe Barlaeus's entire history of Dutch Brazil as a 340-page speech. Indeed, he invites us to do so in his dedication to Johan Maurits, in the opening sentences of the book: "I offer you Brazil, Most Illustrious Count, radiating the brilliance of your supreme rule and military glory. If the country were able to speak [*loqui*] and could address you, it would surrender itself to you."[70] Brazil, of course, could not speak of its own accord, and so Barlaeus, the eloquent historian-orator, felt obliged to speak for it.

Standing in for Brazil in Barlaeus's *Historia,* providing the visible but silent occasion for the author's speech, are Frans Post's landscapes. In the etching of Fort Maurits, as I have suggested, the tiny figures of the Portuguese soldiers fleeing across the river visualize the efforts of Barlaeus, and of historical writing more generally, to bridge place and event, to reintroduce an argument into the *parergon.* Performing a similar kind of work in all of Post's illustrations for the

Historia is another remarkable feature, one that is not present in any of the paintings: the winged banner that floats in the sky, identifying each site and expressing its significance vis-á-vis Barlaeus's text. In most cases, this ornamental label consists of a flowing banner inscribed with a place name and attached to a pair of wings (attributes of Fame) with dangling vegetation or military ornaments. Often it also includes a heraldic device, designed by Johan Maurits himself, that corresponds to the particular province, or *capitania,* depicted in Post's landscape. Barlaeus writes, for example: "The capitania of Rio Grande, named for the river, was given the image of an ostrich on the riverbank, for these birds are frequently seen there"[71] (see Figure 2.11). These labels range in complexity from the simple winged banderole aloft over the São Francisco river (see Figure 2.10), to the more elaborate, triumphal compositions that appear in Post's seascapes with naval battles, such as the ornament composed of wings, a laurel wreath, heraldic banners and blasting trumpets hovering above the fourth and final battle with the Spanish fleet that was fought at the mouth of the Rio Grande on January 17, 1640 (Figures 2.12–2.13). In this etching, Clio's trumpet, which is so quietly held in the model's hand in Vermeer's *Art of Painting,* bursts into cloudy action to declare the fame Johan Maurits has achieved for the Dutch in a great naval victory.

Post's landscapes and seascapes need these labels because, lacking any clear argument, they are not self-evidently linked to the narrated history. Without the banner, this could be any naval battle. Nor is it by any means obvious that the etching identified as Fort Maurits on the São Francisco river in fact shows Fort Maurits: the fort is barely discernible in the distance, and indeed, by any strict narrative standards, it should not even be pictured, since it had not yet been built at the time the Portuguese were driven across the river. We need the winged messenger to arrive and deliver the landscape's meaning to us. Post introduced these identifying elements into his pictures in order to accommodate his silent landscapes to Barlaeus's eloquent *historia.* Yet it would not be accurate to say the gap between landscape and event is in fact bridged by these efforts toward the re-introduction of an argument: the retreating Portuguese remain tiny and insignificant details in Post's vast, airy, and empty landscape as they beat their hasty retreat offstage. And the winged banner, entering like a *deus ex machina* to save the landscape for history, simply begs the question: to what extent *can* the historian's voice account for Post's landscapes? The most remarkable quality of Post's early Brazilian landscapes, in both their painted and etched versions, is not their "historicity," not their capacity to deliver the past to us, but the way they ask us to hesitate before attaching landscape to history.

FIGURE 2.12. Jan van Brosterhuyzen after Frans Post, fourth battle with Spanish fleet at the mouth of the Rio Grande, from Caspar Barlaeus, *Rerum per octennium in Brasilia . . . historia* (1647). Rijksmuseum, Amsterdam.

The capybara in Post's painting of the São Francisco river is a compelling presence (Figure 2.14). It immediately catches us with its single, dark eye and holds us in its stare. Its look is different, however, from that of the man who engages us from within Eckhout's *Tapuya Dance*. However foreign the Brazilian dance may seem to us, this man offers access to it. With his lips slightly parted, he even seems to greet us with speech or song. We cannot hear him, of course, just as we cannot hear the trumpets sounding in Post's winged banner. As Barlaeus reminds his reader, the trumpets of Fame have the appearance (*speciem*), not the power, of speech.[72] But, if a picture cannot in fact be heard, it may still ask that we lend it our ears. This is what a good painting should do, according to Alberti, and therefore he advises painters to include a figure—like Eckhout's dancer—who looks out and invites the viewer to examine the action of the *istoria* more closely.[73]

QUARTUM PRÆLIUM
CONIOVIAN INTER ET
FLUVIUM RIO GRANDE
XVII IAN.

FIGURE 2.13. Detail of Figure 2.12.

FIGURE 2.14. Frans Post, *São Francisco River,* 1639 (detail). Copyright RMN-Grand Palais / Art Resource, N.Y.

Post's capybara provides no such invitation. One can spend a good deal of time looking at this animal and still not find the words for it. Its silence confirms its distance.[74] Like the capybara's unreadable gaze, the empty, silent river running through the painting, dominating the landscape, solicits a pause from the historian. What Frans Post's paintings "say" is that landscape will always be awaiting the entrance of history's voice onto its stage, and this is the crucial but easily overlooked work of landscape in the American encounter. Before Post's landscapes make Brazil over into an image of Europe, they provide the background against which a story of the New World might be voiced.

Magical Pictures, or Observations on Lightning and Thunder, Occasion'd by a Portrait of Dr. Franklin

O N A S T O R M Y A F T E R N O O N I N 1 7 4 5 , Gilbert Tennent, a leading revivalist preacher of the Great Awakening, was at home preparing the evening exercise for his Philadelphia congregation when a flash of lightning struck his chimney and then headed straight for the upstairs study, where it knocked Tennent to the floor, tore his shoes—melting a buckle on one of them—and scorched his feet.[1] For Tennent, the lightning strike was a sign from an angry God. Such episodes had long sparked fear in the hearts of the devout, spawning numerous pamphlets and sermons in the seventeenth and eighteenth centuries, on both sides of the Atlantic, that carried ominous titles like *The Sinner's Thundering Warning-Piece* (London, 1703), *Farther, and more terrible Warnings from God* (London, 1708), and *God's Terrible Doings are to be Observed* (Boston, 1746). After recovering from his own harrowing encounter with the lightning, Tennent saw fit to preach yet another sermon on the topic, not least of all to dispel rumors circulated by his Moravian enemies that the lightning strike was an expression of God's particular dissatisfaction with his ministry.[2] Tennent titled the published sermon *All Things Come Alike to All: A Sermon on Ecclesiastes 9 . . . Occasioned by a Person's Being Struck by the Lightning and Thunder,* and in it he stressed that God's thunderous voice of warning could be visited upon anyone, good or wicked. It was the duty of Tennent, as one who had experienced God's anger and lived, to carry this warning to his congregation: "It is but reasonable my Brethren, that we should offer Homage to that great God, who is All-sufficient in himself, and whose Majestick Voice in the Thunder, produces such sudden and amazing

Effects and Alterations in the Kingdoms of Nature and Providence. . . . Who can stand before this Holy Lord God, when once his Anger begins to burn?"[3]

If only Tennent had been protected by a lightning rod, like the one installed on a chimney outside the window of his friend Benjamin Franklin, as portrayed in 1762 by the London artist Mason Chamberlin (Plate 9; Figure 3.1). A nearly life-sized Franklin sits in the upstairs study of his Philadelphia residence while, outside his window, we witness a storm like the one Tennent had experienced seventeen years earlier. One can almost hear the cracks of thunder as the roof of a nearby house and the steeple of a church, struck by a zigzagging bolt of lightning, explode in a violent burst of electrical energy. Two pieces of the destroyed structures—both of a brick-colored hue and perhaps intended to represent fragments of a chimney—are launched into the air by the blast. Yet Franklin, appearing calm and collected, does not seem to fear having his buckles melted, for his own invention protects him from God's burning anger. Franklin first introduced the idea of electrical conductors to the public in 1751 in his *Experiments and Observations on Electricity*. A few years later, in the second edition, he described the experiment in which we find him engaged in Chamberlin's portrait, as he turns his attention away from the storm and toward two small brass bells: "I erected an Iron Rod to draw Lightning down into my House, in order to make some Experiments on it, with two Bells to give notice when the rod should be electrified."[4] Paper in hand and quill at the ready, and with the volumes of his impressive library within reach just behind his chair, Benjamin Franklin, fellow of the Royal Society, employs the tools of experimental science to domesticate the lightning. He sits before us as the "Prometheus of modern times," a title Immanuel Kant conferred on him in 1756.[5] Having stolen fire from the heavens, Franklin reduces the thunderous voice of God to a gentle ring in the scholar's study, disenchanting the heavens for the sake of Enlightenment.

This was neither the first nor the last time Franklin was represented as a master of the lightning during his lifetime. In a mezzotint published two years earlier, Franklin holds a volume entitled "Electrical Experiments" and stands before a desk on which sit quills, paper, and an electrostatic generator (Figure 3.2). The print is based on a portrait by Benjamin Wilson, who was not only a sought-after painter in London but also, like his friend Franklin, an "electrician" and fellow of the Royal Society. Wilson portrays Franklin standing before a massive bolt of lightning that lays waste to a distant urban skyline. Franklin's own vertical form reflects but also dwarfs the natural phenomenon: his left hand brushes against his volume as he points toward the bolt in the distance, suggesting that the

FIGURE 3.1. Mason Chamberlin, *Benjamin Franklin*, 1762 (detail). Philadelphia Museum of Art, Gift of Mr. and Mrs. Wharton Sinkler, 1956–88–1.

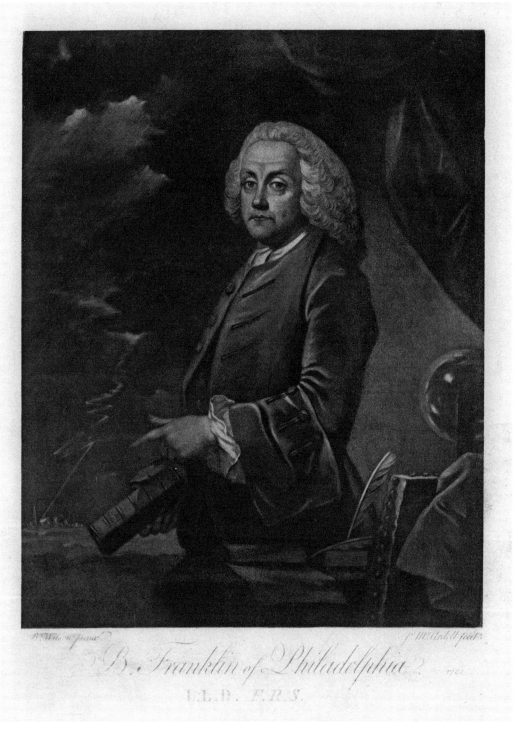

FIGURE 3.2. James McArdell after Benjamin Wilson, *Benjamin Franklin,* 1761. Print Collection, Miriam and Ira D. Wallach Division of Art, Prints and Photographs, The New York Public Library, Astor, Lenox, and Tilden Foundations.

great experimentalist has tamed the lightning by gathering its energies between
the covers of a book. Wilson's portrait, like Chamberlin's, foregrounds Franklin's
stature within London's scientific community at mid-century, a moment of in-
tense experimental fervor around electricity. By the 1770s, well after Franklin's
commitments as a public servant had taken him away from active experimenta-
tion, artists continued to associate him with the electrical fire as it developed into
a powerful political rhetoric. Turgot's celebrated Latin epigram, *eripuit coelo ful-
men sceptrumque tyrannis* ("he snatched lightning from heaven, and the scepter
from tyrants"), received its visual interpretation in an etching of 1779 designed
by Jean-Honoré Fragonard and dedicated "To the Genius of Franklin" (Figure
3.3). An Olympian Franklin, more Zeus than Prometheus, dominates the compo-
sition. As the allegorical figure of America rests on his leg, Franklin directs the
shield of France against the lightning with one hand and with the other commands
a warrior to drive out Tyranny and Avarice.[6]

These are heroic portrayals, but of all the portraits made of him, Franklin
seems to have been fondest of Chamberlin's. It was painted at the end of his five-
year stay in London from 1757 to 1762, a period during which Franklin played
an official role as diplomat while reserving ample time to pursue his scientific
interests. Commissioned by Colonel Philip Ludwell III, a planter and politician
from Virginia who was then a resident in the city, the painting went on display
to the public at the Society of Artists in 1763; it is now in the collection of the
Philadelphia Museum of Art. We know little of the artist himself. An original mem-
ber of the Royal Academy of Arts, Chamberlin was a devout Presbyterian who,
unlike the fashionable artists of the West End, resided in the more commercial
parish of Spitalfields, where he specialized in painting likenesses of London trades-
men. He was a respected painter, although his unassuming portraits did occasion-
ally receive criticism for a monotony of tone and expression. As a critic for the
Morning Post wrote in 1784, after seeing the artist's portraits of his own family at
the Society of Artists exhibition: "Mr. Chamberlin, his wife and son, are all fright-
fully alike, God bless 'em."[7] But Chamberlin's portrait of Franklin, while it may
show a preference for muted tones and generally lacks Reynoldsian flair, undeni-
ably captures a compelling likeness of the famous American. Franklin was pleased
enough with the painting that he had a replica made for his son and ordered over
one hundred mezzotint copies by the engraver Edward Fisher (Figure 3.4).[8] The
print became a kind of circumatlantic calling card as Franklin circulated it through
the colonial Atlantic Republic of Letters. He asked his cousin, for example, to
distribute a dozen of the prints around Boston. "It being the only way in which I

ERIPUIT COELO FULMEN SCEPTRUMQUE TIRANNIS

A. GENIE D. FRANKLIN

FIGURE 3.3. Marguerite Gérard after Jean-Honoré Fragonard, *Au Génie de Franklin,* 1779. Open Access Image from the Davison Art Center, Wesleyan University.

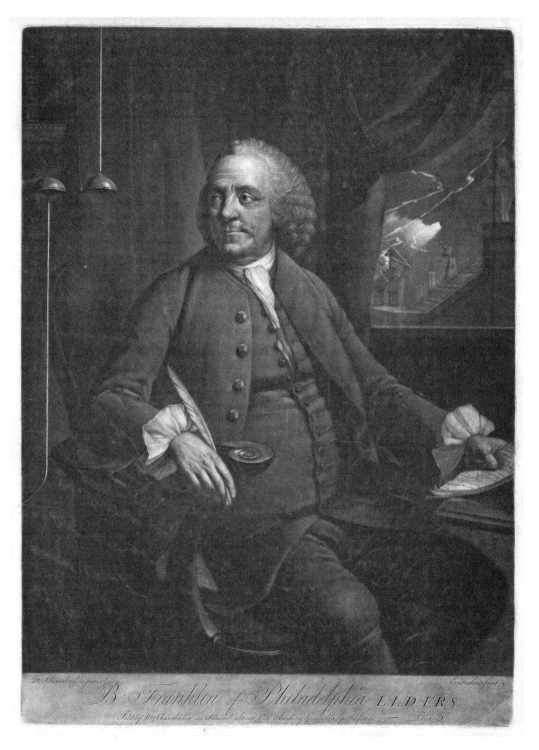

FIGURE 3.4. Edward Fisher after Mason Chamberlin, *Benjamin Franklin,* 1763. Library of Congress Prints and Photographs Division.

am now likely ever to visit my friends there," writes Franklin, "I hope a long Visit in this Shape will not be disagreable to them."[9] Indeed, here we encounter a Franklin not to be found in any other of the numerous portraits made of him: a gentleman-scientist who, despite the storm, has become absorbed in a moment of experimentation within the very domestic setting that served as his primary laboratory in his electrical pursuits. The portrait's modesty in presentation seems suited to the quiet gravity of its protagonist and setting.

Surely the portrait's appeal for Franklin lay in this calm intellectual heroism. But is the voice of God, which was so clearly heard by Tennent when he was struck by lightning in his study, so fully silenced within Franklin's? We should not be too quick to dismiss Tennent's awe before the lightning and thunder, for undoubtedly Franklin too would have thrilled to the violent destructiveness of the scene outside his window, a violence that exceeds the merely human propor- tions of the scholar's cozy study. His own scientific interests, after all, were by no means limited to a quiet rationality. As James Delbourgo has shown, eighteenth century electricity was both a science and a marvel, and evident throughout Franklin's writings is a "tension between experimental claims to rational knowl- edge and the persistence of wonder at the surprising powers of the electric fire."[10] Franklin and others cultivated a popular fascination with the wonders of electric- ity in which the public came to know this mysterious force by feeling its effects in their bodies. Franklin's colleague Ebenezer Kinnersley, for example, traveled widely in the early 1750s lecturing on the electrical fire and demonstrating its powers in performances. In the *New York Gazette* for June 1, 1752, he advertised "a Course of Experiments" to be held "at the House of Mr. John Trotter in the Broad-Way" that included such attractions as "Fire darting from a Ladies Lips" and "a Battery of eleven Guns discharged by Fire issuing out of a Person's Finger."[11] Such demonstrations had become increasingly visible amidst recent efforts, like Delbourgo's, to reenchant the transatlantic Enlightenment by addressing its irra- tional, excessive, wondrous, and emotional qualities, qualities that entertained the audiences of electrical demonstrations, but which also led the God-fearing Gilbert Tennent to marvel at his melted buckle.

To what, then, should we attribute the lightning outside Franklin's study? Was it a natural phenomenon that could be known and contained by human art, or was it the mysterious workings of the divine? Chamberlin's picture offers no answer to this question; rather, its particular interest *as a picture* lies in the way it stages the question itself. Franklin's window, separating the storm outside from the calm within the study, forms a threshold between rationality and mystery,

between the electrician's pen and God's thunderous voice. It is a threshold that invites reflection on the relationship between the lightning that descends from the sky and the "electrical fluid" manipulated by electricians in their experiments and performances, a hotly debated issue in the eighteenth century. But more than this, it invites reflection on the nature of representation itself, which, for Franklin, as we will see, was a means of navigating the not always self-evident boundaries between enlightenment and enchantment. One might even say that Chamberlin's portrait poses an *electrical* model of representation in which meaning is understood to travel along alternating currents, one that moves from the chaotic and stormy world beyond the window to the calm that reigns inside the scholar's study, and another that takes us in the opposite direction. Finding the words to articulate this model is not a matter of choosing which current to follow, but of attempting to think with them simultaneously.

CURBING ENTHUSIASM
FOR THE ELECTRICAL FIRE

The window, with its curtain drawn back and looking almost as if it were a picture hanging on Franklin's wall, is a good place to begin. Through it, we behold a meteorological spectacle of the kind that had long been interpreted as a sign of divine wrath and punishment. According to Mircea Eliade, across cultures there is an almost universal belief in divine beings who inhabit the skies, who make a brief visit to earth to establish moral laws, and who watch to see that those laws are obeyed, "and lightning strikes all who infringe them."[12] If, at times, certain free thinkers had protested against the prevailing beliefs about lightning and thunder, like Lucretius, who insists in *De rerum natura* that they are simply elements set into motion by an indifferent nature, such views did little to alter popular opinion. As Lucretius himself asks:

Whose mind does not cringe with superstitious fright,
And whose flesh does not creep with awe, when the burnt earth shakes
Struck by hair-raising bolts of lightning, and the vast sky quakes
With rumbling thunder?[13]

In Christian visual representations, lightning often assumes the form of an arrow, which is indicative of the divine intention behind it, as well as a reference to the book of Psalms: "The clouds poured out water: the skies sent out a sound:

thine arrows also went abroad."[14] One of the most popular emblem books in seventeenth-century Europe, Julius Wilhelm Zincgref's *Emblematum ethico-politicorum centuria* (1619), includes a device entitled *Omnium Metu* ("a terror to all"), in which a city receives God's punishment in the form of a massive bolt that forks into four arrow-like prongs (Figure 3.5).[15] Lightning was the agent of divine Providence, a belief firmly held by Puritans who regularly witnessed the striking of houses and churches by lightning in New England.[16] Cotton Mather

FIGURE 3.5. *Omnium Metu,* from Julius Wilhelm Zincgref, *Emblematum ethico-politicorum centuria* (1666 [1619]). O. Meredith Wilson Library Rare Books Collection, University of Minnesota.

may have been a member of the Royal Society, but he too interpreted thunder-storms in these enchanted terms: "The *Thunder* has in it *the Voice of God. . . .*There is nothing able to stand before those *Lightnings,* which are stiled the *Arrows of God.*"[17] Franklin's introduction of protective conductors during the 1750s, like the one that protects the nearby house in Chamberlin's painting, did show that one could at least redirect those arrows; but Franklin's innovation hardly brought an end to deep-rooted beliefs about lightning and thunder. As the young John Adams com-plained: "I have heard some Persons of the highest Rank among us, say, that they really thought the Erection of Iron Points, was an impious attempt to robb the almighty of his Thunder, to wrest the Bolt of Vengeance out of his Hand."[18]

While Franklin could not change the minds of all God-fearing Christians, there is no question he had an impact within the Republic of Letters. As a result of his influential *Experiments and Observations on Electricity* (the first edition appearing in 1751 and numerous expanded editions thereafter), and thanks to the publication of Joseph Priestley's Franklinist account of electricity, *The History and Present State of Electricity* (1767), by the late 1760s, the official historiography of electricity had effectively silenced debates among natural philosophers between experimen-tal and religious accounts of the electrical fire. Priestley offered a rationalist and materialist explanation, one that stressed the progressive value of natural philoso-phy within civil society. There was a place for piety in this philosophy, but it was a piety that derived from recognition of the solemn responsibilities that came with the natural philosopher's ability to materialize the creator's powers, not from awe at his incomprehensible workings.[19] Priestley's account had no room for entertaining possible tensions or contradictions between electricity (that is, the sparks demonstrated with the electrician's instruments) and the divine "celes-tial fire" manifested in the lightning.

Yet such tensions had only recently, during the 1740s and 1750s, been at the center of public controversy in London about the nature of the electrical fire, and it is important to situate Chamberlin's portrait of 1762 against this stormy back-ground. The key figures in the controversy were the electrical demonstrator and instrument maker Benjamin Martin and the surgeon and electrical amateur John Freke. Both men published books on electricity in 1746, and their ensuing debate, which Simon Schaffer has examined in depth, turned on the question of whether the electricity that appeared in demonstrations was a product of the electrician's instruments—this was Martin's materialist position, one in which natural philo-sophy trumped theological explanation—or the manifestation of a much greater, divine fire.[20] Freke argued the latter position, one in which he was guided by the

writings of the seventeenth-century German theologian and mystic Jakob Böhme, or "Behmen" as he was known in England, whose philosophy of fire and spirit had become important for pietist critiques of Whig culture. Freke and others within his political and religious circle embraced a private, inner light to salvation and opposed it to the vulgarity of a shallow world of commerce in which showmen like Martin sought only to profit from God's creation.

According to William Law, the chief disseminator of Behmenist ideas in England, the scriptures and the natural world speak the same universal language of fire: "All Life, whether it be *vegetable, sensitive, animal,* or *intellectual,* is only a kindled Fire of Life in such a Variety of States; and every dead, insensitive Thing is only so because its Fire is quench'd."[21] In 1764, Law published an edition of Böhme's life and writings for which he designed figures illustrating the "deep principles" of the great "Teutonic Philosopher," giving visual form to the fiery core of Behmenist theology. In one of the engravings, for example, Law demonstrates how divine anger descends on Lucifer in arrow-tipped bolts of lightning representing God's wrath precipitating down, or rather outward in this diagrammatic rendering, from a central royal residence (labeled "4") that is flanked by the ministering angelic spirits of Michael ("M") and Uriel ("U") (Figure 3.6). In Freke's view, Martin's theatrical demonstrations were a debasement and a corruption of this celestial fire, a materialist reduction of Böhme's divine, vital principle to the product of a mere human instrument. If we were to find an image of Freke's fears realized, it might look something like the frontispiece to a French volume on the uses of electricity to heal paralysis, published in 1772, in which the healing light of an ineffable God manifests itself as a generator in the sky exuding rays of electrostatic energy (Figure 3.7).

In Martin's view, Freke was a religious *enthusiast,* a superstitious dreamer for whom electricity was a mystery accessible only through nonrational experience. During the Protestant Reformation, mainstream Reformed theologians had critiqued the enthusiasm of their more radical brethren who made claims to prophecy and divine inspiration unmediated by scripture and often engaged in ecstatic or convulsive behaviors. Enthusiasm has a complex history, and it could come in many stripes, from Freke's pietist enthusiasm, which was cultivated within conservative Tory circles and stressed private individual illumination, to the more public enthusiasm of the religious revival.[22] What remained consistent among all enthusiasts, however, was their quickness to see God's direct interventions in the world and to bear witness to them. It is the enthusiast who hears the voice of God in the lightning strikes outside Franklin's window and attributes them to divine

FIGURE 3.6. After William Law, Plate VI: the wrath of God descends on Lucifer, from Jakob Böhme, *The Works of Jacob Behmen, the Teutonic Theosopher* (1764). Getty Research Institute, Los Angeles.

FIGURE 3.7. Yves-Marie Le Gouaz after Jean-Baptiste Chevalier, frontispiece to
Abbé Sans, *Guérison de la paralysie par l'electricité* (1772). Collections of the Bakken
Museum, Minneapolis.

wrath, whereas the rational electrician sees a God who has established laws in the world and allowed them to take their course, leaving them discoverable and useful to humankind.

Across the Atlantic, resistance to the enthusiasm of revivalist religion directly shaped how one of the key figures in electrical experimentation, Ebenezer Kinnersley, conceived his practice. Kinnersley was a Baptist preacher who moved to Philadelphia around the time Tennent preached one of the landmark sermons of the Great Awakening, *The Danger of an Unconverted Ministry*. The sermon was delivered in March 1740 to a congregation in the small town of Nottingham, Pennsylvania, but Franklin, who, as a printer, was fully aware of the swelling tide of religious enthusiasm in the colonies and recognized the interest that Tennent's sermon would attract among readers, quickly brought it to a much wider audience. *The Danger of an Unconverted Ministry* is a jeremiad that bitterly denounces an ungodly ministry full of pharisees who put on a show of learning but lack authentic faith, and as a result, blindly lead their congregations into the ditch. The discourses of these unconverted ministers "are cold and sapless, and as it were freeze between their Lips": "They have not the Courage, or Honesty, to thrust the Nail of Terror into sleeping Souls."[23] The revivalist preacher John Rowland heard Tennent's call to take up emotional arms, and in a sermon preached in Philadelphia's Baptist Church on July 3, 1740, he showed that he did indeed have the courage to thrust the nails of terror into his audience. Kinnersley sat in the pews and watched as the congregants became increasingly distressed about their wholly ruined condition as sinners until their emotional anguish reached such a pitch that Tennent, who was also present, went to the pulpit stairs and cried out (whether out of true alarm or to stoke passions further is not entirely clear): "Oh, brother Rowland, is there no balm in Gilead?" At this point, Rowland altered his tone and joyfully unfolded the way to salvation.[24] Three days later, in the same church and no doubt before many of the same parishioners, Kinnersley delivered his own sermon in response to this "horrid Harangue." He railed against preachers like Rowland for whipping up audiences into "Enthusiastical Raptures and Exstasies" in which they pretend "they have large Communications from God; to have seen ravishing Visions; to have been encompass'd, as it were, with Flames of lightning, and there to have beheld our Blessed Saviour nail'd to the Cross, and bleeding before their Eyes in particular for them."[25]

Kinnersley carried on his quarrel with enthusiastic preaching in the Philadelphia press through the 1740s, and as a result, even though he remained in the Baptist church and did occasionally preach sermons, he was never given a congregation

of his own. He did, however, pursue a successful career speaking on electricity. In collaboration with Franklin, he drew up a series of lectures on the electrical fire that, for four years, between 1749 and 1753, he delivered throughout the colonies and even took to the West Indies.[26] Against the ravings of enthusiastic preachers, Kinnersley's lectures sought to wed piety to reason in the form of polite and educational electrical entertainments. If electricity was a wonder, it was a rational wonder, operating according to laws set forth by the God of Nature. But even so, Kinnersley's electrical demonstrations hardly appealed to reason alone. His audiences were not invited simply to think about electricity like so many Franklins in their studies; they were asked to feel its effects. When a man came up from the crowd to kiss the young woman who was connected to an electrostatic generator, they both experienced the electrical fire as an unmediated bodily revelation. Experiment and enthusiasm, in other words, could at times be difficult to distinguish, as one might expect to be the case in a society where matters of science and religion crossed paths at every turn.[27] Kinnersley, after all, as he wandered from city to city declaring Franklin's gospel, brought a preacher's devotion to his electrical pursuits. Even Franklin, as publisher of sermons by Tennent and by the great revivalist preacher George Whitefield, had been involved in the dissemination of the Great Awakening.[28]

While the line separating scientific enlightenment from the enthusiasm of the revival could at times become ambiguous, everything still depended on maintaining it. In this regard, Chamberlin's portrait may be understood as a kind of protective conductor, redirecting the enthusiastic response inspired by its lightning storm toward rational ends. Franklin, significantly, turns away from the storm. Instead of directing us toward the distant scene—as sitters often do in portraits with emblematic features, like the portrait by Wilson—Franklin's relationship to it is indirect, prosthetic. It is through his instruments, his art, that he draws down the lightning. Franklin himself is a solid, somewhat rotund presence. He sits upright in his chair, his posture echoing the stable verticality of the lightning rod outside the window and contrasting with the toppling buildings in the distance. He is a singular, alert intelligence whose keen senses are attuned to his devices: to the bells that ring in defiant, rationalist answer to the common practice (and one that Franklin critiqued) of ringing church bells to ward off God's anger in the lightning, and to the two cork balls suspended from one of the bells by silk threads that repel each other as they become charged (Figure 3.8).[29] Franklin looks and he listens. His perceptions will, in turn, be harnessed by a powerful intellect that will transfer them through his pen to his paper. Lightning will become words on

vero eorum adeo suauis erat, vt inexpertis vix sit credibile, quam optime sym-
phonia illa quadret, praesertim cùm Barbari musicae artis penitus sint ignari. Ac

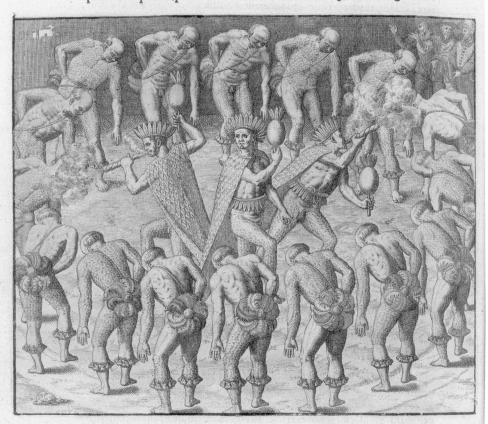

sane cùm initio aliquo fuissem perculsus metu, vt nuper cómemoraui, contra
tunc tanta fui laetitia perfusus, vt non modo extra me raptus fuerim : sed nunc
etiam, quoties mihi in mentem venit concentus ille, & exultat animus, & eo
aures continuo personare videntur, praesertim vero rhithmi epodium gratum
auribus sonum exhibebat, quod post singulos versus ad hunc modum modu-
labantur.

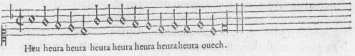

Heu heura heura heura heura heura heura heura ouech.

Modula-

PLATE 1. Workshop of Theodor de Bry, Tupinambá dance, from Jean de Léry,
Navigatio in Brasiliam Americae (1592). Courtesy of the John Carter Brown Library at
Brown University.

PLATE 2. Lucas van Leyden, *Worship of the Golden Calf,* c. 1530, detail of center panel. Oil on panel. Rijksmuseum, Amsterdam.

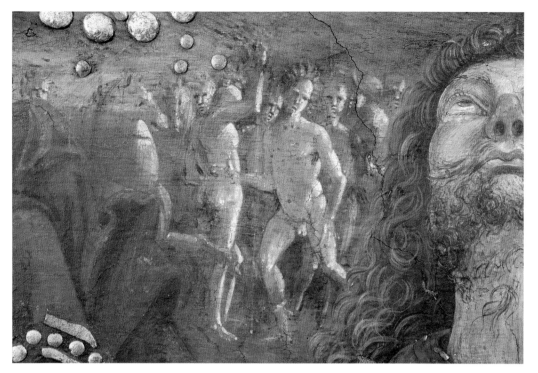

PLATE 3. Pinturicchio (Bernardino di Betto), *Resurrection,* Hall of the Mysteries of the Faith, Borgia Apartments, c. 1494 (detail). Courtesy of the Vatican Museums.

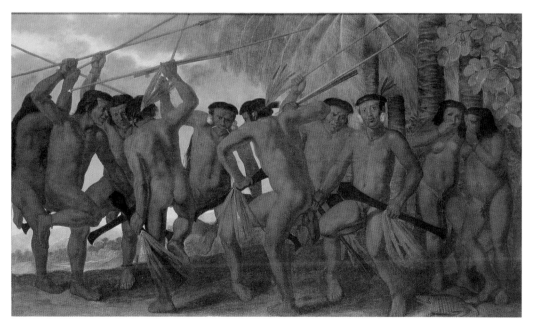

PLATE 4. Albert Eckhout, *Tapuya Dance,* 1640–44. Oil on canvas, 172 × 295 cm. Nationalmuseet, Denmark.

PLATE 5. Frans Post, *View of Itamaracá,* 1637. Oil on canvas, 63.5 × 89.5 cm. Rijksmuseum, Amsterdam.

PLATE 6. Frans Post, *View of Fort Ceulen,* 1638. Oil on canvas, 62 × 95 cm. Copyright RMN-Grand Palais / Art Resource, N.Y.

PLATE 7. Frans Post, *São Francisco River,* 1639. Oil on canvas, 62 × 95 cm. Copyright RMN-Grand Palais / Art Resource, N.Y.

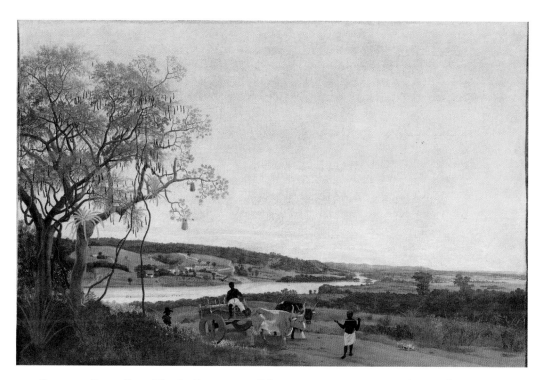

PLATE 8. Frans Post, *The Ox Cart,* 1638. Oil on canvas, 62 × 95 cm. Copyright RMN-Grand Palais / Art Resource, N.Y.

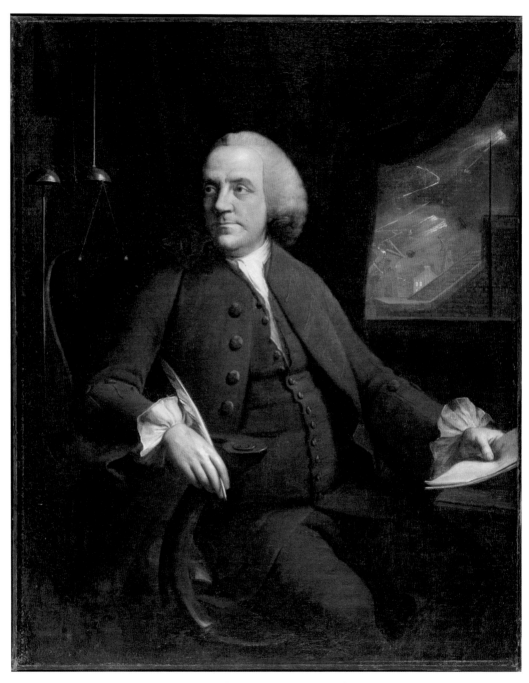

PLATE 9. Mason Chamberlin, *Benjamin Franklin,* 1762. Oil on canvas, 128 × 103.5 cm. Philadelphia Museum of Art, Gift of Mr. and Mrs. Wharton Sinkler, 1956–88–1.

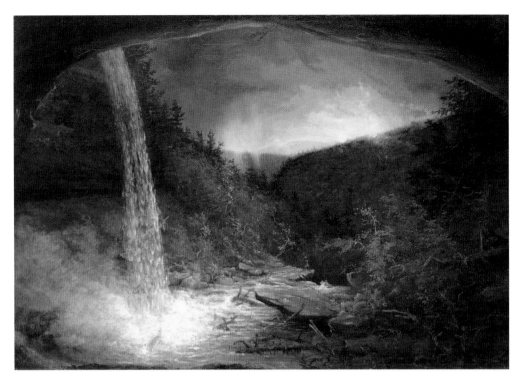

PLATE 10. Thomas Cole, *Kaaterskill Falls,* 1826. Oil on canvas, 64.2 × 89.7 cm. Wadsworth Atheneum Museum of Art, Hartford, Connecticut. Bequest of Daniel Wadsworth, 1848.15.

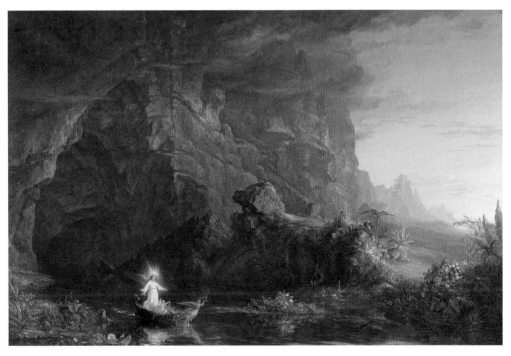

PLATE 11. Thomas Cole, *The Voyage of Life: Childhood,* 1839. Oil on canvas, 132 × 198 cm. Munson-Williams-Proctor Arts Institute / Art Resource, N.Y.

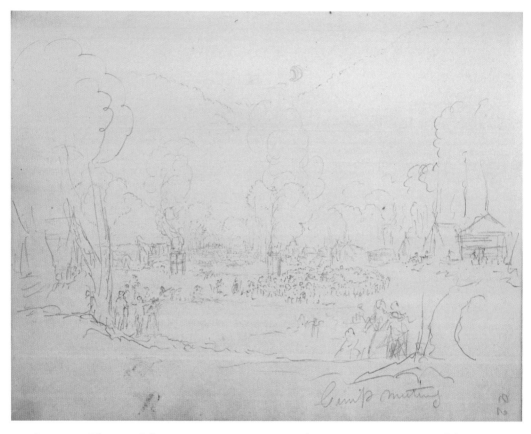

PLATE 12. Thomas Cole, *Camp Meeting,* 1827. Graphite on paper. Courtesy of the New York State Library, Manuscripts and Special Collections.

PLATE 13. Thomas Cole, *Landscape, Composition, St. John in the Wilderness,* 1827 (detail).
Wadsworth Atheneum Museum of Art, Hartford, Connecticut. Bequest of Daniel
Wadsworth, 1848.16.

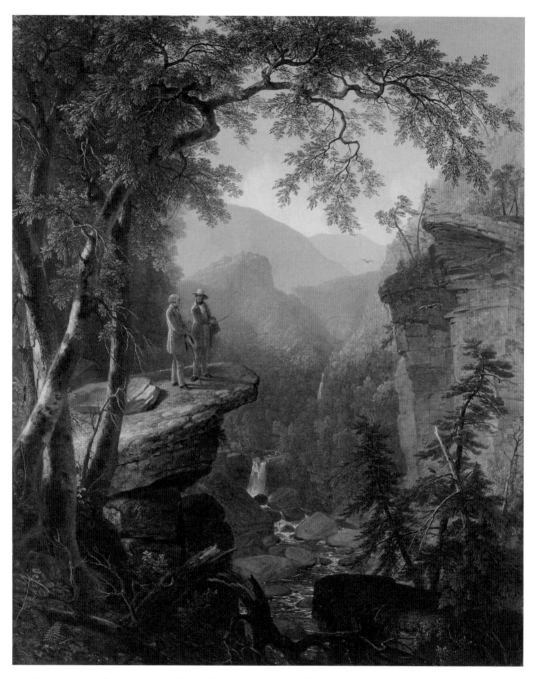

PLATE 14. Asher B. Durand, *Kindred Spirits,* 1849. Oil on canvas, 111.8 × 91.4 cm. Crystal Bridges Museum of American Art, Bentonville, Arkansas, 2010.106. Photography by the Metropolitan Museum of Art.

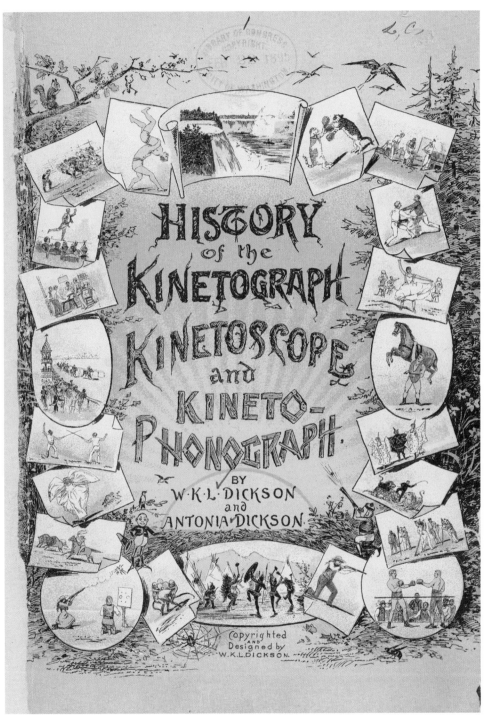

PLATE 15. Title page from W. K. L. and Antonia Dickson, *History of the Kinetograph, Kinetoscope, and Kineto-Phonograph* (1895). Library of Congress, Rare Books and Special Collections.

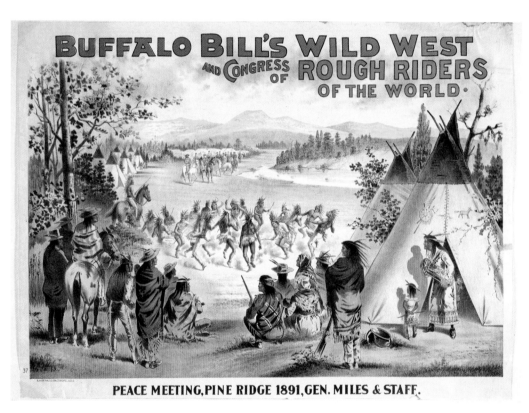

PLATE 16. "Peace Meeting, Pine Ridge 1891, Gen. Miles & Staff," colored lithograph poster for Buffalo Bill's Wild West, c. 1894. Buffalo Bill Center of the West, Cody, Wyoming. 1.69.406.

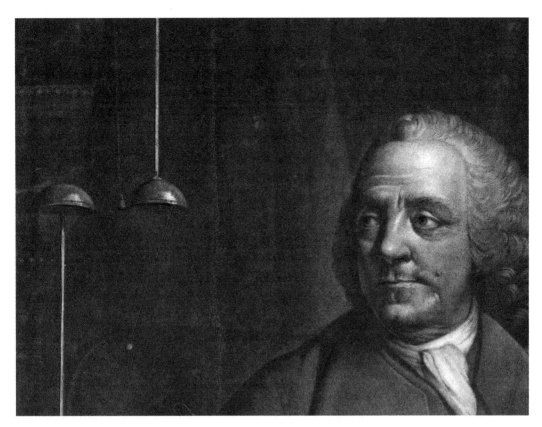

FIGURE 3.8. Edward Fisher after Mason Chamberlin, *Benjamin Franklin,* 1763 (detail). Library of Congress Prints and Photographs Division.

the page, a report to his friend Peter Collinson, one in a series of letters that became the *Experiments and Observations on Electricity.*[30] A tight circuit thus runs from the lightning to the bells to the man to recorded observation. The portrait insists that, through Franklin's instrumental rationality, nature is transformed into knowledge. If the explosions outside the window signify dispersion and chaos, electricity uncontained, then the prominent armrest of Franklin's chair, terminating in a decorative scroll, signifies the opposite: spiraling in upon itself, the hand-carved scrollwork stands for the focused work of the writing hand that rests on it. In the scholar's study, nature is tamed by human art.

FRANKLIN AT THE CROSSROADS

It would be a mistake, however, to overstate the painting's efficiency as a conductor, for Franklin's bells were not always so successful at redirecting the lightning.

The bells were the terminating points of a wire that ran from the lightning rod, through the roof, and then divided at the well of the staircase outside the study. One night Franklin was awakened by "loud cracks on the staircase," and upon opening the door, noticed that "the fire passed, sometimes in very large quick cracks from bell to bell, and sometimes in a continued dense, white stream, seemingly as large as my finger, whereby the whole staircase was enlightened as with sunshine, so that one might see to pick up a pin."[31] At other times, the small brass clapper suspended between the two bells, just visible in Chamberlin's painting and slightly moreso in Fisher's mezzotint, vibrated so violently that they could be heard all over the house, prompting Franklin's wife, Deborah, to write to him in London and complain about the disturbing ringing.[32] Franklin's bells may have toned down the thunderstorm, but something of the storm remained in them, a reminder that eighteenth-century electrical experimentation sought to know the electrical fire not just as words on paper, but as a felt force. What if, then, as interpreters of Chamberlin's portrait, we adopted a less unidirectional perspective, one that would likely be closer to Franklin's own? What if, instead of moving from the chaos outside into a subdued interior and coming to rest there, we turned back toward the storm? To do so would be to see the world outside the window as an amplified version of what happens within, the lightning as an exemplification of the kinds of marvels that both Franklin and Kinnersley sought to reproduce in their experiments even as they harnessed nature's power.

Indeed, the scene outside the window might just *be* another experiment. The buildings that are being destroyed by the lightning bolts recall a popular electrical demonstration of the period, staged by Kinnersley and many others, known as the "thunder house."[33] Figure 3.9 includes three eighteenth-century examples from the Harvard collection of scientific instruments: a tall jointed steeple (left), the profile of a house (center); and a church with a small steeple (right). If an electrician applied a spark to the conducting tip of the jointed steeple or house profile while interrupting the internal circuit that runs from the tip to the ground, the model would collapse. In the case of the steeple, the top sections would fly off in a manner similar to the collapsing steeple in Chamberlin's painting. The thunder house with the small steeple was used in a somewhat more dramatic demonstration, illustrated on the title page to an eighteenth-century German instructional text on electricity (Figure 3.10). The conducting rod of this type of thunder house included a chain that could be attached to the rod in order to direct electricity away from the model, but if the chain was removed (as it is in the illustration), and if a spark was applied from a Leiden jar or electrostatic

machine, the electricity would pass directly into the house and there ignite a packet of gunpowder, causing the walls of the house to blow apart like the house outside Franklin's window. As the German engraving makes clear in its inclusion of the parallel background case of an unprotected church that has burst into flame because of a lightning strike, the thunder house demonstrates the protective value of the lightning rod.

As this experimental model suggests, electricians were, like painters, consummate imitators of nature. They re-created lightning in controlled conditions in order to experience it on a smaller scale. Priestley wrote that the electricians of his day imitate "in miniature all the known effects of that tremendous power."[34] Franklin, for instance, describes an experiment in which he imitated a cloud by making a pasteboard tube ten feet long and a foot in diameter, charged and suspended by silk threads, and then drew electricity from his model.[35] Kinnersley's lectures included numerous imitations of the effects of lightning, such as "the

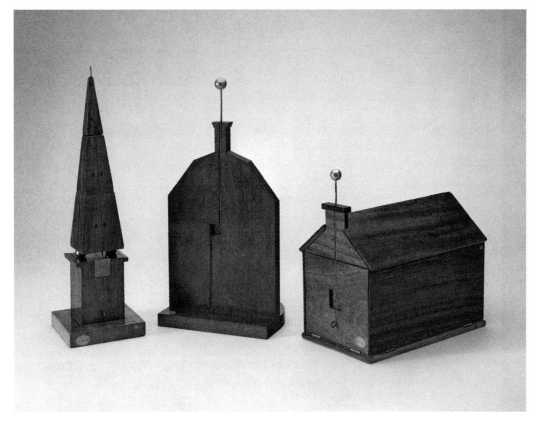

FIGURE 3.9. Thunder Houses, c. 1765–89. Collection of Historical Scientific Instruments, Harvard University.

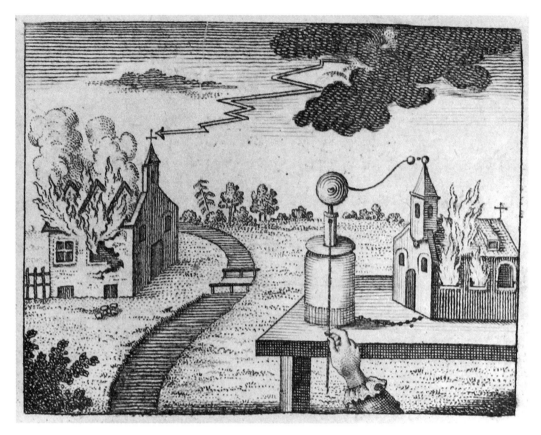

FIGURE 3.10. Title page illustration to Dominikus Beck, *Kurzer Entwurf der Lehre von der Elektricität* (1787). Collections of the Bakken Museum, Minneapolis.

Force of the Electric Spark making a fair Hole thro' a Quire of Paper" and "Metal melted by it (tho' without any Heat) in less than the thousandth Part of a Minute."[36] The leading electrician in England in the 1740s, William Watson, was known for staging performances in which the effects of the electrical fire were made visible as it traveled through the bodies of participants. In a plate from the French edition of his *Experiments and Observations Tending to Illustrate the Nature and Properties of Electricity* (1746), a man grasps a charged iron rod with one hand and with the other touches the tip of his sword to a spoon held by a woman, igniting the spirits contained in the spoon and producing a bright flash; above them, two well-dressed, electrified children cause small bits of glass, paper, and cork to become suspended in the air (Figure 3.11). All of this makes for "a most agreeable spectacle."[37] Watson's bodily performances turned the violence of the thunderstorm into a genteel parlor game.

FIGURE 3.11. Jean-Jacques Flipart, Plate III from William Watson, *Expériences et observations pour servir à l'explication de la nature et des propriétés de l'éctricité* (1748). EC75.W3392.Eh748r, Houghton Library, Harvard University.

Priestley was certain that, in conducting such experiments, electricians were "disarming the thunder of its power of doing mischief, and, without any apprehension of danger to themselves, drawing lightning from the clouds into a private room, and amusing themselves at their leisure, by performing with it all the experiments that are exhibited by electrical machines."[38] The line that separated the storm from its imitation, however, was not always so clearly marked, for electricians often did apprehend danger to themselves during their experiments. Franklin notes that he drew a charge from his model cloud that was strong enough to make his knuckle ache.[39] Electricians regularly reported receiving powerful shocks in the line of duty. In 1746, the Dutch natural philosopher Pieter van Musschenbroek performed an experiment in which he drew a spark with his left hand while holding a Leyden jar in the right: "My right hand . . . was struck with such force that my whole body quivered just like someone hit by lightning, . . . the arm and the body are affected so terribly I can't describe it. I thought I was done for."[40] The following year, Watson recorded a similar experience: it was "as though my Arm were struck off at my Shoulder, Elbow, and Wrist; and both

my Legs, at the Knees, and behind near the Ankles."[41] In the most famous case of a thunderstorm intruding upon the protected realm of experiment, the German electrician Georg Wilhelm Richmann was killed in 1753 when a bolt of lightning struck an ungrounded conductor in his laboratory.[42] The difficulty of determining whether the scene outside Franklin's window is nature or its imitation is therefore significant, for it puts into question a crucial distinction upon which Priestley's disenchanting narrative depends.

Positioned between his experiment and the thunderstorm, turning toward his bells but prepared, it appears, to turn his attention back toward the window at any moment, Chamberlin's Franklin is more ambivalent than a Priestlian interpretation of the painting would allow. If he is Prometheus having stolen fire from the gods, he is also Hercules at the crossroads confronted with a choice between an experimentalism that resides comfortably within the study and one that reaches toward the inexplicable wonders of the thunderstorm. The challenge of deciding on how we should read Chamberlin's portrait comes down to a question of how meaning flows through the world and the role of human art in discovering that meaning. Does it flow into the study, where thunder and lightning are explained by the laws revealed through the experiments of natural philosophers? Or does it flow out the window, toward a God whose mystery is always in excess of the human art that attempts to reveal it? If Chamberlin has captured Franklin at a decisive experimental moment, the papers in Franklin's left hand nevertheless remain blank.[43] Firm conclusions are not yet to be drawn. We can only contemplate the choice the portrait offers.

Chamberlin's picture stages an ambivalence that runs not only through the history of Enlightenment electrical experimentation, but through the history of picture-making as well. In commentaries on the visual arts going back to antiquity, the question of what a picture can adequately represent and what might lie beyond the capacities of human art was often framed as an electrical question. For the same reason that human societies long attributed lightning to the gods, lightning has been a marker of the limits of representation. In his *Natural History*, Pliny the Elder praised Apelles for painting "things that cannot be represented in pictures—thunder, lightning and thunderbolts."[44] In the sixteenth century, Pliny's comment provided Erasmus with language for praising the modern Apelles, Albrecht Dürer, whose art tests the limits of pictorial naturalism by depicting the undepictable: "fire; rays of light; thunderstorms; lightning; thunderbolts."[45] Kant later found a place for lightning and thunder within his aesthetics of the sublime, since the fear excited by "thunder clouds towering up into the heavens, bringing

with them flashes of lightning and crashes of thunder," confronts us with our inability to take in the immensity of a nature that lies beyond the representational capacities of our senses.[46]

It is surely of interest, moreover, that one of the most heavily glossed art-historical texts of the early twentieth century, an essay concerned with the origins and limits of symbolic representation, turns on this problem of representing the lightning: Aby Warburg's lecture delivered at Ludwig Binswanger's Sanatorium at Kreuzlingen in 1923, a study of the snake as a lightning symbol in the pueblo cultures of the southwestern United States. Warburg based his lecture on his observations during a trip he had taken to the American Southwest over thirty years earlier. The Hopi snake dance, a seasonal ritual that Warburg never in fact witnessed, is the lecture's centerpiece. Although Warburg, in his eagerness to find parallels to the pagan primitivism he detected within Renaissance art, appears to have misunderstood important aspects of the dance, the lecture nevertheless provides a compelling illustration of his mythic thinking about the origins of the symbol.[47] For Warburg, the snake dance demonstrated the achievement of a level of symbolic control over nature's processes. Through its mimetic magic, the Hopi dancers entered "into cultic exchange with the most dangerous beast, the live serpent," first through an intimate struggle with nature as they held the snakes in their hands and mouths, and then by releasing the snakes back into nature, only now transformed. No longer a terror from the underworld holding humanity in fear, the serpent now became a symbol capable of returning as the lightning to produce rain. This symbol, Warburg found, still survived in the drawings of Hopi schoolchildren, some of whom, despite the impact of modern American school-ing, continued to depict lightning as an arrow-tongued serpent.[48]

Warburg was seeking in the Hopi dances an antidote to a technological mod-ernity initiated by Franklin. Franklin is mentioned only briefly in the closing paragraphs of the lecture, but he carries much symbolic weight for Warburg, who saw Franklin as the modern Prometheus who destroys the reflective distance so hard-won by primitive man. Believing he has conquered nature, technological man steals the lightning directly from nature without need of the symbol: "The lightning serpent is diverted straight to the ground by a lightning conductor. Sci-entific explanation has disposed of mythological causation."[49] Warburg's Franklin is a version of the great disenchanter that Max Weber had portrayed twenty years earlier as the embodiment of the spirit of capitalism, the "bland deist" for whom the highest good is to make money, whose utilitarianism has no room for reflec-tion because it is preoccupied with the endless work of reducing everything in the

world to its monetary end.[50] At the close of his slide lecture, Warburg offered his audience an image for this figure, a photograph he took in San Francisco of a man whom he calls "Uncle Sam in a stovepipe hat," the "gold-seeker" who has ousted primitive humanity and who hurries down the street while above his head runs the wire with which "he has wrested lightning from nature"[51] (Figure 3.12).

There is some irony in the fact that Warburg's lecture can help us see beyond his own caricatured image of Franklin. Warburg's "culture of symbolic connection," which he located between "a culture of touch" that has not yet achieved freedom from the oppressive terrors of nature and "a culture of thought" that has so alienated itself from those terrors that it believes itself to be past them, is an apt description of the in-between world Chamberlin has conjured in his portrait

FIGURE 3.12. Aby Warburg, "Uncle Sam," 1895–96. The Warburg Institute Archive, London.

of Franklin.[52] Seated between a chaotic nature and his electrical device, Franklin is no Uncle Sam. On the contrary, he occupies the liminal condition of Warburg's dancers: if Franklin is a disenchanter, he is nevertheless one who wrests the lightning from nature through an experimental mimicry that has not yet fully severed its magical links with the world beyond his window. There is still room for wonder in Franklin's study, and a final example of the electrician's art may help us to see how a sober Presbyterian painter in eighteenth-century London put that wonder to work.

MAGICAL PICTURES

In his *Experiments and Observations,* Franklin describes an experiment, originally devised by Kinnersley, called "the magical picture." The electrician begins with "a metzotinto with a frame and glass, suppose of the King (God preserve him)." A mezzotint by John Smith after Sir Godfrey Kneller's portrait of King George II, a print that circulated widely throughout the colonial Atlantic, is the kind of picture Franklin must have had in mind[53] (Figure 3.13). Franklin provides detailed instructions for cutting out the interior of the picture and then pasting the border and interior sections to opposite sides of the piece of glass, which has been covered with gold or brass foil (both conductors) on portions of both the front and back. A crown is then made from foil and inserted into a slit in the print at the top of the king's head, so the crown touches the unseen foil behind the picture. The end result, which had the appearance of a typical framed mezzotint when held in the electrician's hand, was now ready to be tested on a member of the audience. Franklin writes: "If now the picture be moderately electrified, and another person take hold of the frame with one hand, so that his fingers touch its inside gilding, and with the other hand endeavor to take off the crown, he will receive a terrible blow, and fail in the attempt. . . . The operator, who holds the picture by the upper end, where the inside of the frame is not gilt, to prevent its falling, feels nothing of the shock, and may touch the face of the picture without danger."[54]

 The magical picture belongs to the myriad educational entertainments of the Enlightenment, from automata to magic lantern shows to *trompe l'oeil* paintings, that taught lessons about discernment and deception. Earnest experimentalists and charlatans alike (it was not always easy to tell the difference), understanding that knowledge was a matter of experience, created illusions and dared audiences to trust the evidence of their senses. One of the most famed Enlightenment automata was a mechanical duck created by Jacques Vaucanson, which he unveiled

Georgius Secundus D. G. Mag. Britanniæ Franciæ et Hiberniæ Rex

Brun. et Lunen Dux S. R. I. Arch Thesau. et Princeps Elector &c. Inauguratus XI die Octo. 1727.

G. Kneller S. R. Imp. et Mag. Brit. Baronet Pinx. Ab Originali J. Smith Fecit Sold by I. Smith at ye Lyon & Crown in Ruffell Street Covent Garden

FIGURE 3.13. John Smith after Sir Godfrey Kneller, *King George II,* c. 1727–43. Leon Kolb Collection of Portraits. Courtesy of Department of Special Collections and University Archives, Stanford University Libraries.

in Paris in 1738 along with an automated pipe-and-tabor player and flute player (Figure 3.14). Capable of flapping its wings, paddling in water, quacking, drinking, eating, and even defecating, Vaucanson's duck attracted substantial crowds and earned money and fame for its creator, who was hailed by Voltaire as the rival of Prometheus. As this praise from a great *philosophe* suggests, the mechanical duck was more than a commercial entertainment; it was a philosophical entertainment as well, and its central question was "to what extent can art imitate life?" When some critics pointed out that the duck's mechanized innards were not in fact true to the physiological process of digestion, this did not mean Vaucanson was a fraud; rather, it meant that his machine had answered its philosophical question by showing the limits of mechanical imitation.[55] Arousing the skepticism of audiences did not necessarily undermine such Enlightenment demonstrations; skepticism was precisely the point.

Often the stakes in these entertainments were political, and indeed, Wendy Bellion has shown that pleasurable deceptions were vital to the creation of "citizen spectators" in the early American republic.[56] When visitors to the first Columbianum exhibition, held in the assembly room of the Pennsylvania State House during spring 1795, encountered Charles Willson Peale's *Staircase Group,* their own powers of perception were put to the test in a politically charged site (Figure 3.15). In this life-sized painting, Peale's sons Titian and Raphaelle appear to ascend a staircase adjoining the Assembly Room, thus confusing the distinction between actual and virtual space. Deceptive paintings like this one, Bellion argues, helped to produce an audience of discerning republican subjects.[57] Like Peale's *Staircase Group,* Franklin's magical picture also comes with a political lesson, but in this case, a lesson about loyal subjects of the king within the colonial Atlantic. While the electrician, who does not touch the foil on the picture, pretends his immunity to electrical shock "is a test of his loyalty," the individual who removes the king's crown is punished for his seditious act. Franklin further writes that, if the performance is carried out with a ring of persons to take the shock, it may be called "the conspirators."[58]

The audience is entertained by the electrician's trick and enjoys its political lesson, but the real lesson, of course, is about the dangers of credulity. The magical picture plays on the (superstitious) belief in the fetish that has the capacity to answer back and punish the individual who offends it. It is the irrational primitive who fails to see through such magic, thus endowing a mere object with powers that any enlightened observer would realize it cannot possibly sustain. It is not by chance that the public's fascination with educational entertainments like the

H. Gravelot delin. Vivares Sculp.

FIGURE 3.14. François Vivares after Hubert Gravelot, frontispiece to Jacques Vaucanson, *Le mécanisme du fluteur automate, présenté à messieurs de l'Académie royale des sciences* (1738). FC7.V4617.738m, Houghton Library, Harvard University.

FIGURE 3.15. Charles Willson Peale, *Staircase Group (Portrait of Raphaelle Peale and Titian Ramsay Peale I)*, 1795. Oil on canvas, 227.3 × 100 cm. Philadelphia Museum of Art, The George W. Elkins Collection, E1945–1-1.

magical picture—entertainments in which objects move, speak, and in general
become animated—coincided with northern Europe's growing commercial in-
volvement with societies along the West African coast during the seventeenth and
eighteenth centuries. It was from this cross-cultural space that the category of
the "fetish" emerged and was introduced into Enlightenment thought through
the travel accounts of merchants.[59] The fetish was an object unlike the commodi-
ties of European traders. Typically endowed with the power of speech and other
anthropomorphic qualities, it held a supernatural efficacy capable of protection
and punishment. Europeans insisted on the difference between such superstition
and their own commonsense objectivity, and indeed, this distinction became a
foundation for Enlightenment conceptions of rational social order. Just two years
before Franklin sat for Chamberlin, the French *philosophe* Charles de Brosses
coined the word "fetishism" in his *Du culte des dieux fétiches* (*On the Worship of the
Fetish Gods*), a book in which the worship of "certain terrestrial and material
objects called *Fetishes* by the African Negroes" is developed into a general theory
of the origins of religion, which de Brosse grounds in the childlike impulse to
divinize inanimate objects.[60] The conceit of Franklin's entertainment is that its
audience, which experiences the anger of its king as a shock from a common
printed image, participates in the fetishism of the primitive African.

If Franklin's audience plays the role of the ignorant multitude, the electri-
cian himself assumes the role of the cunning priest who knows his magic show
to be fraudulent yet willfully uses it to mislead his followers. Seventeenth- and
eighteenth-century critics, turning a skeptical eye on religious customs and cer-
emonies, identified an elite "sacerdotal order" that, throughout the history of the
world's religions, had promoted superstition out of its own self-interest.[61] One
of the priest's classic deceptions was the pagan oracle, and Enlightenment writers
waged a full-fledged war on these speaking idols. Christians had long linked the
birth of Christ to the cessation of the pagan oracles, but Bernard Le Bovier
de Fontenelle, for one, saw no such moment of miraculous silencing. The speech
of oracles, Fontenelle argued, continued well beyond Christ's nativity because
it was due not to supernatural causes, but to the "cheats of the priest."[62] In the
engraving by Bernard Picart that opens the 1728 edition of Fontenelle's *Histoire
des oracles,* priests tend the sacred fire and direct the attention of supplicants to the
speaking statue of the god; meanwhile, beneath the temple's floor, a man holding
an oil lamp inadvertently sheds light on priestly duplicity as he feeds lines to his
accomplice, who speaks through a tube to provide the oracle's voice (Figure 3.16).
Picart's engraving presents us with the paradigmatic scenario of Enlightenment

FIGURE 3.16. Bernard Picart, frontispiece to *Histoire des oracles,* from Bernard de Fontenelle, *Oeuvres diverses* (1728). FC6.F7375.C728, Houghton Library, Harvard University.

unmasking, one that allows us to enjoy the enthralling drama played out in the temple even as we are made aware of the mechanics by which the deception is achieved. The same scenario was rehearsed in oracular entertainments of the later eighteenth and early nineteenth centuries, such as William Pinchbeck's "acoustic temple," which reproduced an Egyptian oracle that spoke with a disembodied female voice. Audiences took pleasure in the deception, but at the same time, they were challenged to find the hidden tubes that made it possible.[63] Like Pinchbeck with his acoustic temple, the electrician with his magical picture is both priest and disenchanter. His playful imposture teaches us that what looks like magic is really electricity, a phenomenon that answers to humans and not to the gods. While the audience member who removes the king's crown appears to be punished with a shock for his political act of desacralization, the true act of desacralization belongs to the electrician, who shows that the image never was magical in the first place.

There is more to the performance of the magical picture, however, than this rationalist lesson. The members of the audience know that the picture is not magical, yet it is not fully silenced, for they still feel its invisible force in their bones when they receive its shock. The disavowal of the fetish is incomplete because its effects continue to be felt in the body even after the lesson is learned; and it is here, in the gap between knowledge and experience, that Franklin's experiment opens a space for reflection on the power of images. Perhaps it even opens onto a theory of picturing that would proceed as follows: in order to disenchant the picture, we must enchant it; disenchantment comes through an opening onto an electrical potential that lies beyond the frame of representation. Or outside the window, as the case may be. All of this seems fully polite and rational, but still we catch a glimpse of something that lies beyond the grasp of reason, and Franklin does go on to note that, "if the picture were highly charged, the consequence might perhaps be as fatal as that of high-treason."[64] The picture retains an excessive potential that the experiment cannot exhaust.

This potential may help us to think more generally about the power of images like the mezzotint of George II, or Fisher's mezzotint of Franklin, as they circulated throughout the colonial Atlantic world. Mezzotints were powerful objects that attracted the eyes of consumers during a period of rapid growth in the colonial economy. Increasingly over the course of the eighteenth century an "empire of goods" knit together the British Atlantic.[65] As the American market took off during the 1740s, goods poured from the London metropole and made their way through ships, shops, and peddlers to remote consumers. Mezzotint portraits,

widely collected and often framed and hung on walls, were part of this bur-
geoning trade. The 1743 probate inventory of the Boston merchant Peter Faneuil,
for example, shows that he left behind over 250 pictures, mostly engravings,
including "nineteen mezzotints covered with glass" that hung in the best room
of his house.[66] Mezzotint portraits were put to other uses as well: they became
embellishments for lacquered furniture, models for provincial artists, and source
material for the polite recreation of "painting on glass," an activity in which the
mezzotint was applied to a piece of glass, rubbed with a damp cloth until trans-
lucent, and then painted from behind to create an effect similar to oil painting.[67]
The framed mezzotint on glass in Franklin's magical picture would have been a
familiar and desirable object for its audience.

London's mezzotint engravers—often called "scrapers," since their tonal pro-
cess involved roughening the entire surface of the plate so it would print black
and then scraping selected areas to produce the lights—worked in a booming
industry. Fisher and his teacher, James McArdell, who engraved Wilson's portrait
of Franklin (see Figure 3.2), were members of the so-called "Dublin Group" of
Irish mezzotinters that was instrumental in reinvigorating the practice in London
during the third quarter of the eighteenth century.[68] Demand for their work was
fueled by demand for the portraits of Joshua Reynolds and other artists who,
beginning in 1760, were exhibiting their paintings publicly in London at the
annual Society of Artists exhibitions. Finding the right mezzotint engraver was
critical to the success of these painters, since their own fame and that of their sit-
ters depended on the circulation of reproductive prints.[69] They preferred mez-
zotint engravers over line engravers because the process was faster and because
they admired the subtle gradations in tone that a skilled scraper could produce.
In the words of James Chelsum, author of the first history of the medium pub-
lished in 1786, mezzotint has introduced "a softness and delicacy before unknown
in prints."[70] From the shadowy backgrounds of mezzotints by McArdell, Fisher,
and their colleagues emerge the faces of eighteenth-century celebrity, faces whose
fame (and sometimes infamy) guaranteed their currency throughout Britain's
empire. These pictures, "highly charged" in their own way, trafficked in the secu-
lar magic that, for Joseph Roach, goes by the name of "It."[71] "It" is a charismatic
aura, a singular and seemingly effortless poise possessed by certain individuals
in the face of the overwhelming desire for public intimacy ushered in by the con-
sumer revolution of the eighteenth century. "It" radiates from Franklin, who, ren-
dered in the soft and delicate tones of Fisher's mezzotint, coolly keeps his balance
despite the picture's opposing electrical polarities. As he focuses his attention on

the sound of his electrified bells, we cannot help but keep our eyes focused intently on him.

Franklin distributed his effigy widely to friends, relatives, public figures, and institutions in Europe and the colonies, and when his initial order of one hundred copies of Fisher's mezzotint proved not to be enough, Franklin's son ordered an additional one hundred prints.[72] To one of the recipients of this print, the French physicist and botanist Thomas-François Dalibard, Franklin wrote: "As I cannot soon agin enjoy the Happiness of being personally in your Company, permit my Shadow to pay my Respects to you."[73] Franklin sensed that Chamberlin's portrait carried something of his presence within it. Why else would he have ordered so many mezzotints? He fetishized Chamberlin's portrait, just a bit.

Or was Franklin simply being tongue-in-cheek in his letter to Dalibard? Surely he was capable of seeing through the picture's magic, and so are we. The modern-day historian, for example, might explain that special "It" possessed by sitters in eighteenth-century mezzotint portraits by appealing to Marx's critique of the commodity form, which adopts the language of the fetish as a way of dealing with the strange, animate quality of the commodity in the eyes of the consumer. The commodity fetish is an illusion, masking the labor that goes into its production as a mysterious power that seems to emanate from the object itself. Understood in these terms, mezzotint portraits of Franklin, the king, and other notable figures become so many deceptions bobbing around the Atlantic world, detached from their makers and the circumstances of their production, obscuring a clear-eyed understanding of the workings of empire as they magically "speak" to consumers through a transatlantic cult of personality and kingship.

But disenchanting the fetish in this way only partially explains the desires that sustained the circumatlantic traffic in portraits. It is not enough for the historian to expose the cunning priests of empire at work behind the scenes. The voice that speaks through Franklin's portrait does not come from a ventriloquist concealed beneath the floor; it is activated through an individual's embodied encounter with the portrait. Seeking to satisfy a desire for intimacy, audiences reached out toward compelling likenesses in a mimetic exchange that was, in fact, intimate. Their objects of desire were illusory in many respects, but their experience was real, no less so than Tennent's experience of God's voice in the thunder, and it demands more than an unmasking of the ideology behind the spectral fetish to account for its force.

It is easy to look at the portrait and dismiss its magic. Art history, a practice normally carried out within the comfort and quiet of the study, tends toward its

containment: we curb our enthusiasm for pictures by capturing their potential within disciplinary frames, by turning our heads from the problem posed by the scene outside the window. But just behind Franklin's head, the lightning still prompts us, as it prompted admirers of Apelles, to reflect on "things that cannot be represented in pictures." With Franklin, we look and we listen; we wait for a voice to enter from beyond the frame. It is this potential for shock that provides the very conditions of possibility for Chamberlin's pictorial demonstration of Benjamin Franklin's Promethean art.

At the Mouth of the Cave

Listening to Thomas Cole's *Kaaterskill Falls*

LOIS RIEGL BEGINS HIS 1899 essay "Mood as the Content of Modern Art" by describing an interrupted landscape viewing experience. The author imagines himself settling down atop a lonely Alpine summit. The ground slopes away before him, leaving nothing within reach, nothing to stimulate any sense but vision. He takes in the dark forested peaks around him, and beyond them, he can see meadows, the tiny white forms of cows grazing by the edge of a wood, and in the valley below, a cottage with a puff of smoke hovering beside it. A hushed stillness falls over everything. In the distance a waterfall runs down a rocky cliff, and even though the author recently experienced this waterfall up close and listened to its "angry thunder," from his current position on the mountaintop, his "distant vision" (*Fernsicht*) perceives it only as a bright band of silver. He takes pleasure in this calm, contemplative state of being. Suddenly, however, his reverie is disturbed by a noise. A chamois leaps nearby and runs across the neighboring slopes. The author jerks, and out of a hunter's instinct, he reaches for his gun. He is thrust back into an embodied awareness of his immediate surroundings. The beautiful mood he had enjoyed moments ago, now vanished, is a fragile thing. Any sensory intrusion, such as the leap of an animal, a sharp breeze that causes one to shiver, or the shriek of a bird in the air, is capable of shattering it.[1]

What does this parable mean? Modern life, Riegl explains, is an endless Darwinian struggle for existence. Its conditions are discord and destruction. Our day-to-day experience is one of "near vision" (*Nahsicht*) in which the chamois is constantly leaping before us. The view from the Alpine summit is a respite from the sensory oppressiveness of the modern world. On the mountaintop, we

become aware of a higher law of causation in nature that governs what would seem, on the near view, to be random, intentionless actions. This feeling of harmony toward which we all strive is what Riegl calls *Stimmung*. Typically translated as "mood," *Stimmung* is not to be mistaken for a transient emotional state; it is a redemptive knowledge in which the tensions and contradictions of near vision are resolved through the assumption of modernity's "scientific worldview."[2] But it is difficult to reach this state of serene detachment amidst the immediate demands of modern life, and so we seek it in art. *Stimmung* is the content of art in the modern era. Some kinds of art, however, are more conducive to it than others. When we look at a painting that shows the human figure in arrested motion, for example, our expectation of the figure's continued movement makes it difficult to achieve a contemplative distance. Vegetation and inorganic matter (rock, water, clouds), on the other hand, can reveal their true nature to us without the risk of such distraction. Landscape, in Riegl's view, therefore "occupies the highest place in modern art."[3]

For Riegl, *Stimmung* is the historical culmination of an unfolding human desire for liberation from the narrow conditions of worldly existence. Art had to pass through several phases—primitive, antique, and Christian-medieval—before it could finally awaken to this mood in which we experience a peaceful distance from our struggles with the material world, and indeed, with the materiality of art itself. Whereas primitive man could not comprehend the natural forces at work around him, and therefore worshiped his fetish in the hope that it would bring him some relief from his constant state of warfare, art in the modern age is no longer worshiped, but operates according to laws that we view from the summit of history, as it were. *Stimmung,* in other words, is the mood of art history, a science that seeks to understand the causal principles of art's development. This is a distinctly Hegelian outlook. If art history has a founding statement, surely it is Hegel's famous dictum, delivered in his Berlin lectures on aesthetics in the 1820s, that "art, considered in its highest vocation, is and remains for us a thing of the past."[4] Art history's disciplinary imperative is to achieve the distant historical view, and although Riegl's and Hegel's ideas about the pastness of art were hardly simple or straightforward for these thinkers, art history nevertheless gets on with its steady ascent toward the summit.[5] More often than not, this means avoiding those obstacles or intrusions that pose a threat to our sense of the historicity of art.

Consider the case of the American landscape painter Thomas Cole. In the early 1980s, Bryan Jay Wolf offered a provocative reading of Cole's early sublime landscapes as enactments of a psychic drama, an oedipal struggle toward self-consciousness in which the beholder must overcome an obtruding foreground

hillock or promontory before identifying with an often threatening middleground peak or idealized meadows in the background (Figure 4.1). For Wolf, as for Riegl, the process of viewing landscape is a metaphor. In Wolf's case, it is one about the romantic artist who, by representing his birth to self-consciousness through the natural imagery of landscape, locates his authority prior to the influence of social forces beyond himself. As Wolf puts it, "Cole sought in nature a metaphor for the self unburdened of history."[6] This approach was largely rejected by historians of American landscape painting. Wolf was charged with the "elimination of history as a category of critical discourse," and studies of Cole have hardly looked back since.[7] We now have accounts of the ways in which Cole and his patrons participated in the politics and class formations of Jacksonian America, nineteenth-century tourism and commerce, geological science, and Freemasonry.[8] In short, the story of Cole scholarship has been a story of "landscape into history," to

FIGURE 4.1. Thomas Cole, *View of the Round-Top in the Catskill Mountains,* 1827. Oil on canvas, 47.3 × 64.5 cm. Museum of Fine Arts, Boston. Gift of Martha C. Karolik for the M. and M. Karolik Collection of American Paintings, 1815–1865. 47.1200. Photograph copyright 2019 Museum of Fine Arts, Boston.

borrow the subtitle of the 1994 Thomas Cole retrospective at the National Museum of American Art.[9] The result has been a richly textured historical account in which Cole's world spreads out before our vision with exceptional clarity, much as the details of the Connecticut River valley are made available to us when seen from the top of Mount Holyoke in Cole's well-known landscape from 1836 (Figure 4.2). But the scholarship on Cole has still not come to terms with the ways in which his art might be at odds with the very discipline that attempts to make it a thing of the past.

This chapter is by no means a call to neglect the pastness of Cole's landscapes and accept uncritically the notion of a romantic artist unburdened of history. It is, however, an effort to listen attentively for the disruptive sound of the bounding chamois, the sudden intrusion that brings us back to our immediate surroundings and prevents the landscape from remaining comfortably *in* the past. And in this case, I do mean "listen"; for Cole, it is the sound of the landscape that unsettles our mood of contemplative distance. One sonorous painting in particular, Cole's early landscape *Kaaterskill Falls,* occupies my attention in the following pages,

FIGURE 4.2. Thomas Cole, *View from Mount Holyoke, Northampton, Massachusetts, after a Thunderstorm—The Oxbow,* 1836. Oil on canvas, 130.8 × 193 cm. The Metropolitan Museum of Art. Gift of Mrs. Russell Sage, 1908 (08.228).

where I make much of the loudness of the painting's tumbling cataract (Plate 10). I begin by considering how Cole paints landscape as an uneasy relationship between optical and aural modes of experience: by painting the falls in their "angry thunder" rather than as a silver band in the distance, Cole does not allow us to leave behind their sound. Accordingly, in the second part of the chapter, I continue to attend to those sounds and argue for their implication in a specific cultural context of the 1820s: the notoriously loud and, indeed, "sublime" sounds of the religious revival. I turn to the revival not to give it priority over Cole's art, as if it could somehow stabilize within history the radical act of unburdening that is *Kaaterskill Falls*. Rather, popular religion is best understood as a remainder that this painting leaves in its wake, a trace—or better yet, given the significance of sound in what follows, an *echo*—of the world in which Cole's earliest landscapes took shape.

"THE VOICE OF THE LANDSCAPE"

The story of Cole's *Kaaterskill Falls* is well known. First told in November 1825 in the *New-York Evening Post,* it is the classic story of the origins of an American school of landscape painting. The eminent painter, and at that time president of the American Art Union, Colonel John Trumbull, while visiting a New York art dealer, had come upon three landscapes by a young and unknown artist. Trumbull was particularly impressed by a view of Kaaterskill Falls in the Catskill mountains, a painting he chose to acquire for himself: "What I now purchase for 25 dollars, I would not part with for 25 guineas. I am delighted, and at the same time mortified. This youth has done at once, and without instruction, what I cannot do after fifty years' practice."[10] The canvas purchased by Trumbull, a view from a cavern behind the falls, is now unlocated. But the following year, Cole made a replica for another patron, Daniel Wadsworth, the son of a wealthy Hartford merchant, who had seen Trumbull's painting and was evidently impressed by it. Cole expressed in a letter to Wadsworth that he was not entirely satisfied with the copy: "I have laboured twice as much upon this picture as I did upon the one you saw: but not with the same feeling. I cannot paint a view twice and do justice to it."[11] Despite Cole's protest about the unrepeatability of his initial inspiration, Wadsworth was pleased enough with the result. There were, at least, no complaints, and Wadsworth remained an enthusiastic collector of Cole's landscapes.

It is the striking immediacy of Cole's Catskill waterfall, one suspects, that impressed Trumbull and Wadsworth. Standing before *Kaaterskill Falls,* we feel less

like observers than participants in the landscape. Cole places us just within the mouth of the cavern behind the upper portion of the falls. While the cavern opens onto an expansive view of the Catskills in the distance, the landscape in the immediate foreground solicits a more bodily response. Out of the dark mass of brush and foliage in the lower right corner emerge a few dead branches that invite us to grab hold and make a short but hazardous hike that will lead, if the branches don't snap under our weight, to the diamond-shaped rock that juts into the water in the central foreground. Planting our feet on that rock would be a fitting conclusion to a spiraling journey that begins along the well-defined ledge at left and continues around the unseen back of the cavern to where we presently stand, then through the thick branches and undergrowth at right, and back toward the central rock.

The purpose of this journey would be to bring our bodies, and thus our full capacity for sensation, as close as possible to the remarkable waterfall that drops over the top of the cavern and tumbles into the pool in an explosion of mist (Figure 4.3). Cole has painted the falling water loosely, in flecks of lead white that recall Natty Bumppo's description of Kaaterskill Falls in James Fenimore Cooper's *The Pioneers* (1823), a description Cole may well have had in mind as he was painting: "The first pitch is nigh two hundred feet, and the water looks like flakes of driven snow, afore it touches the bottom."[12] But, in contrast to Cooper's passage, Cole's painting asks us to take in more than the look of the falls. The apparent motion of the flakes and the disturbance they cause in the churning water below, as dead branches pop erratically above the surface, create a palpable sense of loudness: the mists rising from the pool seem to carry with them the very sound of the cataract. The foreground of *Kaaterskill Falls* is, in short, a multisensory landscape. It is a place for the body, a "place of exposure," as Edward S. Casey has described the foreground of Cole's later landscape, *View from Mount Holyoke* (see Figure 4.2).[13] We cannot take it in at once, but must negotiate it slowly, on foot, "feeling" it out with our eyes, with our hands, and perhaps above all, with our ears.

Kaaterskill Falls serves as a declaration. For Trumbull, for landscape painters who subsequently modeled themselves on Cole's example, and later for art historians, it declares that landscape painting will hereafter look different, that we will now be presented with a distinctly American landscape, sublime in its mood; and it declares that there is a particular painter who will show this landscape to us, Thomas Cole.[14] Here is a type of painting the venerable Trumbull could not manage "after fifty years' practice." Compare with Cole's painting one of Trumbull's views of Niagara Falls, painted in 1807 and purchased by Wadsworth in 1828 (Figure 4.4). Trumbull's is a much more placid view of a waterfall:

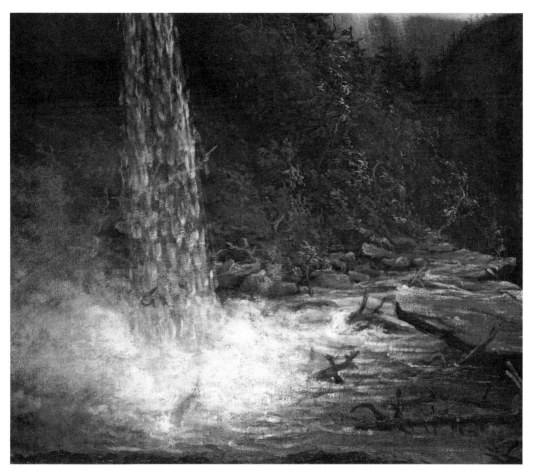

FIGURE 4.3. Thomas Cole, *Kaaterskill Falls,* 1826 (detail). Wadsworth Atheneum
Museum of Art, Hartford, Connecticut. Bequest of Daniel Wadsworth, 1848.15.

the rising mists of the falls, seen at a distance through framing trees, belong to a
quiet picturesque to contrast with Cole's noisy sublime. A British soldier, advanc-
ing from the left side of the painting toward the foreground, raises his arm in the
direction of the falls in order to display this natural wonder to his two female
companions, although he seems equally to be addressing the viewer. This direc-
torial gesture, which has the effect of removing the viewer still further from an
untutored experience of nature, stands as a military metaphor for the kind of
command the painting's soldier-artist, Colonel Trumbull, exercises over us, as he
gently yet firmly regulates our experience of Niagara Falls. It is precisely this kind
of control that Cole, painting "without instruction," relinquishes in the foreground
of *Kaaterskill Falls,* and as a result, we experience his landscape not as an effort at

FIGURE 4.4. John Trumbull, *Niagara Falls from an Upper Bank on the British Side,* 1807. Oil on canvas, 62 × 92.9 cm. Wadsworth Atheneum Museum of Art, Hartford, Connecticut. Bequest of Daniel Wadsworth, 1848.4.

containment, but as an audible release in which the distinctive voice of a young artist spills beyond the conventions of eighteenth-century landscape painting.

Cole does, however, offer some relief from the clamor of the foreground. *Kaaterskill Falls* changes key at the rocky precipice that protrudes over the unseen lower falls and on which the tiny figure of a Native American stands, his miniaturization in effect reducing the viewer's own body to a point, to a gaze that looks east over the deep depression of Kaaterskill Clove and toward a clearing sky, a distant peak, and the rising sun. To assume this point of view is to abandon one's body in the foreground, and with it, the sensory excess of that space: its noise, its motion, and its disorder; we become only an eye that takes the measure of the transcendent landscape laid out before us.[15] It is a view that many of Cole's contemporaries would have recognized, for by 1826, Kaaterskill Falls had already become enough of a tourist destination to justify the building of a viewing platform at the top of the falls. Standing before Cole's painting, however, we are no tourists: this is not a landscape previous sightseers have taken in. As Natty Bumppo describes

the site, "there has that little stream of water been playing among them hills, since He made the world, and not a dozen white men have ever laid eyes on it."[16] As we gaze silently on the Catskills with the tiny Indian, we see the mountains as Natty has seen them, through eyes untainted by civilization. It is the kind of view that Cole must have had in mind when, in his "Essay on American Scenery" (1836), he wrote that the highest purpose of art is to "sublime and purify thought."[17]

Yet, just as Riegl's distant vision is disturbed by the sudden jumping of an animal, something prevents the full sublimation of the viewer's body into ocular experience. For all the optical pull of that distant Catskill landscape, we cannot close our ears to the sound of Cole's waterfall; its claim on us is more immediate than is the viewpoint enjoyed by the figure on the cliff, who is actually quite distant from us. While the jutting rock in the central foreground may be a difficult journey by foot, the Indian's rock seems positively out of the question. To access it, we must disavow our own bodies, but this is a great deal to ask, given the bodiliness with which Cole endows us. The crashing of the waterfall will always keep us partially in the foreground; it will always be the background noise to our optical experience of the landscape, if only because it is here, at the mouth of the cave, where the body stands. Perhaps it was Cole's success in creating this oscillation between sight and sound, between optical and aural modes of experience, that both "delighted" and "mortified" Trumbull when he purchased the first version of the painting in 1825. For our purposes, it provides an occasion to think about the relationship between vision and voice within Cole's own aesthetics and within the larger cultural project of imagining the American landscape during the early nineteenth century.

A sensible place to begin exploring this relationship, the place Cole's painting asks us to begin, is at the mouth of the cave—that "singular feature," as Cole describes it, of "the vast arched cave that extends beneath and behind the cataract."[18] Like Plato long before him, and like many writers and visual artists working before his time and since, Cole seizes on the figure of the cave to construct his allegory about the process of coming to knowledge of the world through the senses. In Plato's well-known version, told by Socrates in the *Republic,* prisoners chained within a cave mistake the shadows and echoes of figures on the outside for reality. Not until one of these prisoners escapes from his bonds and turns to the light coming in through the cave mouth does he begin to clear up his confusion and see the forms and hear the voices of the people walking outside for what they really are. Cole shows an unspoken involvement with this allegory throughout his body of work.[19]

Consider his prose sketch from the 1820s, "The Bewilderment." Having lost his way in the dark woods, the narrator falls through the earth into a deep hole and begins to follow an underground stream. Without light to guide his way, he can only describe his body's blind struggle with the objects it encounters in the darkness. Creeping on hands and knees, bumping into rocks and dead branches, the narrator makes his way through a dark and treacherous netherworld until, finally, he discovers the mouth of his imprisoning cave. "A strange luminous appearance not far from me invited my steps, for light from whatever source was light. I approached it; it was a beautiful but strange brightness on a spot of smooth sand. I stretched my hand to touch it and, behold, my hand was illuminated and cast a shadow." At this point, the benighted narrator is still like one of Plato's prisoners, dwelling within the cave and perceiving the outside world obliquely, through its shadows. But then, after noticing the shadow cast by his hand, he turns to the source of light: "I turned and beheld the blessed moon, looking down a long cavernous passage, like a pitying Angel of light. I knelt down and could have worshipped it."[20] Looking directly into the angelic moonlight streaming through the mouth of the cave, the narrator is finally released from his bewilderment.

It is a release that is repeated elsewhere in Cole's work, as in his *Childhood*, completed in 1839, the first canvas of his allegorical series *The Voyage of Life* (Plate 11). Here, the cave is associated with birth, with an emergence from the darkness of the womb that signifies the child's awakening into consciousness. In the explanatory notes for the series, Cole was quite clear about how he wanted his public to interpret this element of the painting: "The dark cavern is emblematic of our earthly origin, and the mysterious Past."[21] In a letter to Wadsworth written in 1828, Cole comments on this symbolic dimension of his caves. Most likely referring to a cave entrance that appears in the right middleground of his *Garden of Eden,* an element that Wadsworth felt too "formal" and "gloomy," Cole writes: "Though a cave may be a gloomy object in Nature—a *view* of its entrance gives rise to those trains of pensive feeling and thought that I have always found the most exquisitely delightful—The poets often speak of caves, and grottos as pleasing objects, and I do not know why the painter may not think as the poet" (Figure 4.5).[22]

Pictures like *The Garden of Eden* and *The Voyage of Life* adopt a familiar romantic trope (one thinks, for instance, of the "caverns measureless to man" from Coleridge's *Kubla Khan*) in which the cave evokes mysteries that exceed the representational capacities of the poet's pen or painter's brush. *Kaaterskill Falls* draws on the same poetic imagery, yet it also reverses our relation to the cave. Instead of including the dark cave mouth within the painting as an emblem to be "read"

FIGURE 4.5. Thomas Cole, *The Garden of Eden,* 1828. Oil on canvas, 97.8 × 134 cm. Amon Carter Museum of American Art, Fort Worth, Texas, 1990.10.

like a poem, Cole activates the cave's perceptual role in the landscape. Instead of looking at a child coming out of the cave, we take on the role of that child. We begin our "voyage of life," or escape from our "bewilderment," as we emerge from the cave behind the falls, as our eyes and ears awaken directly onto the sights and sounds of nature.

One of the reasons the cave in *Kaaterskill Falls* lends itself to allegories of birth and awakening is that Cole is not excessively concerned with imitating the actual structure of a cave. An instructive comparison in this respect is William Guy Wall's depiction of the same view, painted around 1827, probably after Wall had seen Cole's canvas (Figure 4.6).[23] An accomplished topographical painter, Wall insists on the capacity of vision to take in the falls, and he does this by pushing the viewer further into the depths of the cavern. From this more distanced viewpoint, one has a better understanding of how the cavern sits above the pool and a clearer view of the cavern walls, which the artist paints with geological precision. Cole, on the other hand, refuses the distance and detail favored by Wall; instead,

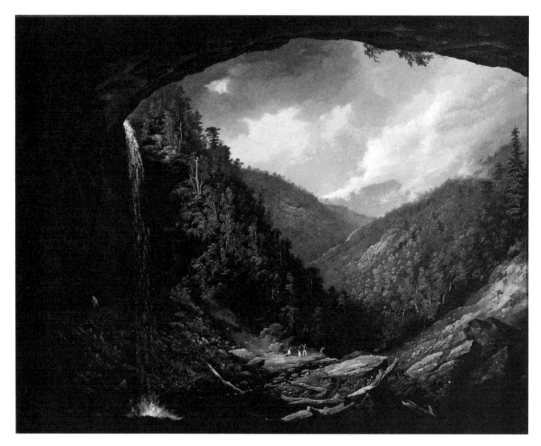

FIGURE 4.6. William Guy Wall, *Kaaterskill Falls on the Catskill Mountains,* c. 1827. Oil on canvas, 95.3 × 119.4 cm. Honolulu Museum of Art. Gift of the Mared Foundation, 1969, 3583.1.

he places the viewer right before the pool and shows only the upper edges of the cave entrance, which he paints loosely and with a satisfying symmetry, unlike the decentered mouth of Wall's cave. All of this suggests that Cole's interest in the cave is not so much a topographical concern as an interest in framing, in figuring for the viewer the very processes of producing and experiencing landscape.

What, then, is the pictorial logic of this act of framing? If the cavern's clear resemblance to a proscenium arch suggests an overtly theatrical act in which Cole insists on his own role as director of our landscape experience, at the same time, the smooth and even fleshy forms of the arch constitute a perceptual framing. The cave is a cyclopean eye through which we enter Cole's landscape optically. It is also a cave *mouth,* an oral frame from which a young painter boldly voices a new land-scape aesthetic. And it is an ear as well, a receptive portal into whose protective

space we are led by a winding pathway that leads from exterior to interior, as it spirals ear-like around the noisy pool. I do not suggest that any one of these readings could be called the "correct" interpretation of Cole's cave; instead, they speak to the open-ended sensory potential of the frame. In short, if Plato's allegory provides a model for reading Cole's cave, we should by no means mistake it for a purely ocular fable about awakening to the truths of nature. For, Cole insists that we do not simply *look* from the mouth of the cave; we also *listen*.

Here is how Cole describes Kaaterskill Falls—not the painting, but the actual site—in a prose piece dating from 1843. The passage is best read aloud, so that one can hear the way Cole rehearses in his writing a perceptual ambivalence similar to that which structures the earlier painting:

> It is a singular, a wonderful *scene,* whether *viewed* from above, where the stream leaps into the tremendous gulf scooped into the very heart of the huge mountain, or as *seen* from below the second fall—the impending crags—the *shadowy* depth of the caverns, across which darts the cataract, that, broken into fleecy forms, is tossed and swayed, hither and thither, by the wayward wind—the *sound* of the water, now falling upon the ear in a loud *roar,* and now in fitful lower *tones*—the lovely *voice*—the solitary *song* of the valley.[24] [Emphasis added]

Cole begins his description of the falls with an appeal to vision: his pairing of "scene" and "seen" captures the optical nature of this initial experience. In the middle of the passage, however, the entrance of the cataract disrupts the view and initiates a shift into an aural experience of nature. Mesmerizing rhythms of speech ("tossed and swayed, hither and thither, by the wayward wind") turn our attention to sound, and by the end of the passage, we have forgotten our eyes and now simply listen to nature's song.[25]

The aurality of Cole's *Kaaterskill Falls* is not unique among his early landscapes. One of his compositions of the 1820s, created not long after he painted *Kaaterskill Falls,* demonstrates a similar pairing of a cave entrance with sound. In 1829 or 1830, Cole completed a painting of an Old Testament scene entitled *Elijah in the Wilderness—Standing at the Mouth of the Cave.* That painting is now unlocated, though several studies do survive, including a sketch that bears the title, scrawled at the bottom of the sheet, *Elijah at the Mouth of the Cave* (Figure 4.7). Although the walls of Elijah's cave are visible only on the right-hand side of the sheet, the compositional structure of the drawing essentially repeats that of *Kaaterskill Falls*: the opening of the cave frames a landscape that consists of a foreground plane at

FIGURE 4.7. Thomas Cole, *Elijah at the Mouth of the Cave,* c. 1829. Pen and ink over graphite on paper. The Detroit Institute of Arts / Bridgeman Images.

the edge of which stands a tiny figure, and beyond that, a distant view of mountainous wilderness and stormy skies.[26] Elijah, however, shielding his eyes with a raised arm, does not look at that distant view. The relevant verse from the book of 1 Kings, that provided the inspiration for Cole's composition, reads: "[Elijah] wrapped his face in his mantle, and went out, and stood in the entering in of the cave: and behold, there came a voice unto him, and said, what doest thou here, Elijah?"[27] Elijah's experience of divine presence is, finally, a blind experience: vision gives way to the pronouncement of the Word, to the voice of God.

In *Kaaterskill Falls,* with its naturalized divinity, the substitute for the voice of God is the cataract, a natural feature that Cole refers to throughout his prose writings as "the voice of the landscape":

The waterfall may be called the voice of the landscape, for, unlike the rocks and woods which utter sounds as the passive instruments played on by the elements, the waterfall strikes its own chords, and rocks and mountains re-echo in rich unison.[28]

The tactile flakes of paint that descend from the cataract's unseen source and the scumbled mists that rise from the pool in a sense *are* this voice in *Kaaterskill Falls*. We might say that Cole is "quoting" nature in this white, painterly noise that does not fully resolve into the autumnal landscape view. Suspended in the foreground, it interrupts our visual progress through the painting, clouding our vision, so to speak.

Michel de Certeau has argued that quotation has the potential to disrupt representation by introducing "voices of the body" into the text. Such voices are memories of the bodies that are always lodged in language but are not reducible to it; they are "cries breaking open the text that they make proliferate around them."[29] Among these voices in the pictorial register, we could include Cole's sounding cataract, a voice that reverberates well beyond the rocks and mountains of a Catskill landscape. As we will see in the next section, Cole's waterfall reechoes in the embodied sounds of popular religion, in the noisy religious fervor of the Second Great Awakening that, it turns out, was of some interest to the artist right around the time he was painting *Kaaterskill Falls*.[30]

"THE DIN OF THE REVIVAL"

In a sketchbook dated 1827, Cole made a list of over one hundred ideas for future paintings, most of them never executed.[31] The very first item on this list is a scene of "Preaching in the woods as is seen in the Western country," a title that refers to the revivalist preaching that was rapidly gaining momentum in the first years of the nineteenth century, particularly in the western states of Kentucky, Tennessee, and Ohio, regions that had been prime ground for camp meetings since the massive Cane Ridge revival in Bourbon County, Kentucky, in 1801.[32] These popular, open-air gatherings were the defining conversion events of the great evangelical movement that transformed American Christianity during the early years of the republic. As the country's burgeoning population sought to realize the promise of its recent revolt against aristocratic authority, Protestant worship in America—its setting, its hymns, the style of its preachers, the way people responded to the preacher's words—was definitively wrested from the control of elites who presided over the established churches and remolded in the image of the common people.[33]

Preaching in the woods was not, of course, an invention of nineteenth-century American Protestantism. As the celebrated open-air preacher George Whitefield asked in 1749: "What do you think of *Jesus Christ* and *his* Apostles? Were they not Field-Preachers?"[34] Open-air preaching is as old as evangelism itself, although it

did become an especially important practice in the transatlantic revivals of the eighteenth century. As early as 1739, Whitefield and John Wesley were saving souls in the fields rather than in churches.[35] Following their lead, itinerant Methodist preachers in the British Isles traveled through city and country during the eighteenth and early nineteenth centuries, evangelizing the urban working class and the rural poor in outdoor services. Field preaching traveled to the American colonies with Whitefield in 1740, and eventually, around 1800, the practice developed into the camp-meeting format characteristic of the Second Great Awakening. Held in forest clearings, these boisterous multiday and often multidenominational affairs, attended by large crowds that camped on the meeting grounds and heard the services of any number of preachers, proved highly effective at evangelizing on the frontier.[36] The nineteenth-century American camp meeting was part of a sweeping mobilization of people on both sides of the Atlantic in which vast populations, many of them existing on the economic and geographic fringes of society, found a voice in the enthusiastic expression of personal faith.[37]

This voice was far from unified. It belonged to Methodists, Baptists, Presbyterians, and many other sects both large and small. Both whites and African Americans participated in revivals, and many of the central actors in them were women. Scholars have argued that revivals fed popular resistance to the consumerist orientation of an expanding market economy, but they have also argued that revivalism instilled in the common people precisely the kind of middle-class morality that prepared them for participation in the market. Revivals were a leveling force that brought about the democratization of religion in early America, but they were also a repressive force that primed the masses for the discipline of the factory.[38] There was, in short, no single direction to the transatlantic revivals. But what their participants did have in common, despite racial, gender, class, and sectarian differences, was a personal and passionate involvement in religion. Nowhere is this fact more apparent than in the nineteenth-century camp meeting. Regardless of how one understands its social and political significance, the camp meeting was a place where religion was experienced as ecstatic, emotional release. Above all, observers who witnessed these gatherings agreed on the overwhelming noise generated by the singing, shouting, and groaning of preachers and their enraptured audiences. For the champions of revivals, these sounds of the body signified an awakening to a new birth in Christ. For the many antirevivalists who made their opinions known, they were proof of the fanaticism that resulted when the practice of religion was put in the hands of the untutored mob.[39]

Cole spent his life in the shadow of the religious revival. He was born in Bolton, Lancashire, in 1801, where Wesleyan Methodism was establishing a strong presence as the Industrial Revolution took hold during the early years of the nineteenth century.[40] The Cole family emigrated to America in 1818, and although there were many aspects of British culture they left behind as they "bid a final adieu to England," the revival was not among them.[41] From 1819 until 1823, Cole lived with his family in eastern Ohio, an area rife with Methodist camp meetings.[42] This evangelical fervor followed Cole back east in the early 1820s, as it spread into the same regions of western New York that inspired some of his early landscapes and continued to inspire him throughout his career. Indeed, the revivals raged with such intensity in this part of New York that it came to be known as the "burned-over district."[43] Is it any surprise, then, that revivalist preaching turns up at the top of the young landscape painter's list of potential subjects in 1827?

The second item on the list continues with this theme: Cole envisions a "Camp Meeting at Night—a fire light & moonlight." While no final version for either of the first two items on the list is currently known, Cole's sketchbook does include a compositional study for the second (Plate 12). In this drawing, labeled "Camp Meeting," small groups of observers stationed in the right and left foreground look out over a more-or-less typical setting for such a gathering: the tents of the revivalists ring the periphery of a clearing in the woods while two large fires illuminate the nocturnal scene. The composition is similar to other nineteenth-century views of the camp meeting, like an aquatint after a drawing by the French artist and naturalist Jacques Gérard Milbert, who encountered a Methodist camp meeting during his travels along the Hudson River in 1817 (Figure 4.8). In his published journal, Milbert describes the excited oratory of a preacher who is heard by a crowd of twelve to fifteen hundred, including women and girls "who believe they are inspired by the Holy Ghost, often utter cries that resound through the forest, roll in the dust, and beat their heads."[44] Milbert's view, however, like Cole's, plays down the bodily passions of the revival. Both artists accommodate the camp meeting to the conventions of picturesque landscape, framing it with trees and emphasizing the natural setting over the actions of the participants. In Cole's view, a ridge of mountains, suggested by a rough, sloping curve just beneath the crescent moon, ties this scene of religious revivalism to the artist's interest in the mountainous landscape of the Catskills and western New York.

The choice of subject is understandable: by all accounts, the camp meeting was a remarkable sight, especially at night. Frances Trollope, travelling in America in

Camp Meeting of the Methodists in N. America

FIGURE 4.8. Matthew Dubourg after Jacques Milbert, *Camp Meeting of the Methodists in N. America,* 1819. Courtesy of Winterthur Museum. Museum purchase, 1970.402.

1829, wrote of a meeting she observed in the backwoods of Indiana. Having arrived late at night with the moon "in meridian splendor above our heads," she observes the crowd assembled before the preacher. "It is certain," she writes, that

> the many fair young faces turned upward, and looking paler and lovelier as they met the moon-beams, the dark figures of the officials in the middle of the circle, the lurid glare thrown by the altar-fires on the woods beyond, did altogether produce a fine and solemn effect, that I shall not easily forget.[45]

Cole may well have had similar memories of the picturesque camp meeting. It was a promising subject for a landscape painting, and one can't help but wonder what he would have done with his "fire light & moonlight" in oils.

Although his sketch and his list of subjects suggest that, early in his career, Cole cultivated an interest in popular religion, it was an interest he never carried into a finished work of art. Perhaps the subject matter was too vulgar, too immediately caught up in the noisy religious fervor of the times for a landscape painter of Cole's ambition. Vulgarity is, at least, what spoiled it for Trollope. While she admires the mysterious effects of the night-time scene, her reverie is soon broken by noises "discordant, harsh, and unnatural," noises that "in a few moments chased every feeling derived from imagination, and furnished realities that could neither be mistaken or forgotten."[46] Trollope goes on to describe a Bedlam of jerking preachers and maniacal crowds in language that enlists Milton and Dante for aid and is, as far as I am aware, unequalled in the literature on camp meetings for its condemnatory tone. And yet, however intense her personal horror may be, Trollope is sounding a note we hear regularly in accounts from the period, which habitually rehearse this disturbance of a picturesque view by a disconcerting irruption of noise. Another English traveller, Frederick Marryat, gives a similar account of an Ohio camp meeting witnessed on his tour of America in 1837. At first overtaken by the visual grandeur of the scene, the "snowy whiteness [of the tents] contrasting beautifully with the deep verdure and gloom of the forest," Marryat is soon so shaken by the "groans, ejaculations, broken sobs, frantic motions, and convulsions" coming from the congregation that he retreats into the surrounding woods.[47]

Cole's suspicion of the democratic mob, evident throughout his writings, surely made him conscious of a tension between the silent, private experience of beauty enjoyed by the spectators in his drawing and the public cacophony of frontier religion.[48] When it came to depicting the voice crying in the wilderness, Cole preferred biblical subjects over the camp meeting. Indeed, the third painting on his list is "Elijah in the Wilderness—Standing at the mouth of the Cave," a study for which we have already encountered. For Cole, prophets like Elijah or John the Baptist were more suitable associations for a sublime landscape, and several years later, in 1835, when he expounded on the sublimity of American scenery, it was definitively the prophets he wanted his readers to hear:

Prophets of old retired into the solitudes of nature to wait the inspiration of heaven.
It was on Mount Horeb that Elijah witnessed the mighty wind, the earthquake, and

the fire; and heard the "still small voice"—that voice is YET heard among the mountains! St. John preached in the desert; the wilderness is YET a fitting place to speak of God.[49]

It is important to our sense of the natural grandeur and moral profundity of Cole's wilderness scenes that they are occupied by prophets like the one who harangues his audience in *Landscape Composition, St. John in the Wilderness,* not by the backwoods preachers of the artist's own day (Figure 4.9).

But, if the sublimity of the subject and the exoticism of the palm-accented mountains in *St. John in the Wilderness* raise the sounds of revival above the mundane, this painting still has the capacity to place its viewers in the midst of popular religion in the 1820s. Cole painted it for Wadsworth in 1827, the same year he was sketching out ideas for camp-meeting scenes, and given Cole's interest in popular religion at the time, it requires no stretch of the imagination to read the painting as a kind of biblical camp meeting. After all, the arrangement of figures in the composition *looks* like a camp meeting: the animated prophet stands on his rocky pulpit before an attentive audience, some of the figures enthusiastically throwing up their arms in gestures that echo those found in nineteenth-century depictions of camp meetings like Alexander Rider's revivalist scene of about 1829 (Plate 13; Figure 4.10).[50] Rider's image is suggestive simply in its attempt to capture some of the theatrics for which the revivalist movement was known: the swoons and gesticulations of the penitent and the shouts of the preacher who, in this case, leans into the podium, his eyes raised to the heavens and his arms in the air as his saving words ripple through the crowd. The difference of the revival in *St. John in the Wilderness* is that John's audience does not only get religion; it gets nature too. As John extends one arm toward the crowd, the other points toward the cross and, beyond that, toward the distant cataract, a gesture that links his own cries in the wilderness to the voice of the landscape.

Many preachers of Cole's day gestured right along with St. John toward the sublime. John's voice resonates powerfully, for example, with that of the great prophet of the burned-over district, Charles Grandison Finney. Finney was a powerful speaker, a master of millennial rhetoric and also of parables. He was particularly fond of telling his "hearers"—as the audiences at camp meetings were commonly called—the parable of Niagara Falls. In this story, a man lost in reverie drifts toward the falls, unaware of the danger in which he places himself. Just as he is about to plunge over the edge, an observer lifts a "warning voice above the roar of the foaming waters, and cr[ies] out, *Stop,*" a voice that "pierces

FIGURE 4.9. Thomas Cole, *Landscape, Composition, St. John in the Wilderness,* 1827. Oil on canvas, 91.4 × 73.5 cm. Wadsworth Atheneum Museum of Art, Hartford, Connecticut. Bequest of Daniel Wadsworth, 1848.16.

FIGURE 4.10. H. Bridport after Alexander Rider, *Camp Meeting*, c. 1829. Library of
Congress Prints and Photographs Division.

his ear, and breaks the charm that binds him."[51] The man thus realizes his predi-
cament, and he is saved. The parable answers a question: What must I do to be
saved? The answer: as a sinner, I must listen and be responsive to the voice of the
preacher. The parable is instructive not only for the importance it places on the
preacher's voice but also for the way in which it compares that voice to the "roar
of the foaming waters," as if this were the true test for the preacher, to measure
up to the roar of Niagara Falls.

While Finney and Cole both link the preacher's voice to the waterfall, even
more frequently it is the shouting of the multitudes that Cole's contemporaries
likened to the sound of vast cataracts.[52] One observer at the Cane Ridge revival
recounts: "A vast crowd, supposed by some to have amounted to twenty-five
thousand, was collected together. The noise was like the roar of Niagara."[53] It was
due to such associations that Niagara became a popular site for revivalists through-
out the nineteenth century. In his account of a visit in 1835, the Baptist minister
Francis Cox expounds on the need to describe the sublimity of the falls that is felt

by every writer who has witnessed "the woods, the rapids, and the cataracts, and heard the thunder blending its awful voice with the everlasting dash and rattle and roar of the gathering waters as they fret and foam and rage in convulsive agony." But no, Cox protests: "I shall not attempt it. Let imagination supply the place of description." And so, rather than dwelling further on sublime Niagara, he proceeds into an extended account of a Methodist camp meeting "held in the woods, about half a mile from the Falls."[54]

Revivalism, in short, went hand in hand with the cult of nature, which helps to explain why the subject of the revival posed a certain attraction to a worshiper of nature like Cole.[55] It also helps to explain how the sounds of Cole's *Kaaterskill Falls* mingle with those of the revival. As we listen to Cole's landscape, as the turbulence of the cataract insists on our bodily presence in the foreground despite the attraction of the distant prospect, we experience a disruption similar to that experienced by observers of the camp meeting like Trollope and Marryat. We are called back to our bodies by a voice that exceeds the view given to our eyes, a voice through which we come to understand, in a visceral way, why Samuel Monk, in his classic study on the sublime, describes its embrace of emotion as "a sort of Methodist revival in art."[56]

I do not, however, wish to press too hard on the link between religious revivalism and Cole's sublime landscapes of the 1820s. The Second Great Awakening certainly does not explain these early landscapes. St. John is not, finally, Charles Grandison Finney, and the landscape in which he preaches is decidedly not western New York. It is also important to remember that the nature-worshiping artist and the penitent sinner represented two very different spiritual camps in the early nineteenth century. The cult of nature found its members among the refined and educated; in Perry Miller's words, it was a religion of "Nature spelled with a capital N, which Cooper celebrated, Thomas Cole painted," and to which an elite "fled for relief from the din of the revival."[57] The revival, in contrast, emerged by and large out of populations that had gained little from the expanding markets of the early republic, and its loudness was a crucial sensory means of constituting class hierarchies in early America.[58] It was against the intolerable noise and unrestrained bodies of evangelicals that quiet nature-worshipers could invent their own habits of composed reverence. "Compared with almost any chapter in the history of Protestantism," writes Miller, the Second Great Awakening "is vulgar, noisy, ignorant, blatant."[59]

Yet it is difficult to make definitive statements about Cole's attitude toward revivalism or his position within the religious landscape of the early nineteenth

century. Alan Wallach has stressed the importance of the "dissenting tradition" for Cole, which the artist inherited from a strong culture of religious dissent in his native Lancashire. Popular works like *The Voyage of Life,* which was aimed at a broad audience familiar with an emblematic tradition that dates back to the seventeenth century and was associated with dissent, support Wallach's claim that Cole was "inclined to low-church evangelism."[60] Such leanings could help to explain why, when Cole wrote up his 1827 list of ideas for paintings, his thoughts immediately turned to a subject like the camp meeting. But, while the visual conventions of the dissenting tradition helped to shape Cole as an artist, "dissent" as such is not a term with much purchase in describing the notoriously complicated history of evangelical Protestantism in the early nineteenth century. Even within this movement, there were major divisions, particularly between the middle-class Finneyites, who were mostly Presbyterians and Congregationalists, and the other large, populist evangelical churches like Methodists and Baptists, whose members existed closer to the margins of the market revolution.[61]

Cole, whose writings are unhelpful on the topic of his religious beliefs, is difficult to locate within this maze of religion and social class. While he may have inclined to a low-church evangelism, his early patrons hailed primarily from the Federalist aristocracy. As Wallach has argued, Cole's identity was definitively shaped by the English class system: although he came from middle-class origins in the industrial region of Lancashire, a fear of sliding into the working class instilled in him a sense of his own moral superiority and gentlemanly status that naturally allied him with patrons like Trumbull and Wadsworth.[62] The extent to which he "shared the aristocracy's political and social conservatism" is evident in his disdain for unrestrained public displays of populist political sentiment.[63] In a journal entry from November 1834, he recounts being interrupted during a tranquil walk with companions through a favorite dell, as his party gathered mosses and noted the beautiful play of light through the trees: "While we were in the valley we heard the shouts of a company of Jacksonians who were rejoicing at the defeat of the Whigs of this county. Why were they rejoicing? because of the triumph of good principles of the cause of virtue & morality? No! but because *their party* was victorious!"[64] We have no direct commentary from Cole on the religious revivals of his day, but his attitude toward noisy Jacksonians, which echoes that of Trollope and Marryat toward the discordant sounds of the camp meeting, makes it easy to imagine him being repelled by the democratic, everyone-can-be-saved spirit of frontier religion.

Cole's religious commitments did become more defined in the 1830s, when he became an active member of St. Luke's Episcopal Church in Catskill. The Episcopal Church of the United States during this period was divided into two parties: the Evangelical or Low Church party, and the High Church party, which found in the distinctiveness of the Anglican tradition an alternative to the widespread Protestant revivalism of the period.[65] In 1842, Cole more clearly identified himself with this antirevivalist faction when he was baptized by his friend Louis Legrand Noble, an Episcopal priest and later Cole's biographer. Noble's biography of Cole, published in 1853, was important for securing a legacy for the artist consistent with the self-image of quiet gentility that he increasingly sought in the 1840s. Describing the young Cole painting landscapes in a narrow garret in his father's house in 1825, Noble writes that "a light flowed out upon his canvass from the silent cave of his thought."[66] In 1853, we are indeed a long way from the noisy cave of 1826, when Cole was still actively negotiating the radically uncertain boundaries of landscape painting and popular religion.

The emblematic image for this quiet and contemplative Cole, a landscape painter now fully awakened to the mood of modern art, is Asher B. Durand's *Kindred Spirits* (Plate 14). In this painting, completed in 1849, Cole, who had died the previous year, stands on a rocky precipice alongside his friend William Cullen Bryant—their two names are engraved on the trunk of a tree in the left foreground—as the painter and poet converse about the expansive view of Kaaterskill Clove that stretches out into the infinite distance beyond them. The painting's Catskill scenery makes direct reference to the landscapes with which Cole had first achieved fame, and indeed, the very falls that dominate the foreground in the 1826 painting appear in Durand's picture as a small silvery band in the distance. The inspiration for *Kindred Spirits* was Bryant's funeral oration occasioned by the death of his friend and delivered before the National Academy of Design in 1848.[67] The title of Durand's painting, however, refers not only to the sympathetic bond between two men; it refers to the sister arts of painting and poetry, a theme Bryant stresses in his eulogy when he describes Cole's *Voyage of Life,* for example, as "a perfect poem."[68] Durand links the "solitary song" of Kaaterskill Falls to the refined sounds of music and poetry through the figure of Cole himself, who directs our eyes toward the falls with the recorder he holds in his right hand. As our eyes follow Cole's instrument into the soft, hazy distance of the clove, the gentle strains of Durand's brush seem far removed from the harsh sounds of the camp meeting. This is not because the camp meeting was no longer

an important feature of the American religious landscape in 1849; it is because the respectable sublimity evoked by mid-century Hudson River landscapes has muted any traces of it. Durand's invocation of the Horatian discourse of *ut pictura poesis* domesticates the turgid waters of Cole's earlier painting.[69] From our elevated perspective, we look out on the Catskills with Cole and Bryant and, at this optical distance, free from any disruptions, come to a poetic comprehension of the American landscape.

When considered alongside Durand's posthumous tribute, the painting Cole made for Wadsworth in 1826 reverberates all the more emphatically with the sounds of the revival. But as we have seen, even though the camp meeting topped Cole's list of ideas for paintings in 1827, it was never a subject he was prepared to embrace in all of its auditory excess. My appeal to nineteenth-century revivalism as a context for Cole's early landscape is not meant to add up to an accounting for *Kaaterskill Falls*. Cole's painting stages a fraught relationship between the viewer's sensory response to his art and the historical conditions from which that art emerged, and I have tried to explicate that relationship, not to resolve it. I conclude, therefore, on a note of ambivalence, with the contention that the sound of Cole's *Kaaterskill Falls* both is and is not the sound of the camp meeting; in this painting, we find historical context *and* we lose it. The novelty of *Kaaterskill Falls*, its ingenuity and creative work, lies in its transformation of popular religious experience in the 1820s into aesthetic experience. Cole recuperates the revival for the project of landscape painting, transposing the shouts of the preacher into the voice of the landscape, but at the same time, he keeps the revival before us by making its sensory excess part of our experience of the picture. To what extent does such an art belong to a history from which it would unburden itself? As we survey the work of Thomas Cole from art history's alpine perch, this is the question *Kaaterskill Falls* leaves ringing in our ears.

Dancing for the Kinetograph

The Lakota Ghost Dance and the Silence of Early Cinema

O N APRIL 14, 1894, Thomas Edison's kinetoscope made its commercial debut at a storefront on Broadway in midtown Manhattan. An illustration of this space published in the following year shows ten of Edison's machines arranged in the center of the room and overseen by two attendants (Figure 5.1). A customer would pay twenty-five cents to see five films or fifty cents for all ten and then peer into a kinetoscope's peephole and watch for about twenty seconds as fifty feet of film sped by on a continuous spool. For the earliest viewers of motion pictures, this must have been a thrilling twenty seconds, and in the illustration, we find a sense of visual excitement everywhere: in the woman at left who leans over to read a title on one of the machines prior to viewing, in the watchful presence of the two incandescent dragon lamps on the walls, and in the play of glances among the patrons, as a fashionable woman on the right exits the parlor while turning to catch the eye of the dapper man on the far left. Next to the departing woman a bust of the wizard himself looks out at us and, our own visual curiosity having been aroused by this scene, invites us to wed that desire to his magical box. The visual entertainments awaiting the viewer during the parlor's first months ranged from the risqué to the ridiculous: the strongman Eugen Sandow in a loincloth flexing biceps and buttocks, the billowing skirts of the Spanish dancer Carmencita, the anatomy-defying movements of the female contortionist Ena Bertoldi, or the antics of trained bears and boxing cats. Such vaudeville and circus acts proved highly popular, and by the end of the year, they were being seen in kinetoscope parlors across the country, from Boston to San Francisco.[1]

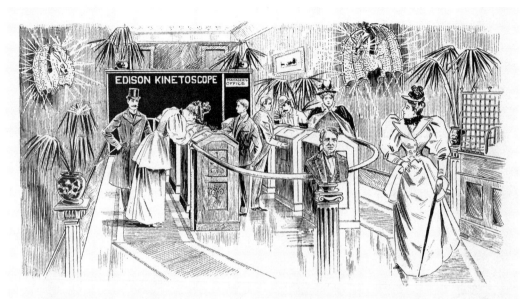

Interior of Kinetoscope parlor at 1155 Broadway, near 28th Street, New York, operated by the Kinetoscope Co., controlling the United States and Canada. The first Kinetoscope exhibition started in the world; opened April 14, 1894.

FIGURE 5.1. "Interior of Kinetoscope Parlor at 1155 Broadway," from W. K. L. and Antonia Dickson, *History of the Kinetograph, Kinetoscope, and Kineto-Phonograph* (1895). Library of Congress, Rare Books and Special Collections.

New subjects were needed to satisfy demand, and throughout 1894 and early 1895, William Kennedy-Laurie Dickson, the head of the Edison Manufacturing Company's kinetograph department, was occupied with the task of filming them at Edison's Black Maria studio in West Orange, New Jersey. It was fortunate for Dickson, then, that a month after the opening of the parlor at 1155 Broadway, Buffalo Bill's Wild West and Congress of Rough Riders of the World set up camp in Ambrose Park in Brooklyn, where people packed the grandstands to see William F. Cody's multiethnic band of performers engage in feats of horsemanship and sharpshooting, act out historical sketches of the Wild West, and display the dances, warfare, and hunting customs of American Indians. Dickson produced a total of eight films based on the Wild West show in 1894, four of them on a single day, September 24, when Cody and a group of sixteen Oglala and Brule Lakota men and boys took the train to West Orange and put on an exhibition of highlights from the show. Edison and his wife Stella looked on as Dickson directed and his assistant, William Heise, manned the kinetograph, the camera that shot the film for the kinetoscope. The event was widely covered in the press the next day in articles

such as "Dancing for the Kinetograph" (*The New York Sun*), which named all the par-
ticipants and identified the four subjects that were filmed: Buffalo Bill in a display
of rapid firing, an "Indian War Council" that involved much handshaking and the
passing around of the peace pipe, the buffalo dance, and the Omaha war dance.[2]

The fact that two of the four films made that day were dances from the Wild
West show suggests that, three hundred years after Theodor de Bry published the
first volumes of his *America,* the subject of Native American dance remained a
powerful one for audiences eager to satisfy their curiosity about strange peoples
and customs through lifelike images. The significance of this subject for the new
medium of film is declared on the title page of the first history of the kinetograph
and kinetoscope, written by Dickson and his sister, Antonia, and published in
1895 to celebrate and publicize the new invention (Plate 15). Twenty-two some-
what embellished sketches of early Edison films surround the title, with pride of
place given to two large views at top and bottom. One of them is a resonant
subject we have already encountered, Niagara Falls (waterfalls, including an 1897
film of Kaaterskill Falls, were particularly popular subjects in Edison catalogs of
the 1890s). The other is a group of dancing Indians brandishing shields, war clubs,
and tomahawks.[3]

The film of the buffalo dance lasts sixteen seconds and features five performers
who dance before the black curtains that served as the backdrop for all the films
made in the Black Maria. Two drummers, Strong Talker and Pine, sit cross-legged
on the floor and maintain the rhythm that guides the movements of the three
chiefs—Last Horse, Parts His Hair, and Hair Coat—who circle the stage coun-
terclockwise. While Last Horse, who wears a buffalo tail, seems to imitate the
movements of the animal, the tomahawk he carries and the confrontational over-
tures of the dancers also lend warlike overtones to the dance. According to a
reporter for the *New York Press,* the dancers "had been told that the strange thing
pointed at them would show them to the world until after the sun had slept his
last sleep," and in both the buffalo dance and the Omaha war dance, they seem
to vie for the camera's attention.[4] At one point toward the end of the film, Hair
Coat looks pointedly into the camera and defiantly holds up what appears to be a
knife or short pipe stem before the viewer (Figure 5.2).

The war dance, which includes a partially obscured placard in the lower right
corner that reads "Buffalo Bill's Wild West S[how]," is a slightly longer film, at
eighteen seconds, and features a larger cast of eleven dancers, including two boys
who stand front and center at the beginning of the film.[5] Although the dancers'
feet do not yet move, their bodies sway slightly, while at the upper left corner,

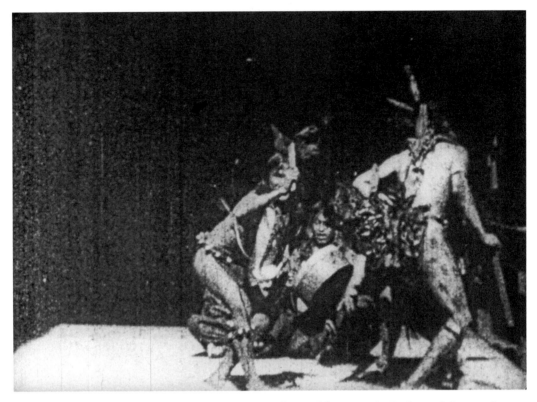

FIGURE 5.2. Still from *Buffalo Dance* (1894), directed by W. K. L. Dickson. Library of Congress Motion Picture, Broadcasting, and Recorded Sound Division.

a mallet belonging to a drummer whose body is cut off by the frame begins to beat a hide drum, first with two slow beats and then more rapidly. Staring directly at the spectator, the boy on the left then opens his mouth wide in a silent shout, and the dancing begins as the man on the right in a full headdress whirls into the center of the picture (Figure 5.3). The dancers are thus set into motion through instrumental and verbal cues, and the drum continues to beat throughout the film, its rhythm echoed by stomping feet. The light levels in the war dance are significantly lower than in the buffalo dance, and the action is cramped due to the small stage necessary for fitting all the dancers within the lens of the kinetograph, but the brightness of the dancers' bone breastplates, the white feathers on their heads, and the white beadwork on their moccasins help us to track them as they circle in clockwise fashion. The action of both films, which is directly addressed to the spectator, exemplifies the exhibitionist approach of early filmmaking that the film historian Tom Gunning has dubbed the "cinema of attraction."[6] Rather than seeking to absorb the spectator in cinematic narrative, the cinema of attraction

FIGURE 5.3. Still from *Sioux Ghost Dance* (1894), directed by W. K. L. Dickson. Library of Congress Motion Picture, Broadcasting, and Recorded Sound Division.

boldly advertises its own visibility in a manner that is self-consciously theatrical and, in the case of these warlike dances, even confrontational.

But what sort of confrontation was it that took place between a group of Lakota dancers and the camera lens on a September morning in 1894 in West Orange, New Jersey? One reporter who was present at the filming seemed quite sure of the answer to that question. The next morning a headline in the *New York Herald* announced:

RED MEN AGAIN CONQUERED.
Easily Subdued Before the Rapid Fire of the Kinetoscope at Edison's Laboratory.
MORE EFFECTIVE THAN GUNPOWDER.

The kinetoscope was a new kind of war machine, one that demonstrated "to the red men the power and supremacy of the white man," for at the Black Maria, "savagery and the most advanced science stood face to face, and there was an

absolute triumph for one without the spilling of a single drop of blood."[7] Like Aby
Warburg's prideful "Uncle Sam in a stovepipe hat," who strolls down a San Fran-
cisco street beneath the telegraph wire, knowing that "in this copper serpent of
Edison's he has wrested lightning from nature" (see Figure 3.12 in chapter 3),[8]
the *Herald* reporter displays a supreme confidence in Edison's technological mas-
tery and its power to subdue savagery in the face of civilization. The savage, in
contrast, is unable to comprehend the white man's harnessing of nature, a point
the *Herald* article makes through the figure of Holy Bear, one of the Lakota visi-
tors to Edison's studio. Curious about the source of the kinetoscope's magic,
Holy Bear receives a terrible shock when he picks up a large cable that carries
power to the studio: "Howls and shrieks rent the air as the luckless Indian's hands
were firmly glued to the cable."[9] The kinetograph accomplishes painlessly what
Holy Bear's mishap achieves with howls and shrieks. Subdued before the rapid
fire of the camera's stop-motion action, the Lakota dancers become captives to a
box in which white men and women can watch a primitive dance and their own
technological superiority unfold before their eyes.

 Ralph and Natasha Friar, in a frequently cited passage, argue that the dances
filmed at the Black Maria mark the beginnings of "the filmic cultural genocide of
the Native American," a process by which Edison's commercialization of Wild
West–show stereotypes leads to the persistence of the "Hollywood Indian" in
twentieth-century cinema.[10] It is an argument that grants but reverses the terms
of the confrontation staged in the *Herald* article. In this revisionist interpretation,
a confrontation does indeed occur in Edison's studio, but it is one in which the
forces of cultural exploitation, not civilization, triumph over the Indian. One
must be careful, however, to distinguish between the cultural uses to which film
is put and the inherent characteristics of the technology itself. Certainly, from an
early period, the medium is put to work within American cinema in a way that
shapes and perpetuates pernicious myths; but as recent Native American film-
making clearly demonstrates, there is nothing about film as a medium that re-
quires this to be the case. And in 1894, the year of its commercial debut, film
was hardly ready to conquer the world. Edison himself was not at all clear about
the meaning of his new invention and said of the kinetoscope: "I do not see where
there is anything to be made out of it. I have been largely influenced by sentiment
in the prosecution of this design."[11] Most importantly, as we will see, Edison was
acutely aware of what the kinetoscope could *not* capture: synchronized sound.
My concern in this chapter will be to explore the significance of this limitation.
What kinds of meanings, and indeed what potentials, inhabit this silence?

THE GHOST DANCE

From the moment of the making of the films, one event above all echoes behind their silence: Wounded Knee. When the reporter from the *Herald* wrote about the Wild West–show Indians facing off in battle with the kinetograph, he noted that it "was indeed a memorable engagement, no less so than the battle of Wounded Knee, still fresh in the minds of the warriors."[12] It was also still fresh in the minds of an American public that, less than four years earlier, had been the target of intensive and sensationalist press coverage about the troubles developing at Pine Ridge, the Ghost Dancing on the reservation and the government's efforts to contain it, and the resulting "battle" at Wounded Knee on December 29, 1890.[13] Aware of the resonance of the films with these events, the Edison Company's production team decided to release at least one of them as *Sioux Ghost Dance,* a title that became a staple of kinetoscope catalogs through the 1890s. It remains unclear, however, which of the two films circulated under this name. In their *History of the Kinetograph,* the Dicksons label the film of the buffalo dance as *Sioux Indian Ghost Dance,* but it is also entirely possible that both were sold under that single title in different film catalogs.[14] In any case, it is likely that, in 1894, white audiences would have been inclined to associate the dances in both films with the widely publicized events surrounding Wounded Knee. It is important, therefore, to consider what those events could have meant for the viewers who paid their nickel to watch Edison's dancing Indians.

The Ghost Dance was the central ritual of the Ghost Dance religion, whose messiah, the Paiute prophet Wovoka, preached that by dancing, being always good, and not fighting, Indians would bring about a time of reunification with their ancestors on a regenerated earth, when all would live in happiness, free from death and disease.[15] Combining elements of traditional Native American religions with Christianity, the Ghost Dance spread rapidly throughout the American west during 1889–90. A painting on deerskin from 1891 by Yellow Nose, a Ute captive among the Cheyenne, shows Cheyenne and Arapaho men and women performing the dance (Figure 5.4).[16] Participants would clasp hands and shuffle slowly in a circle in clockwise fashion, looking up all the time and singing Ghost Dance songs, until individuals began falling into trances in which they experienced visions of the messiah and their dead relatives. In Yellow Nose's painting, a medicine man on the far right helps a dancer to achieve a trance, while already entranced figures lie inside the circle with their arms outstretched. As the Ghost Dance was adopted by different tribal groups, each integrated the dance with its

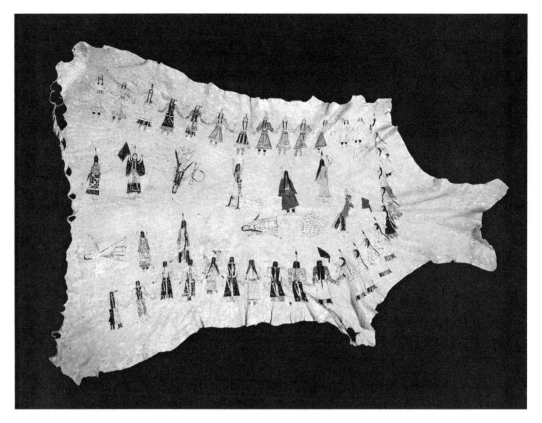

FIGURE 5.4. Yellow Nose, painting on deerskin of Ghost Dance, 1891. Department of Anthropology, Smithsonian Institution, E165127–0.

own religious traditions and introduced variations in its performance. For the Lakota, this included the wearing of Ghost Shirts that rendered dancers invulnerable and the placement of a pole or tree at the center of the circle, symbolic of a people now dormant but about to bloom.

Ghost Dancing began at Pine Ridge in the summer of 1890 and soon spread to the Rosebud, Standing Rock, and Cheyenne River reservations. For the Lakota, this was a difficult time. Their traditional hunting culture had rapidly come to an end due to the loss of the buffalo, and a government policy of assimilation had confined them to reservations where they were expected to become self-supporting through farming. At the same time, the vast reduction of reservation lands and the introduction of the allotment system with the Dawes Act put further pressure on Lakota society and turned their condition into one of dependency on the government. By 1890, failed crops and government reduction of rations had turned dependency into famine. All of this context is essential for

understanding the condition of the Lakota prior to Wounded Knee, although it is equally important to recognize that the Ghost Dance was more than a surface-level response to these external stresses. On the contrary, it was an authentic expression of Lakota religion and, indeed, an alternative to the ideology of competition and progress being imposed on them. The Lakota were seeking to take control of their own destiny, peacefully, through ritual dancing and prayer that would cause the dead to return, the white man to disappear, and the buffalo to be released again from the earth.[17]

The Ghost Dance was entirely misunderstood by the U.S. government. Indian agents and military officials could see it only as a symptom of social and political unrest and, despite its nonviolence, as preparation for armed uprising.[18] In November 1890, U.S. Army troops arrived at Pine Ridge and Rosebud to suppress the dancing and prevent an "outbreak" on the reservations. At this point, several hundred Ghost Dancers fled to a stronghold in the Badlands, and tensions grew worse when the influential medicine man Sitting Bull, whose camp had become the center of the Ghost Dance religion on Standing Rock Reservation, was shot and killed by the Indian police during an attempt to arrest him. By late December, however, many of the Ghost Dancers had returned from the Badlands to Pine Ridge Agency to negotiate peace. This was also the destination of a group from the Cheyenne River reservation under Chief Big Foot, when it was intercepted on December 28 by the Seventh Cavalry and escorted to Wounded Knee Creek, where the Indians set up camp. When they awoke the next morning, they found themselves surrounded by about 500 soldiers aiming rapid-fire Hotchkiss cannons directly at them. As the soldiers conducted a search for arms, a shot was discharged (probably inadvertently), to which the army responded with indiscriminate firing on the camp, killing between 150 and 250 Lakota men, women, and children. The dancers in Dickson's films would have been at Pine Ridge and Rosebud Reservations that winter and were painfully familiar with these events. One of them, in fact, had been present at the massacre itself: Johnny Burke No Neck, an orphan of Wounded Knee who, according to the program of the Wild West show, was "found on the Battle Field" (Figure 5.5).[19] In the film of the war dance, he is the young boy in front who looks into the camera and opens his mouth as the dance begins.

Any viewer who has a basic familiarity with the Ghost Dance can easily see that this is not the dance we witness in either of the Edison films. The dancers do not hold hands; one of them, Last Horse, carries a tomahawk in both films (no weapons were allowed to be carried during the Ghost Dance); none of the dancers

"JOHNNY BURKE NO NECK."
Found on the Battle Field of Wounded
Knee after the annihilation of
Big Foot's Band.

FIGURE 5.5. Johnny Burke No Neck, from *Buffalo Bill's Wild West and Congress of Rough Riders of the World: Historical Sketches & Programme* (1894). Metcalf Collection, Brown University Libraries.

wear Ghost Shirts; the motion in both dances is quick rather than a slow shuffle; and while the Ghost Dance had no instrumental accompaniment, the dancers in Dickson's films follow the beat of a drum.[20] The typical viewer in the kinetoscope parlor of the 1890s, however, would not have had detailed knowledge of the Ghost Dance, but only the title on the machine and vague notions of the warlike nature of the dance that had circulated in the media. Edison film catalogs describe it as "a dance by genuine Sioux Indians in war paint and costume," language that echoes the descriptions that circulated in the press coverage immediately after

the filming.[21] According to the account in the *Newark Daily Advertiser,* for example, the Indians at the Black Maria performed a "war dance, in which the entire band, in their warpaint and feathers, to the music of the native drums, danced a howling war dance, brandishing their tomahawks and scalping knives." The *New York Press* noted that, although the buffalo dance gave the performers more space than the war dance, "if anything the antics were more furious and wild. Pity the camera could not reproduce those yelps!"[22]

Such descriptions, in turn, echo the way the Ghost Dance had typically been portrayed by the reporters who had followed government troops to Pine Ridge and turned the conflict on the reservation into an international media event. On November 22, 1890, a *New York Times* article reported on "insanely religious" Ghost Dances in which Indians danced in war paint "with their guns strapped to their backs."[23] A visual parallel to such reports can be found in a centerfold wood engraving of "The Ghost Dance of the Sioux Indians in North America" from the January 3, 1891, issue of the *Illustrated London News,* in which the artist, Amédée Forestier, focuses our attention on a dancer in the central foreground who raises in his right hand a rather large and menacing knife, while another dancer to the far left thrusts a rifle above his head (Figure 5.6). Forestier's bellicose Ghost Dance, however, has little to do with the actual ceremony. As Short Bull, one of the leaders of the dance at Pine Ridge, asked: "How could we have held weapons? For thus we danced, in a circle, hand in hand, each man's fingers linked in those of his neighbor. Who would have thought that dancing could make such trouble? For the message that I brought was peace."[24]

Nevertheless, in popular culture, the Ghost Dance remained a symbol of the untamed and hostile savage, an image that was in part sustained by Buffalo Bill's Wild West show. During its 1891–92 tour of Britain, the show's cast included twenty-three Lakota Ghost Dancers who had been incarcerated by the U.S. Army at Fort Sheridan, Illinois, but then released into the custody of Cody with the expectation that a stint in his show would keep them off the reservation and lead to their improvement by showing them "the extent, power and numbers of the white race."[25] This group included Short Bull and Kicking Bear, both of them prominent Ghost Dancers who had traveled to Nevada to meet the messiah and later led the flight into the South Dakota Badlands after the arrival of government troops. The presence of these infamous "hostiles" was a draw for audiences eager to see actual participants in the events of the previous year that had been sensationalized in the press. The Wild West show also played up Cody's own role as a tamer of the savage. As he displayed in Dickson's film *Indian War Council,* Cody

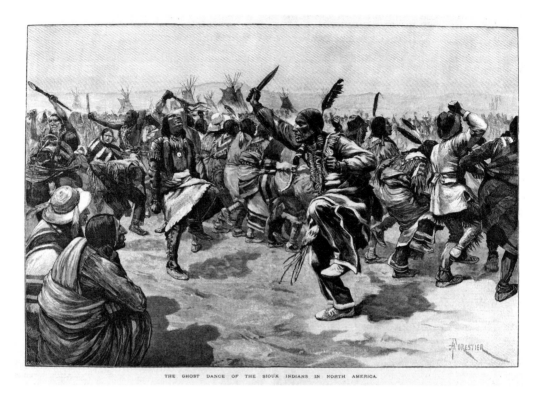

THE GHOST DANCE OF THE SIOUX INDIANS IN NORTH AMERICA.

FIGURE 5.6. Richard Taylor after Amédée Forestier, *The Ghost Dance of the Sioux Indians in North America,* from *Illustrated London News,* January 3, 1891. Copyright Illustrated London News Ltd. / Mary Evans.

cultivated the role of a peacemaker who could bring the Indian around to reason, and the events of 1890 became a focal point for demonstrating his skills as intermediary between the hostile Indians and the white race. Not only was he doing a service to the government and to the Lakota by improving the prisoners from Fort Sheridan, but he had himself attempted to intercede in the growing tensions on the South Dakota reservations in November 1890, when he traveled to Pine Ridge in a thwarted attempt to meet and come to terms with Sitting Bull, a former member of the Wild West show. He remained at Pine Ridge through early 1891, and a publicity poster for his show from about three years later plays up his peacemaking role after Wounded Knee, as Cody, astride his white horse, leads a military party into an Indian camp to talk down frenzied Ghost Dancers who kick up dust as they prepare for the warpath (Plate 16).[26] Here is the Moses of the Wild West who will bring the wild circular dance of the heathens to an end.

It would seem that Edison and Cody, by tapping into the widespread perception of the hostility of the Ghost Dance and related anxieties about indigenous resistance to U.S. sovereignty, knew how to give their audiences what they expected. But here lies the problem, because what audiences expected is not entirely clear in the case of the Ghost Dance. While it is true that alarming headlines tended to dominate press coverage of events surrounding Wounded Knee, at other times, yellow journalism took a back seat to more measured portrayals of the Ghost Dance as an understandable expression of discontent with difficult circumstances and unjust treatment.[27] In an article in *Harper's Weekly* from December 6, 1890, Lieutenant Marion P. Maus clearly shows sympathy with the dancers:

> For years [the Indian] has been confined to military reservations, and has chafed under the restraint thus put upon him. Little wonder he looks for a change, and longs for his once free life, and gladly grasps the new belief in the red Saviour, which is rapidly spreading to every Western tribe, and which the great chief Red Cloud "says will spread over all the earth."[28]

Though Maus's article on the "New Indian Messiah" considers the dance a perversion of the Christianity taught to the Indians by missionaries, it differs from many—though by no means all—contemporary reports by attempting to understand the dance as being motivated by sincere religious belief rather than desire for armed conflict. Maus had witnessed the ceremony when he visited a Pine Ridge dance camp in the company of the artist Frederic Remington, whose illustration of the Ghost Dance appears in the same issue of *Harper's* (Figure 5.7). Like Maus, Remington avoids sensationalizing his subject. Although his composition clearly served as the source for the later engraving in the *Illustrated London News,* Remington, unlike Forestier, does not portray the Ghost Dance as a ritual of militaristic frenzy. His more subdued approach is perhaps better compared to the deerskin painting by Yellow Nose, insofar as both artists are primarily interested in costume and in suggesting the slow and regular movement of dancers, none of whom hold weapons.

Was the Ghost Dance hostile or peaceful? Should it incite fear or sympathy among whites? Was Wounded Knee a triumph for the U.S. Army or a blunder? The answers to these questions were not clear or consistent in the popular press, and this ambivalence found its way into the Wild West show as well. Cody himself referred to Wounded Knee as "an unlooked-for accident." Programs for the show gave sensational histories of the Wild West that included the Ghost Dance as a

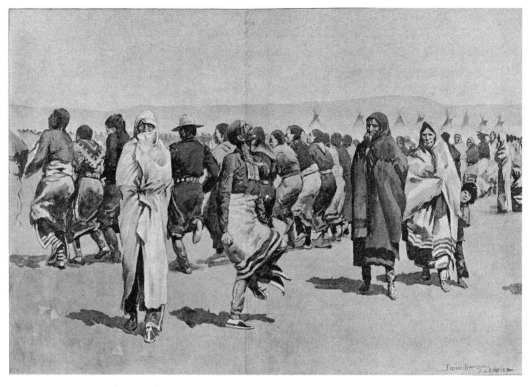

FIGURE 5.7. After Frederic Remington, *The Ghost Dance by the Ogallala Sioux at Pine Ridge Agency, Dakota,* from *Harper's Weekly,* December 6, 1890. Courtesy of HarpWeek.

significant element, yet they did not pronounce on its meaning. Audiences were instead invited to make up their own minds. The 1894 program, for example, describes the Ghost Dance as "a warlike demonstration," but only after saying it had become so due to "wrongs suffered at the hands of the whites."[29] Other similar remarks and an illustration of the Lakota dead scattered across the frozen field at Wounded Knee can hardly be taken as an unequivocal endorsement of government actions (Figure 5.8). Much of the material about the Ghost Dance that makes it into the Wild West show programs after Wounded Knee (material ranging from an account of the dance's origin and development to the reproduction of Ghost Dance songs in staff notation) was taken from the magazine *The Illustrated American.* At the end of this material in the 1893 program, the manager of the Wild West show, John Burke, provides an interesting coda: "The compiler gives it without comment, as the whole matter has yet to be investigated to get at bottom facts."[30] Could there be clearer evidence of the unsettled meaning of this event? During the show itself, moreover, the actual Ghost Dance was never performed,

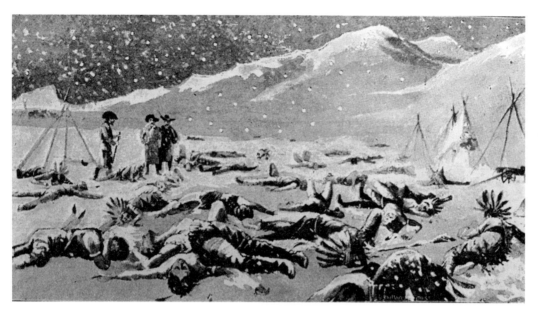

FIGURE 5.8. *After the Battle.—Field of Wounded Knee.—Campaign 1890–91*, from *Buffalo Bill's Wild West and Congress of Rough Riders of the World: Historical Sketches & Programme* (1894). Metcalf Collection, Brown University Libraries.

even if an uninformed public tended to conflate it with the dances that were part of the show. It is also clear that Wounded Knee was never reenacted, even though Cody did stage famous battles in the West like the Battle of the Little Big-horn.[31] The choice not to reenact Wounded Knee speaks to how raw the events were for the Lakota performers, to Cody's own awareness of this fact, and to the fact that many people in his audiences may not have approved of the government's actions.

Despite the absence of the Ghost Dance and Wounded Knee from the arena, Buffalo Bill's Wild West did help to sustain the question of their meaning at a time when the government was doing its best to erase them from history. From the viewpoint of proponents of the government's Indian policy, which called for the suppression of the Ghost Dance and sought complete assimilation of Indians to white society through allotment and education, Wild West shows like Cody's jeopardized reform by perpetuating a "savage" past. There was reason for them to be concerned. The Lakota participants in Buffalo Bill's Wild West were in important respects able to maintain an unassimilated existence where the memory of the Ghost Dance was kept alive among performers and audiences, however undecided its meaning may have been.[32]

THE SILENCE OF THE KINETOSCOPE

Any effort to contextualize the two Edison films that probably both circulated under the title *Sioux Ghost Dance* must take into account the volatility of the dance's meaning in 1894, as well as the volatility of the new medium of film. On the one hand, the capturing of Lakota dancers in the sights of the kinetograph was a way of deciding the dance's meaning. In both films, the Ghost Dance (or rather, what viewers took to be the Ghost Dance) manifests a primitive hostility over which the white race must triumph. Just as the battles enacted in the Wild West show would without fail, despite shows of prowess by Indians, end in the defeat of the savage, who must give way before the progress of civilization, so the recording of the Ghost Dance on Edison's new cinematic invention served as a symbolic rehearsal of the social and technological superiority of white culture. As the reporter from the *Herald* made clear, here is a venue in which Wounded Knee was indeed reenacted, but "without the spilling of a single drop of blood."

On the other hand, the interest of these filmed performances lies precisely in the way they exceed the meaning the *Herald* reporter attributed to them. The viewing conditions of the kinetoscope stand in contrast to those of the Wild West show, where spectators in the grandstands, viewing in real time and from a distance, could never have felt as directly confronted by the dancers as does the viewer of the film. As we observe the facial expressions of the dancers and the details of their costume, they challenge us to decipher the meaning of their performance, a meaning made all the more unstable by the fact that the films are not framed by the narratives of civilization and racial progress developed in the Wild West show and announced in its programs. This detachment of the dance from the original conditions of its viewing is enhanced by the mobility of the films, by the fact that they traveled from city to city in multiple copies and could be watched repeatedly in kinetoscope parlors. Philippe-Alain Michaud, in a discussion of these uniquely cinematic effects, argues that the film of the war dance enacts the cinematic operation itself. Beginning in stasis and then breaking into movement, the dancers perform for the camera the coming-into-being of living bodies. And these cinematic bodies do this not for the sake of W. K. L. Dickson, Thomas Edison, newspaper reporters, or the other observers present in the Black Maria studio on September 24, 1894; they dance for their own sakes.[33] The bare set and black background enhance this self-sufficiency of the dancers; it is as if they have materialized before our eyes from nowhere. Dickson noted that the "horribly impressive" black curtains in the studio gave his films a "supernatural effect."[34]

This optical magic of cinema, its capacity to reproduce the experience of human vision liberated from its original spatial and temporal constraints, is crucial to any account of the powerful hold this medium can have over viewers, particularly those encountering it for the first time. There is, however, one important element of the Wild West show performances filmed at the Black Maria that viewers are not able to experience. We see the dancers move; we see Johnny Burke No Neck's shout that begins the motion of the dance, we see drums being beaten as dancers strike their feet against the floor of the studio; we see all of this movement that conjures sound and auditory rhythms, but we do not hear it. In the present digital age, we are not even forced to listen to the whirring and clacking of the kineto-scope. But even with that mechanical noise in their ears, along with the back-ground sounds of the nickel-in-the-slot phonographs that were typically found in kinetoscope parlors, the earliest viewers of *Sioux Ghost Dance* would have ex-perienced a disconnection of the optical from the auditory, as they saw bodies in motion but did not hear them.[35] In short, the sound of *Sioux Ghost Dance* was precisely what eluded the magic of the kinetscope in 1894.

Edison himself felt this to be a problem. From the moment he began working on the kinetoscope in 1888 after encountering Eadweard Muybridge's Zoöpraxi-scope, a device that projected moving images from spinning glass disks, Edison's aim was to combine moving images with his earlier invention, the phonograph.[36] He had still not reached a solution by the time the kinetoscope was finally intro-duced in 1894, but as reports in the popular press reminded readers time and again, synchrony between dramatic action and sound remained Edison's objec-tive. In *History of the Kinetograph,* the Dicksons write as if this goal had been achieved:

> The inconceivable swiftness of the photographic successions and the exquisite syn-chronism of the phonographic attachment have removed the last trace of automatic action, and the illusion is complete. . . . The rich tones of a tenor or soprano are heard, set in their appropriate dramatic action; the blacksmith is seen swinging his ponderous hammer exactly as in life, and the clang of the anvil keeps pace with his symmetrical movements; along with the rhythmical measures of the dancer go her soft-sounding footfalls.[37]

The Dicksons are given to overstatement, and there is certainly a degree of wish-ful thinking here, but W. K. L. Dickson does seem to have had moderate success in synchronizing sound within the laboratory conditions of the Black Maria. An artifact of these experiments is a film made not long after the visit from Cody's

Wild West show. As Heise operated the kinetograph, two studio assistants danced while Dickson played his violin in front of the recording horn of the Edison phonograph (Figure 5.9).[38] With the violin melody preserved on a wax cylinder, synchronization of image and sound could be achieved by maintaining exact correspondence during playback between two different devices: the phonograph and kinetoscope. The challenge, however, was to reproduce this synchrony within a commercial setting. In the spring of 1895, the Edison Company introduced a device that, it was claimed, could achieve this: the kinetophone, a kinetoscope with a phonograph inside that played recorded sounds one listened to through eartubes (Figure 5.10). According to an 1895 film catalog, while the kinetoscope

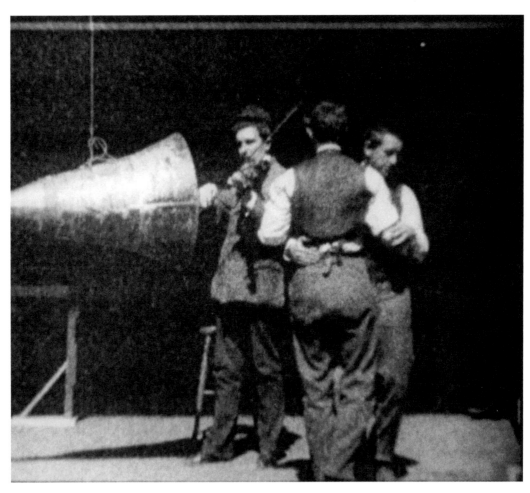

FIGURE 5.9. Still from *The Dickson Experimental Sound Film* (1894), directed by W. K. L. Dickson. Library of Congress Motion Picture, Broadcasting, and Recorded Sound Division.

FIGURE 5.10. The Kinetophone, 1895. Thomas Edison National Historical Park.

showed figures "acting in pantomime only," the kinetophone offered "both the sounds and motions of the subject in a life-like manner."[39] In reality, however, the kinetophone included only nonsynchronized accompaniment to the film, in the form of dance or band records, and was not a commercial success: only forty-five machines were made and sold, compared to over one thousand kinetoscopes. There is no evidence that a phonograph recording was ever made to accompany *Sioux Ghost Dance* on the kinetophone.[40]

At stake in this attempt to fuse sound and image was not just the merging of two different reproductive technologies, but as Gunning has shown, the reconstruction of a human sensorium that those very technologies had helped to deconstruct.[41] What the public found so uncanny about the phonograph was the way it divorced the human voice from the body, a phenomenon that is perhaps most memorably acknowledged in François Barraud's painting *His Master's Voice,* which was registered by Emile Berliner in 1900 as the trademark for his gramophone company and later became the famous label for RCA Victor (Figure 5.11).[42] The dog "Nipper" recognizes the voice coming from the machine but stares in

FIGURE 5.11. Advertisement for the Berliner gramophone, from *The Canadian Magazine,* October 1900. Courtesy of HathiTrust.

confusion at the object that sits before him in the place of his master's absent body. This disembodiment of sound by the phonograph finds its parallel in the disembodiment of vision in the nineteenth century that has been traced by Jonathan Crary, a process by which vision was abstracted from the individual observer, rationalized, and instrumentalized.[43] The various optical and auditory technologies of the nineteenth century contributed to a new understanding of the individual as a bundle of discrete and disconnected perceptual faculties, each of them ready to lend its own particular expertise toward a subjective construction of the world. Under this perceptual model, reality was not some stable world to be found "out there," but rather was constantly being produced by senses that were themselves something like machines, in much the same way that the gramophone *is* the voice of Nipper's master. Edison was an important contributor to this process of sensory fragmentation: in his own words, the development of the motion picture was the result of his efforts "to devise an instrument which should do for the eye what the phonograph does for the ear."[44]

There is a triumphant tone to Edison's statement, but that note of triumph is bound up with a certain anxiety that accompanies this breaking-up of the sensorium, an anxiety seen in Nipper's puzzled stare into the gramophone's horn. For, one desires, of course, to repair this fragmentation, to put the body and its perceptual faculties back together. Nobody desired this more adamantly than Edison himself. After expressing his intention to do for the eye what the phonograph does for the ear, Edison continues: "By a combination of the two all motion and sound could be recorded and reproduced simultaneously." Film, in other words, implied the phonograph, and vice versa: each supplements the other; each promises to provide what the other has lost; all toward the dream of reconstructing the fullness of sensory experience. Edison liked to express this dream through the total art form of the opera. He imagined that, in the coming years, new technological advances would allow for the full scale reproduction of an opera "at the Metropolitan Opera House at New York without any material change from the original, and with artists and musicians long since dead."[45] The same dream finds an expression of another kind in the photograph of the man leaning over the kinetophone. Between the fingers of his right hand, which make contact with both the cabinet and the eartubes, and the fingers of his left hand, which reach from the other side and hold the eyepiece as he peers in, he holds Edison's device in a sensory embrace that seeks to draw together all these forms of perception—hearing, sight, even touch—into a single experience. The kinetoscope, however, could not offer this total experience, and thus, when viewers looked into its

peephole in 1894 and found moving images of singers, blacksmiths, and dancers, but heard no rich voices, clanging hammers, or soft-sounding footfalls, they experienced the loss of something else.[46]

How, then, do we account for the loss registered in the silence of *Sioux Ghost Dance*? What are we permitted to read into it? We could, perhaps, explain it as a symptom of a modern, technologized, and fragmented self, a symptom for which treatments were quickly found. Edison's short-lived kinetoscope was, after all, just one brief phase in the commercial history of film, and new forms of projection accompanied by nonsynchronous and, eventually, synchronous sound soon helped viewers to forget the kinetoscope's evident deficiencies. As Crary argues, Edison is less important as an inventor of individual devices, such as the kinetoscope, in which he saw no intrinsic significance, than he is as a manager of consumption and circulation who "saw the marketplace in terms of how images, sounds, energy, or information could be reshaped into measurable and distributable commodities."[47] Edison's images and sounds, in other words, were soon shepherded into their appropriate places within the emerging film industry; meaning was harnessed to the market. But such an accounting for the silence of *Sioux Ghost Dance* still begs the question of whether the uncertainties surrounding the meaning and purpose of the kinetoscope at the moment of its commercial debut opened possibilities that are too easily lost in future-oriented narratives that absorb this unstable moment into a coherent history of American cinema. Can we enter into the silence of *Sioux Ghost Dance* without filling it prematurely with the authoritative voice of the historian that declares it to signify, for example, the birth of the "Hollywood Indian"? The Ghost Dance itself offers one route into this question. Although Dickson's films of Lakota dancers were sold to kinetoscope parlors as the last war cries of a defeated and vanishing race, their very silence speaks less to endings than to potential meanings that the developers and marketers of the new technology did not grasp and could hardly have contained.

JAMES MOONEY AND THE
SOUND OF THE GHOST DANCE

In order to gesture toward the kind of encounter with the Ghost Dance that was made available, if not realized, in the new reproductive technologies of the late nineteenth century, it is important to consider the work of James Mooney, author of what remains the definitive ethnological study of the Ghost Dance: *The Ghost-Dance Religion and the Sioux Outbreak of 1890,* a work of over eleven hundred pages

that was published in 1896 in the Fourteenth Annual Report of the Smithsonian's Bureau of Ethnology. Mooney began his field research on the Ghost Dance in December 1890 after receiving permission from his employers at the Smithsonian to investigate the religious movement that was at that time receiving extensive but mostly superficial attention in the press, as the papers reported on wild Indians in the West following the doctrine of an obscure prophet and preparing for armed uprising. Leaving Washington on his first trip only days before the massacre at Wounded Knee, Mooney spent a total of twenty-two months in the field gathering information about the religion and its central ritual, interviewing countless individuals, including the prophet Wovoka himself, taking many photographs of the dance, recording its songs, and even participating in the Ghost Dance. Mooney's ethnology, like Jean de Léry's, is fueled by a desire to recover the sounds of the dance he had experienced so intimately. His efforts to body forth those sounds in his text through the aid of the phonograph may help us to reflect more deeply on the silence of Dickson's films.

In July and August 1894, as customers at 1155 Broadway marveled at the kinetoscope and audiences in Brooklyn thrilled at the performances of Buffalo Bill and his Rough Riders of the World, Mooney was completing his manuscript, a task that involved the recording and arrangement of the Ghost Dance songs whose description constitutes a significant portion of his book. Mooney had requested sound recording equipment the previous summer while conducting research among the Kiowa in Oklahoma, writing to the director of the Bureau of Ethnology, John Wesley Powell:

> In view of the fact that Indian music is rapidly perishing, and that it is impossible to learn more than a very few of the tunes of the hundreds of Ghost Dance, Mescal and Gambling songs, I would respectfully request that I might be allowed the use of a phonograph in my work in this connection, as its value for this purpose has now been sufficiently demonstrated. By the same means also it is made possible to record myths and in the everyday language of the narrator, instead of in the bald skeleton form obtained by ordinary dictation.[48]

In response to his request, Mooney was sent a graphophone (an improved version of the phonograph), two batteries, 360 wax cylinders for recording, and recommendations from a physicist in the U.S. Patent Office on steps he could take to "aid in the interpretation of your graphophone records on your return next autumn."[49] After returning to Washington with his cylinders, Mooney employed

Berliner, the inventor of the gramophone, to record fourteen Arapaho, Caddo, Kiowa, and Comanche Ghost Dance songs on the more durable zinc discs used by Berliner's recording machine. Since there was no method available in 1894 for copying a cylinder directly to a gramophone disc, it is likely that a native singer returned with Mooney for the purpose of rerecording the songs.[50]

In the early 1890s, the phonograph was beginning to be recognized as a useful tool at the Bureau of Ethnology, where Powell directed affairs under the banner of Lewis Henry Morgan's stage theory of cultural evolution. All humankind, according to Morgan's schema, must pass through states of savagery, barbarism, and civilization, and Powell saw it as the task of the Bureau of Ethnology to salvage the remnants of a savage and barbarous human past before they disappeared forever in the wake of the progress of white civilization. The documentation of Native American languages was a focus in these efforts, but it also presented special challenges. In an 1889 article entitled "On Alternating Sounds," the anthropologist Frans Boas introduced the problem of cultural relativism into ethnographic research. Speakers of different languages, he argued, hear differently, and thus, when an ethnographer like Boas listened to Inuit speech and thought he was hearing inconsistent or "alternating" pronunciations, this was because he was hearing in the way his own language conditioned him to hear.[51] In the work of Mooney, Jesse Walter Fewkes, and others at the Bureau of Ethnology, the phonograph entered as a corrective to this condition that Boas called "sound-blindness." In contrast to "ordinary dictation," the phonograph was capable of hearing without cultural bias, and could thus serve as a useful tool in the project of salvage ethnography. It could produce what Lorraine Daston and Peter Galison have termed "mechanical objectivity," an epistemic virtue that relied on forms of mechanical reproduction to create knowledge that, because neutral machines were doing the interpreting, was superior to knowledge derived directly from the perceptions of the human eye or ear. The phonograph may not have offered every sonic detail with crystalline perfection—far from it: early listeners were well aware of the challenges of deciphering recorded sounds—but its professional value for ethnographers was that it served as a tool of self-restraint.[52]

As a check on subjective interpretation, the phonograph played a part in the professionalization of anthropology, which was just emerging as an academic discipline in the 1890s and seeking to distance itself from popular interest in the romantic Indian who belonged to the world of entertainment and appealed to sentiment rather than science. The important but often hazy line between science

and spectacle is perhaps best exemplified by the situation in which Mooney found himself in 1893, at the World's Columbian Exposition in Chicago. He had been placed in charge of the Smithsonian exhibit on the Kiowa, which was housed in a structure whose name, the "Anthropological Building," introduced the American public to the new academic term for the science of humankind. Mooney's exhibit, insisting on accuracy in all matters, modeled the precision on which this discipline would be based. According to a feature on Mooney published during the exposition in a Chicago newspaper, when a member of the fair's Board of Lady Managers suggested a change to the wardrobe of one of the life-sized models in the exhibit, Mooney objected: "'No, madame,' said the young ethnologist. 'The hands and arms of that figure never belonged to the tribe that wore this blanket. The exhibit is to educate, not mislead the people.'"[53] Yet, even as Mooney took every pain to educate visitors in the Anthropology Building, just outside the fairgrounds Buffalo Bill was putting on his Wild West extravaganza, its presence a sign of just how close anthropology and entertainment remained in 1893. Smithsonian ethnologists, after all, had brought indigenous peoples from across the world to live on the fair's midway and model their primitive cultures for the public, while Cody was at the same time celebrating the realism of his portrayals of Indian life, and indeed, his program of events for 1893 included a demonstration of the "Life Customs of the Indians." Moving from the Wild West show to the anthropologists' "living exhibits," many fair-goers would not have noticed a difference at all.

The phonograph was a tool for insisting on this difference. If the spectacle of Wild West shows played fast and loose with Native American customs and history, and if Edison's film catalogs appealed to audience expectations with inaccurate titles like *Sioux Ghost Dance,* the phonograph could help remove from ethnographic practice all those subjective and sentimental elements that showmen played on. It hardly needs pointing out, however, that the best of professional intentions could not dictate how listeners would make use of phonographs and gramophones, which were no less a part of 1890s entertainment culture than the kinetoscope. Mooney may have made his recordings for scientific purposes, but Berliner clearly saw a market for them, as evidenced in a broadsheet of Berliner discs from January 1895 that advertises three discs of Ghost Dance songs, sandwiched between a piano march of "Jolly Minstrels" and the sounds of "Morning on the Farm" (Figure 5.12). Surely there was overlap between the audiences who would have purchased these discs and those who would have visited kinetoscope parlors to watch *Sioux Ghost Dance.*

LIST OF PLATES.

JANUARY 1895.

BAND MUSIC.

118 Dude's March
130 Black and Tan
111 Marching Through Georgia.
　　(with cheers)
111 The same—Patrol
2 La Serenata
115 Star Spangled Banner
8 Coxey's Army
11 Salvation Army
9 Semper Fidelis (with drums.)
139 After the Ball
126 Bocaccio March
144 Liberty Bell March
140 Washington Post March
142 Admirals Favorite March
4 Friedensklange
105 National Fencibles
13 Gladiator March
19 Schottische, Nancy Hanks
15 Loin du bal
17 Waltz, Aphrodite
20 Mendelsohn's Wedding March

INSTRUMENTAL QUARTETTE.

807 Die Kapelle
803 Circus Band
806 March, King John
800 Ein neues Blatt

BARYTONE.

163 When Summer Comes Again
182 Sweetheart Nell, and I
175 Old Kentucky Home
191 Black Knight Templars
185 Throw Him Down McCloskey
183 Oh, Promise Me
176 Love Me Little, Love Me Long
150 Oh, Fair Art Thou
155 Anchored
170 Mamie Come Kiss your Honey
　　Boy
166 Then You'll Remember Me
160 The Maiden and the Lamb
165 Red, White and Blue
169 The Coon That Got the Shake
157 Tramp, Tramp, Tramp
158 Sweet Marie
196 The Whistling Coon
189 Phœbe
193 Back among the old folks
198 Swim out O'Grady
902 Sword of Bunker Hill

CLARIONET.

300 Allegro (Verdi)

CORNET.

200 Polka, Elegant
205 Call Me Thy Own
206 Emily Polka
202 U. S. Military Signals
203 Welcome, Pretty Primrose

Cornet Continued.

211 Cloverleaf Polka

CORNET DUETTS.

242 Alpine Polka
248 Swiss Boy
243 La Paloma

DRUM AND FIFE.

700 Biddy Oates
706 American Medley
702 St. Patrick's day
705 The Spirit of '76
　　　　(very dramatic)

TROMBONE.

75 In The Deep Cellar

PIANO.

256 Geisterfunken
253 March, Jolly Minstrels

INDIAN SONGS.

51 Three Melodies from the Ghost
　　Dance
52 Three Melodies from the Ghost
　　Dance
50 Three Melodies from the Ghost
　　Dance

ANIMALS.

53 Morning on the farm

Hebrew Melodies.

400 Parshe Zav

SOPRANO.

359 Oh, Promise Me
352 Oh, How Delightful
355 Star Spangled Banner
353 I've something sweet to tell you
363 Tell her I love her so
362 Some Day
350 Past and Future
365 Punchinello
354 In the gloaming
356 Loves Sorrow

CONTRALTO.

550 Beauties Eyes
551 Drink to me only
552 Oh, Promise me

RECITATION.

We have for this important department
secured the co-operation of the eminent, ver-
satile elocutionist, **Mr. David C. Bangs.**
602 Marc Anthony's Curse
　　　A Lesson in Elocution.
600 The Village Blacksmith
　　　(Many others in preparation.)

VOCAL QUARTETTE.

851 Blind Tom (negro shout)
853 Grandfather's Birthday
855 Negroes' holiday

It is expected that between 25 and 50 New Pieces will be added
every month.

THE UNITED STATES GRAMOPHONE CO.,
1410 Pennsylvania Ave., N. W.,
Washington, D. C.

FIGURE 5.12. "List of Plates," The United States
Gramophone Company, January 1895. Library of Congress
Motion Picture, Broadcasting, and Recorded Sound Division.

But what role do Mooney's recordings play in his study of the Ghost Dance religion? Throughout the book, Mooney is conscious of the difficulties of transmitting information accurately across cultures and distance, and the use of the phonograph for recording Ghost Dance songs is just one of the tools he adopts to overcome them. His chief documentary medium is the printed word itself. Mooney spent months collecting manuscripts and printed documents in Washington archives, and in his book, he reproduces many passages from them, as well as from his own extensive correspondence. In contrast to what Mooney calls the "imperfect medium" of Indian sign language, which was used to disseminate Ghost Dance doctrine across the linguistic barriers that separate the western tribes, print could deliver that doctrine to readers with minimal loss.[54] Visual documentation was important to Mooney as well, and with the "kodak and a tripod camera" he carried during his travels, he took the first photographs of Wovoka, as well as numerous photographs of the Ghost Dance and its trances that served as the basis for the illustrations by Mary Irvin Wright reproduced in his book.[55] With the phonograph, Mooney documented the Ghost Dance songs that are the focus of the second part of his study and are presented there in their original language (in phonetic spelling), in English translation, and in the case of the fourteen songs recorded by Berliner, in musical staff notation, having been arranged for Mooney by John Phillip Sousa and Berliner's assistant, Fred Gaisberg.[56] All of these documentary strategies contribute to the reputation of *The Ghost-Dance Religion* as a landmark of rich and detailed ethnographic research.

It is a remarkable feature of Mooney's study, however, that he pursues this ethnographic rigor within a highly speculative intellectual framework that positions the Ghost Dance in a long tradition of messianic movements in native North American cultures going back to the Pueblo revolt of 1680 and spanning across cultures and periods, from the Hebrew prophets to the "Kentucky Revival" of 1800. In Mooney's view, the Ghost Dance religion was not a distinctly primitive feature of a society soon to vanish; instead, it reflected a recurrent historical pattern found in many societies as they seek to revitalize their cultures in times of profound stress. "The lost paradise is the world's dreamland of youth," writes Mooney:

What tribe or people has not had its golden age, before Pandora's box was loosed, when women were nymphs and dryads and men were gods and heroes. And when the race lies crushed and groaning beneath an alien yoke, how natural is the dream

of a redeemer, an Arthur, who shall return from exile or awake from some long sleep to drive out the usurper and win back for his people what they have lost.[57]

This comparative model was a challenge to the accepted developmental models at the Bureau of Ethnology, and even though Powell was well enough aware of the importance of Mooney's study to have it published in the bureau's annual reports, he warns in his introduction that "caution should be exercised in comparing or

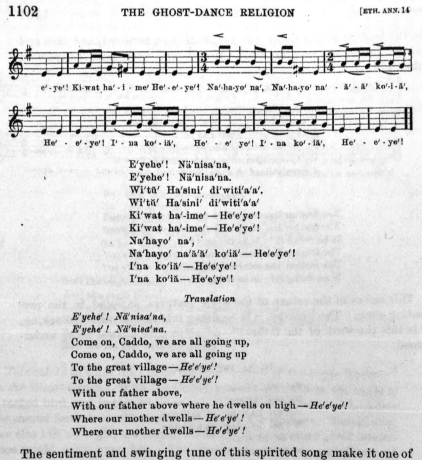

FIGURE 5.13. Music and words for *Wi'tŭ' Ha'sini'* ("Come on, Caddo"), from James Mooney, *The Ghost-Dance Religion and the Sioux Outbreak of 1890* (1896). O. Meredith Wilson Library, University of Minnesota.

contrasting religious movements among civilized peoples with such fantasies as that described in this memoir; for while interesting and suggestive analogies may be found, the essential features of the movements are not homologous."[58]

Mooney may not have exercised the interpretive caution Powell would have preferred, but he is still cautious enough to maintain the perspective of the objective scientist as he looks out across the landscape of human culture from his anthropological perch and identifies the patterns that have given shape to it. He shows little interest in the perspective of the insider for whom the messianic movement could be a means of resistance and of shaping one's own future. Nevertheless, Mooney's insistence upon the objective recording and presenting of the evidence of the Ghost Dance opens possibilities that are by no means fully determined by his scientific framework. This is especially true of the second section of *The Ghost-Dance Religion,* where Mooney's focus shifts from telling the history of the religion to synchronic overviews of seven different tribes and their Ghost Dance songs. In some cases, he offers extensive commentary on the songs, particularly those that address religious traditions like the use of the sacred pipe among the Arapaho, or age-old practices like jerking meat for pemmican among the Sioux. The Ghost Dance songs reproduced in the text, however, are not simply retrospective longings for the old ways. For example, the Sioux song *Michinkshi'yi tewa'quila che* ("I love my children"), which Mooney reproduces without commentary, imagines a transformed future:

I love my children—*Ye'ye'!*
I love my children—*Ye'ye'!*
You shall grow to be a nation—*Ye'ye'!*
You shall grow to be a nation—*Ye'ye'!*
Says the father, says the father.
Haye'ye' Eyayo'yo'! Haye'ye' Eyayo'yo'![59]

As Michael Elliott points out, the song raises "the possibility that the Lakotas would soon assert a nationalism independent of United States jurisdiction."[60]

The final song in Mooney's book, one that was recorded for the gramophone and therefore includes a musical arrangement in the text, is the Caddo song *Wi'tŭ' Ha'sini'* ("Come on, Caddo") (Figure 5.13). Mooney gives it the briefest of treatments and concludes his discussion of the song, and of his book, by noting that it "encourages the dancers in the hope of a speedy reunion of the whole Caddo nation, living and dead, in the 'great village' of their father above, and needs no

further explanation."[61] This comment, of course, leaves us to wonder what really has, in fact, been explained in the lyrics, and whether perhaps, in this "swinging tune," as Mooney describes it, we hear more than a longing for heavenly union, but anticipation of a revitalized earth.

The lesson we can take from Mooney is a simple one: in his use of the phonograph to prepare a text that puts the basic developmental narratives of late-nineteenth-century anthropology into question, he is no more prepared to contain the possibilities opened by this new technology than is the emergent film industry prepared to master the meaning of its films. Having done everything in his power to make us hear the songs of the Ghost Dance on their own terms, Mooney makes it difficult for readers simply to consign those songs to the lost "golden age" of a vanishing race. Indeed, there is much in Mooney's text to suggest the Ghost Dance religion had a future that would offer an alternative to the white man's doctrine of "progress," for even though dancing had ceased at Pine Ridge after Wounded Knee, *The Ghost Dance Religion* documents its continuation elsewhere despite government suppression. Mooney states explicitly (and somewhat surprisingly for a study funded and published by the U.S. government) that, when he visited the Wind River reservation in Wyoming in June 1892, the Arapaho were still dancing, unbeknownst to the government agent, and that Mooney himself had taken part in dances when he was among the Arapaho and Cheyenne.[62] The Ghost Dance religion continued to be practiced in various forms by native communities in North America into the twentieth century and as late as the 1960s.[63]

The Ghost Dance songs recorded by Mooney resonate in the voices of the Lakota members of Buffalo Bill's Wild West: in the voice of Short Bull, for example, the Brule medicine man who was released to Cody for the show's 1891–1892 tour and whose dictated narratives remain the most important sources on the Lakota interpretation of the Ghost Dance; and in the voices of the Oglala men who danced before Edison's kinetograph in 1894, traces of which can be found in the archives. An 1893 Congressional statement objecting to proposed bills demanding payments to whites for "Indian depredations" that occurred on Pine Ridge Reservation during the height of the Ghost Dance is undersigned by several of the men who dance and drum in Dickson's films, including Holy Bear, Strong Talker, and Chief Last Horse.[64]

The point, however, is not to attach specific voices to the silence of these films, as if we could anchor the dancers' movements to a singular source. On the contrary,

it is precisely in the sensory limitations of this new technology, introduced to the public in 1894 but lacking a direction or purpose, that the possibilities behind the imitative magic of cinema become apparent. Sounding out this potential can be difficult, so shaped has it been by the subsequent history of cinema and Hollywood stereotypes. It becomes more available, perhaps, at a distance, and especially when it enters unexpected contexts, such as the installation that allowed these Lakota dancers to return to Brooklyn over one hundred years after performing there in Buffalo Bill's Wild West, but this time in the American art galleries of the Brooklyn Museum, where their dances were rehearsed in continuous loops on video monitors from 2001 until 2016.[65] What did twenty-first century museum visitors imagine when confronted by the silent motion of these dancers who, knowing their images would be shown "to the world until after the sun had slept his last sleep," boldly declare their persistence before the camera?

There is a magic at work in these Edisonian descendants of Franklin's electrified pictures, a magic that has the potential to leave us shocked, with nothing to say except to repeat, in astonishment, what has just been experienced. In Frank Norris's novel *McTeague* (1899), the eponymous protagonist is left in just this condition when he encounters a kinetoscope for the first time at a San Francisco theatre: "McTeague was awe-struck. 'Look at that horse move his head,' he cried excitedly, quite carried away. 'Look at that cable-car coming—and the man going across the street. See, here comes a truck. Well, I never in all my life!'"[66] One may imagine a viewer—in 1894 or in the present—reacting similarly to *Sioux Ghost Dance*: "Look at them dance!"; a response of wonder that signals a meaning behind these animated shadows that is yet to be grasped.

Coda

LIKE A SNAKE BITING ITS OWN TAIL, this book ends where it began. My return to the circular dance suggests continuity over time: I have attempted to show how visual imagery and an aural imaginary intersect in recurring patterns across four centuries of Atlantic visual culture. A sense of closure is a desirable thing at the conclusion of a historical study. Achieving it requires a perspectival distance that allows us to look out on the past and discern its contours, and it is not accidental that this distant view has been a persistent motif in this study, one that I have tied to landscape representation in particular. It is the view of Henri II surveying an artificial Brazilian forest along the Seine from his royal scaffolding, of Frans Post at his telescopic distance from the sounds of conflict in Dutch Brazil, and of Alois Riegl atop his alpine perch, lost in the reflective, historicist mood of modernity. Defining stable patterns amidst the turmoil of Atlantic history necessitates such a lofty viewing point. But another persistent motif throughout the preceding chapters has been the noise that disrupts our *Stimmung*. The sounds of the dance, like Riegl's chamois, draw us through the makeshift hole in the wall, through the peephole of the kinetoscope, and into the sensory excess of the near view. My return, full circle, to the sounds of the dance is therefore more than the buckling of beginning and end; it is their unbuckling as well. We are left, like Franklin, situated between the quiet of the study and the violence of the thunder outside the window.

Any gesture toward closure needs to accommodate this ambivalence, and not only as it applies to the interplay between art and aurality in the past. The soundings essayed in this book have been those of an art historian interested in the

power of the voice in his own profession, a power seldom remarked on, but not to be underestimated. It will come as no surprise to readers of this book that all of its chapters had their beginnings in lectures or spoken papers, as I stood before a group of colleagues or students and searched for suitable words to describe pictures that are unable to speak for themselves. The oral presentation is such a routine stage in the path toward scholarly publication that it hardly seems worth mentioning on the printed page. But, in important respects, humanists of the modern academy still resemble those orators like Caspar Barlaeus for whom intellectual inquiry was synonymous with the art of rhetorical persuasion. We still find it necessary to test our ideas through the spoken word, as we attempt to give substance to the ethereal image on the screen by announcing our thoughts in the presence of others. There is a strange logic to using our voices in this manner. We try to convince auditors that the objects about which we speak belong to the past, even as our voices conjure those very objects back from the dead so they might speak to us in the here and now. We are always sounding historical distance, seeking the words that can simultaneously open and abolish it. This is not an entirely rational enterprise. It is, however, a fascinating imaginative space to inhabit. My goal in *Sound, Image, Silence* has been to occupy art history's aural imagination, an in-between space where the meanings of pictures have not yet arrived, and where the possibility of alternative arrivals is not yet foreclosed.

Notes

INTRODUCTION

1. On the Atlantic origins of a modern representational economy, see Ian Baucom, *Specters of the Atlantic: Finance Capital, Slavery, and the Philosophy of History* (Durham, N.C.: Duke University Press, 2005), 35–79.

2. See W. J. T. Mitchell, "Imperial Landscape," in *Landscape and Power,* ed. W. J. T. Mitchell, 2nd ed. (Chicago: University of Chicago Press, 2002), 9; and Max Weber, *The Protestant Ethic and the Spirit of Capitalism,* trans. Stephen Kalberg (Los Angeles: Roxbury, 2002), 14–18.

3. Martin Heidegger, *Off the Beaten Track,* ed. and trans. Julian Young and Kenneth Haynes (Cambridge: Cambridge University Press, 2002), 71.

4. See Bruno Latour, *We Have Never Been Modern,* trans. Catherine Porter (Cambridge, Mass.: Harvard University Press, 1993). For an interpretation of the nineteenth-century world exhibition through Heidegger's concept of the world picture, see Timothy Mitchell, *Colonising Egypt* (Berkeley: University of California Press, 1988), 1–33.

5. See, for example, Fatimah Tobing Rony, *The Third Eye: Race, Cinema, and Ethnographic Spectacle* (Durham, N.C.: Duke University Press, 1996), 112–13; and William Rothman, *Documentary Film Classics* (Cambridge: Cambridge University Press, 1997), 11–13.

6. Michael Taussig, *Mimesis and Alterity: A Particular History of the Senses* (New York: Routledge, 1993). Taussig discusses *Nanook of the North* on 200–203.

7. The French director Abel Gance, for instance, described cinema as "the great magic Art of the alchemists." See Paul Cuff, *Abel Gance and the End of Silent Cinema: Sounding out Utopia* (Cham, Switzerland: Palgrave MacMillan, 2016), 74.

8. It is Latour's argument in *We Have Never Been Modern* that, despite the modern Constitution, we have in fact always inhabited this in-between space. On the vertiginous in early modern art see Rose Marie San Juan, *Vertiginous Mirrors: The Animation of the Visual Image and Early Modern Travel* (Manchester: Manchester University Press, 2011).

9. Jennifer L. Roberts, *Transporting Visions: The Movement of Images in Early America* (Berkeley: University of California Press, 2014), 13–67. See also Roberts, "Copley's Cargo: *Boy with a Squirrel* and the Dilemma of Transit," *American Art* 21, no. 2 (Summer 2007): 21–41.

10. Taussig, *Mimesis and Alterity,* 201. On the staging of the scene, see Rony, *Third Eye,* 123.

11. A sound version of *Nanook of the North* was released in 1947. On the history of the film, see Roswitha Skare, *Nanook of the North from 1922 to Today* (Frankfurt am Main: Peter Lang, 2016).

12. Leigh Eric Schmidt, *Hearing Things: Religion, Illusion, and the American Enlightenment* (Cambridge, Mass.: Harvard University Press, 2000), 7.

13. See Schmidt, *Hearing Things*; Richard Cullen Rath, *How Early America Sounded* (Ithaca, N.Y.: Cornell University Press, 2003); and Edwin C. Hill Jr., *Black Soundscapes, White Stages: The Meaning of Francophone Sound in the Black Atlantic* (Baltimore, Md.: The Johns Hopkins University Press, 2013). The idea of the "soundscape" was first developed by R. Murray Schafer in *The Tuning of the World* (New York: Knopf, 1977). For a useful overview of the field of sound studies, see Jonathan Sterne, "Sonic Imaginations," in *The Sound Studies Reader,* ed. Jonathan Sterne (London: Routledge, 2012), 1–17.

14. See Michel de Certeau, *Heterologies: Discourse on the Other,* trans. Brian Massumi (Minneapolis: University of Minnesota Press, 1986).

15. See Asma Naeem, "The Aural Imagination," *American Art* 24, no. 3 (Fall 2010): 14–17; and Marlene Eberhart, "Sensing, Time and the Aural Imagination in Titian's *Venus with Organist and Dog,*" *Artibus et Historiae* 65, no. 33 (2012): 79–95. Also see Niall Atkinson's recent exploration of what he calls the "sonic imagination" in Renaissance Florence in *The Noisy Renaissance: Sound, Architecture, and Florentine Urban Life* (University Park: The Pennsylvania State University Press, 2016).

16. Edison quoted in W. K. L. and Antonia Dickson, *History of the Kinetograph, Kinetoscope, and Kineto-Phonograph* (New York: Albert Bunn, 1895), 4.

17. On music and silent film, see Rick Altman, *Silent Film Sound* (New York: Columbia University Press, 2004). On intertitle commentators, see André Gaudreault, "Lecturer," in *Encyclopedia of Early Cinema,* ed. Richard Abel (London: Routledge, 2005), 379–80.

18. Michel Chion, *The Voice in Cinema,* trans. Claudia Gorbman (New York: Columbia University Press, 1999), 8.

19. The literature on the comparison of painting and poetry is vast. A standard work is Rensselaer Lee, "*Ut Pictura Poesis*: The Humanistic Theory of Painting," *Art Bulletin* 22, no. 4 (December 1940): 197–269. For a more recent and highly suggestive intervention, see Leonard Barkan, *Mute Poetry, Speaking Pictures* (Princeton, N.J.: Princeton University Press, 2013).

20. On Wilson's installation see *Mining the Museum: An Installation by Fred Wilson,* ed. Lisa G. Corrin (Baltimore: The Contemporary, 1994).

21. See Katherine Jansen, "Miraculous Crucifixes in Late Medieval Italy," in *Signs, Wonders, Miracles: Representations of Divine Power in the Life of the Church,* ed. Kate Cooper and Jeremy Gregory (Woodbridge, UK: Boydell, 2005), 203–27.

22. On Bernini and the "speaking likeness" see *Bernini and the Birth of Baroque Portrait Sculpture,* ed. Andrea Bacchi, Catherine Hess, and Jennifer Mantagu (Los Angeles: The J. Paul Getty Museum, 2008). On Kircher's Delphic Oracle, which consisted of a portrait bust attached to a thirty-foot-long speaking tube, see Giorgio de Sepi, *The Celebrated Museum of the Roman College of the Society of Jesus,* ed. Peter Davidson, trans. Anastasi Callinicos and Daniel Höhr (Philadelphia: St. Joseph's University Press, 2015), 163–64. Kircher's museum also included a speaking statue of the Virgin (see Joseph R. Jones, "Historical Materials for the Study of the *Cabeza Encantada* Episode in *Don Quijote* II.62," *Hispanic Review* 47, no. 1 [Winter, 1979]: 100).

23. See Hans Belting, *Likeness and Presence: A History of the Image before the Era of Art,* trans. Edmund Jephcott (Chicago: University of Chicago Press, 1994).

24. See Sharon Elizabeth Fermor, "Studies in the Depiction of the Moving Figure in Italian Renaissance Art, Art Criticism, and Dance Theory" (PhD diss., The Warburg Institute, University of London, 1990).

1. "IT SEEMS THEIR VOICES ARE STILL IN MY EARS"

1. Claude Lévi-Strauss, *Tristes Tropiques,* trans. John and Doreen Weightman (New York: Penguin, 1973), 81.

2. Jean de Léry, *History of a Voyage to the Land of Brazil, Otherwise Called America,* trans. Janet Whatley (Berkeley: University of California Press, 1990), 142–44.

3. Michel de Certeau, *The Writing of History,* trans. Tom Conley (New York: Columbia University Press, 1988), 211. On Lery's ravishment by the Tupinambá chants, also see Frank Lestringant, *Jean de Léry, ou, l'invention du sauvage: essai sur l'Histoire d'un voyage faict en la terre du Brésil* (Paris: Champion, 1999), 135–57; Stephen Greenblatt, *Marvelous Possessions: The Wonder of the New World* (Chicago: University of Chicago Press, 1991), 14–19; and Gary Tomlinson, *The Singing of the New World: Indigenous Voice in the Era of European Contact* (Cambridge: Cambridge University Press, 2007), 45–48.

4. For Léry's description of these items see Léry, *History of a Voyage,* 61, 64.

5. Léry, *History of a Voyage,* 142. For the Latin, see Jean de Léry, *Navigatio in Brasiliam Americae* (Frankfurt am Main: Theodor de Bry, 1592), 227. Here and throughout this chapter, I rely on Whatley's English translation (based on the French text), but I will also cite the corresponding page(s) in de Bry's Latin edition.

6. Léry, *History of a Voyage,* 142; Léry, *Navigatio,* 227.

7. Léry, *History of a Voyage,* 142; Léry, *Navigatio,* 227.

8. Staff notations for the chant appear in editions of *Histoire d'un voyage* published from 1585 onward.

9. See Jacques Forge, "Naissance d'une image," in *L'Amérique de Théodore de Bry: une collection de voyages protestante du XVIe siècle,* ed. Michèle Duchet (Paris: Editions du Centre National de la Recherche Scientifique, 1987), 113.

10. *The Bible and Holy Scriptures Conteyned in the Olde and Newe Testament* (Geneva: printed by Rouland Hall, 1560), 41r.

11. *The Bible and Holy Scriptures,* 33r.

12. Charles G. Dempsey, "Poussin and Egypt," *The Art Bulletin* 45, no. 2 (June 1963): 117–18.

13. See Alexander Nagel, *The Controversy of Renaissance Art* (Chicago: University of Chicago Press, 2011), 109–115, and Christopher S. Wood, "Ritual and the Virgin on the Column: The Cult of the Schöne Maria in Regensburg," *Journal of Ritual Studies* 6, no. 1 (Winter 1992): 99–100.

14. The subject appealed to both Protestant and Catholic audiences. Sadeler's print, for example, was first published in Catholic Antwerp in Gerard de Jode's 1585 *Thesaurus sacrarum,* but this collection of biblical subjects was later republished (with modifications) in Amsterdam in 1639 by the Calvinist Claes Jansz. Visscher as the *Theatrum biblicum.*

15. On the ambivalence of Lucas van Leyden's *Worship of the Golden Calf,* see Peter W. Parshall, "Some Visual Paradoxes in Northern Renaissance Art," *Wascana Review* 9, no. 1 (Spring 1974): 100–103, and David Freedberg, *The Power of Images: Studies in the History and Theory of Response* (Chicago: The University of Chicago Press, 1989), 378–85.

16. John Calvin, quoted in Ann Wagner, *Adversaries of Dance: From the Puritans to the Present* (Urbana: University of Illinois Press, 1997), 27.

17. Lambert Daneau, *Traité des danses* (Geneva: François Estienne, 1579), 102 (translation mine). Daneau's comparison, which is drawn from the Reformed theologian Pierre Viret, is repeated in Jean Taffin's 1595 *The Amendment of Life* and William Perkins's 1596 *A Discourse of Conscience* (see Wagner, *Adversaries of Dance,* 27–36).

18. John Forrest, *The History of Morris Dancing, 1458–1750* (Toronto: University of Toronto Press, 1999), 3–4, 74.

19. Léry, *History of a Voyage,* 76.

20. Thomas Harriot, *A Briefe and True Report of the New Found Land of Virginia* (Frankfurt am Main: Johann Wechel for Theodor de Bry, 1590), Plate XVIII. The engraving is based on a watercolor drawing by the British painter John White.

21. Jean Frédéric Bernard, *The Ceremonies and Religious Customs of the Various Nations of the Known World,* vol. 1 (London: William Jackson for Claude Du Bosc, 1733), 251.

22. Antonio Paolucci, "Ecco la prima imagine dei nativi americani raccontati da Colombo," *L'Osservatore romano,* April 27, 2013, museivaticani.va/content/dam/museiv aticani/pdf/musei_papa/saluto_direttore/rassegna_2013/osservatore_romano/MV_130427_Prima_immagine_dei_nativi_americani.pdf (my translation). It is worth pointing out that the figural group behind the head of the Roman soldier also includes a man in profile who appears to wear a Spanish helmet, as well as three horses.

23. Paolucci, "Ecco la prima imagine." Paolucci's statement is not quite correct, since Giuliano Dati's Italian verse translation of Columbus's letter on his first voyage, which was published in June of 1493, and therefore almost certainly predates the completion of Pinturicchio's fresco, includes a frontispiece woodcut showing the Indians encountered by Columbus.

24. Christopher Columbus, *The Four Voyages,* trans. J. M. Cohen (London: Penguin, 1969), 117.

25. Sylvia Poggioli, "Long Hidden, Vatican Painting Linked to Native Americans," *The Two-Way: Breaking News from NPR,* May 5, 2013, accessed January 4, 2017, npr.org/sec tions/thetwo-way/2013/05/05/180860991/long-hidden-vatican-painting-linked-to -native-americans.

26. Christopher Columbus, *Select Letters of Christopher Columbus: With Other Original Documents, Relating to His Four Voyages to the New World,* ed. R.H. Major (London: Hakluyt Society, 1870), xcix. It is also possible, of course, that Pinturicchio was influenced by unpublished reports from the Spanish crown that reached the painter through his Spanish patron, Pope Alexander VI.

27. See J. Schulz, "Pinturicchio and the Revival of Antiquity," *Journal of the Warburg and Courtauld Institutes* 25, no. 1/2, (January–June 1962): 35–55.

28. See Nicole Dacos, "Présents américains a la renaissance: l'assimilation de l'exotisme," *Gazette des beaux-Arts* 73 (January 1969): 59.

29. See Brian Curran, *The Egyptian Renaissance: The Afterlife of Ancient Egypt in Early Modern Italy* (Chicago: University of Chicago Press, 2007), 107–21.

30. Pope Alexander VI, *Inter caetera,* in *European Treaties Bearing on the History of the United States and its Dependencies to 1648,* ed. Frances Gardiner Davenport (Washington, DC: Carnegie Institution of Washington, 1917), 77.

31. See Joseph Leo Koerner, "The Epiphany of the Black Magus Circa 1500," in *The Image of the Black in Western Art: From the "Age of Discovery" to the Age of Abolition,* ed. David Bindman and Henry Louis Gates, Jr. (Cambridge, Mass.: Belknap, 2010), 1–16, and Susan Lynne Swanson, "The Work of the Magi: Adoration Images and Visions of Globalization in Early Modern Europe" (PhD diss., University of Minnesota, 2015), 19–69.

32. Leon Battista Alberti, *On Painting,* trans. John R. Spencer (New Haven, Conn.: Yale University Press, 1966), 81. On Warburg's dissertation and accessory motion, see Georges Didi-Huberman, "The Imaginary Breeze: Remarks on the Air of the Quattrocento," *Journal of Visual Culture* 2, no. 3 (2003): 275–89, and Philippe-Alain Michaud, *Aby Warburg and the Image in Motion,* trans. Sophie Hawkes (New York: Zone, 2004), 67–82.

33. Freedberg, *Power of Images,* xx.

34. Freedberg, *Power of Images,* 378–85.

35. Léry, *History of a Voyage,* lxi; Léry, *Navigatio,* 143.

36. Léry, *History of a Voyage,* 9; Léry, *Navigatio,* 147–48.

37. *The Bible and Holy Scriptures,* 258v. For Calvin's commentary on Psalm 107, see John Calvin, *Commentary on the Book of Psalms,* vol. 4, trans. James Anderson (Edinburgh: Calvin Translation Society, 1847), 245–67.

38. Janet Whatley, "Impression and Initiation: Jean De Lery's Brazil Voyage," *Modern Language Studies* 19, no. 3 (1989): 17. On Léry and experience, also see Andrea Frisch, "In a Sacramental Mode: Jean De Léry's Calvinist Ethnography," *Representations* 77 (Winter 2002): 82–106.

39. I rely here on Tom Cummins's discerning contrast between de Bry's *America* and Herrera's *Historia general* in "De Bry and Herrera: 'Aguas Negras' or the Hundred Years War Over an Image of America," in *Arte, historia e identitad en América: visiones comparativas,*

ed. Gustavo Curiel, Renato González Mello, and Juana Gutiérrez Haces (Mexico City: Universidad Nacional Autónomo de México, 1994), 17–31.

40. Michiel van Groesen, *The Representations of the Overseas World in the De Bry Collection of Voyages (1590–1634)* (Leiden: Brill, 2008), 219–79.

41. The full psalm is printed at the beginning of Léry's text for the first time in the 1586 Latin edition: Jean de Léry, *Historia navigationis in Brasiliam, quae et America dicitur* (Geneva: Eustathius Vignon, 1586). This edition served as the basis for de Bry's Latin and German editions.

42. Jean de Léry, *Schiffart in Brasilien in America* (Frankfurt am Main: Theodor de Bry, 1593), D1r. The motto was also used in de Bry's source, the 1586 Latin edition.

43. *The Newe Testament of Our Lord Iesus Christ* (Geneva: printed by Rouland Hall, 1560), 74r.

44. John Calvin, from *Institutes of the Christian Religion,* quoted in Stephen H. Webb, *The Divine Voice: Christian Proclamation and the Theology of Sound* (Grand Rapids, Mich.: Brazos, 2004), 151. On Luther and the privileging of hearing over seeing, see Joseph Leo Koerner, *The Reformation of the Image* (Chicago: University of Chicago Press, 2004), 41.

45. John Calvin, *Commentaries on the Epistle of Paul to the Romans,* trans. John Owen (Edinburgh: Calvin Translation Society, 1849), 400–401.

46. Léry, *History of a Voyage,* 144; Léry, *Navigatio,* 229.

47. See Hélène Clastres, *The Land-Without-Evil: Tupí-Guaraní Prophetism,* trans. Jacqueline Grenez Brovender (Urbana: University of Illinois Press, 1995).

48. Clastres, *The Land-Without-Evil,* 75. On beautiful words, see x–xi, 73–76, and 103–4.

49. Staden's book was published in February of 1557. In December of 1557, the Franciscan friar André Thevet, who had briefly been in the French colony in Guanabara Bay prior to Léry's arrival, published *Les singularitez de la France antarctique, autrement nommé Amerique.* Thevet's book includes a woodcut of a dancing shaman holding a maraca from which Léry, despite his well-known denunciation of Thevet as a liar, borrowed directly for his own woodcut (see Figure 1.1).

50. Hans Staden, *Hans Staden's True History: An Account of Cannibal Captivity in Brazil,* ed. and trans. Neil L. Whitehead and Michael Harbsmeier (Durham, N.C.: Duke University Press, 2008), 124.

51. On the cult of the maraca, see Clastres, *Land-Without-Evil,* 38–39; Alfred Métraux, *La religion des Tupinamba et ses rapports avec celle des autres tribus Tupi-Guarani* (Paris: E. Leroux, 1928), 72–78; and Tomlinson, *The Singing of the New World,* 110–20.

52. Léry, *History of a Voyage,* 142.

53. Claudia Swan, "*Ad Vivum, Naer Het Leven,* From the Life: Defining a Mode of Representation," *Word & Image* 11, no. 4 (October–December 1995): 353–72.

54. See Harry Vredeveld, "'Lend a Voice': The Humanistic Portrait Epigraph in the Age of Erasmus and Dürer," *Renaissance Quarterly* 66, no. 2 (Summer 2013): 525.

55. See Francesco Petrarch, *The Essential Petrarch,* ed. and trans. Peter Hainsworth (Indianapolis, Ind.: Hackett, 2010), 223.

56. See Alberti, *On Painting*; Erwin Panofsky, *Perspective as Symbolic Form,* trans. Christopher S. Wood (New York: Zone, 1991); and Martin Heidegger, "The Age of the World Picture," in Heidegger, *Off the Beaten Track,* ed. and trans. Julian Young and Kenneth Haynes (Cambridge: Cambridge University Press, 2002), 57–85.

57. Walter Mignolo, "Crossing Gazes and the Silence of the 'Indians': Theodor De Bry and Guaman Poma De Ayala," *Journal of Medieval and Early Modern Studies* 41, no. 1 (Winter 2011): 191.

58. Mignolo, "Crossing Gazes," 180.

59. Edward Burnet Tylor, *Researches into the Early History of Mankind and the Development of Civilization* (London: John Murray, 1865), 118. Also see Matthew Rampley, "Mimesis and Allegory: On Aby Warburg and Walter Benjamin," in *Art History as Cultural History: Warburg's Projects,* ed. Richard Woodfield (Amsterdam: G&B Arts, 2001), 121–49.

60. René de Laudonnière and Jacques Le Moyne de Morgues, *Brevis narratio eorum quae in Florida Americae provincia Gallis acciderunt* (Frankfurt am Main: Theodor de Bry, 1591), E2; Paul Hulton, *The Work of Jacques Le Moyne de Morgues: A Huguenot Artist in France, Florida and England,* vol. 1 (London: Trustees of the British Museum, 1977), 147.

61. For an overview of the royal entry and a facsimile of its festival book, *C'est la deduction* . . . , see Margaret M. McGowan, *L'Entrée de Henri II á Rouen, 1550* (Amsterdam: Theatrum Orbis Terrarum, 1970). I have also relied on Steven Mullaney, "Strange Things, Gross Terms, Curious Customs: The Rehearsal of Cultures in the Late Renaissance," in *Representing the English Renaissance,* ed. Stephen Greenblatt (Berkeley: University of California Press, 1988), 65–92; Michael Wintroub, *A Savage Mirror: Power, Identity, and Knowledge in Early Modern France* (Stanford, Calif.: Stanford University Press, 2006); and Rebecca Zorach, "'Taken by Night from its Tomb': Triumph, Dissent, and *Danse Macabre* in Sixteenth-century France," in *Visualizing Medieval Performance: Perspectives, Histories, Contexts,* ed. Elina Gertsman (Aldershot: Ashgate, 2008), 223–45.

62. "Elle sembloit estre veritable, & non simulée" (McGowan, *L'Entrée de Henri II á Rouen,* K4r). On the Rouen entry and the performative rehearsal of culture, see Mullaney, "Strange Things."

63. Walter Benjamin, "On the Mimetic Faculty," in *Selected Writings,* vol. 2, *1927–1934,* trans. Rodney Livingstone et al. (Cambridge, Mass.: Belknap, 1999), 720–22; Michael Taussig, *Mimesis and Alterity: a Particular History of the Senses* (New York and London: Routledge, 1993).

2. FRANS POST'S SILENT LANDSCAPES

1. Hugh Honour, *The New Golden Land: European Images of America from the Discoveries to the Present Time* (New York: Pantheon, 1975), 81. For an overview of scholarly attitudes toward Eckhout's depictions of indigenous Brazilians, see Rebecca Parker Brienen, *Visions of Savage Paradise: Albert Eckhout, Court Painter in Colonial Dutch Brazil* (Amsterdam: Amsterdam University Press, 2006), 96–99.

2. See Ernst van den Boogaart, "Infernal Allies: The Dutch West India Company and the Tarairiu, 1631–1654," in *Johan Maurits van Nassau-Siegen, 1604–1679: A Humanist Prince in Europe and Brazil: Essays on the Occasion of the Tercentenary of His Death,* ed. E. van den Boogaart, H. R. Hoetink, and P. J. P. Whitehead (The Hague: Johan Maurits van Nassau Stichting, 1979), 519–38; Brienen, *Visions of Savage Paradise,* 97–98, 168–69, 192–99.

3. "Graaf Maurits heeft wilden meegenomen, die dansen uitvoeren, terwijl zij geheel naakt zijn. De dominées, die er met hunne vrouwen naar waren gaan kijken, vonden dat niets aardig" (Constantijn Huygens, Letter to David le Leu de Wilhem of August 27, 1644, in *De briefwisseling van Constantijn Huygens, 1644–1649,* ed. J. A. Worp [Martinus Nijhoff: Den Haag, 1915], 52). C. R. Boxer quotes a letter from a guest who refers to the audience's laughter in *The Dutch in Brazil, 1624–1654* (Oxford: The Clarendon Press, 1957), 157. Also see Peter Mason, *Infelicities: Representations of the Exotic* (Baltimore, Md.: Johns Hopkins University Press, 1998), 43.

4. For some examples of speaking images in medieval romance, see J. Douglas Bruce, "Human Automata in Classical Tradition and Medieval Romance," *Modern Philology* 10, no. 4 (April 1913): 511–26. On speaking crucifixes and other speaking images in the Middle Ages, see Katherine Jansen, "Miraculous Crucifixes in Late Medieval Italy," in *Signs, Wonders, Miracles: Representations of Divine Power in the Life of the Church,* ed. Kate Cooper and Jeremy Gregory (Woodbridge, UK: Boydell, 2005), 203–27, and Hans Belting, *Likeness and Presence: A History of the Image Before the Era of Art,* trans. Edmund Jephcott (Chicago: University of Chicago Press, 1994), passim.

5. See Harry Vredeveld, "'Lend a Voice.'"

6. Quoted in Erwin Panofsky, "Erasmus and the Visual Arts," *Journal of the Warburg and Courtauld Institutes* 32 (1969): 225.

7. For overviews of the history of Dutch Brazil, see Boxer, *Dutch in Brazil,* and Mark Meuwese, *Brothers in Arms, Partners in Trade: Dutch-Indigenous Alliances in the Atlantic World, 1595–1674* (Leiden: Brill, 2012), 15–54.

8. Key modern sources for this material include van den Boogart, Hoetink, and Whitehead, *Johan Maurits van Nassau-Siegen; A Portrait of Dutch 17th Century Brazil: Animals, Plants and People by the Artists of Johan Maurits of Nassau,* ed. P. J. P. Whitehead and M. Boeseman (Amsterdam: North-Holland, 1989); and *Dutch Brazil,* ed. Cristina Ferrão and José Paulo Monteiro Soares, 5 vols. (Rio de Janeiro and Petrópolis: Editora Index, 1997–2000).

9. Whitehead and Boeseman, *Portrait,* 21.

10. See R. A. Eekhout, "The Mauritias: A Neo-Latin Epic by Franciscus Plante," in van den Boogaart, Hoetink, and Whitehead, *Johan Maurits van Nassau-Siegen,* 377–93, and Benjamin Schmidt, *Innocence Abroad: The Dutch Imagination and the New World, 1570–1670* (New York: Cambridge University Press, 2001), 253–54.

11. Frans Post himself did not join the Haarlem Guild of St. Luke until after his return from Brazil in 1646. On Post's background, see Pedro and Bia Corrêa do Lago, *Frans Post, 1612–1680: Catalogue Raisonné* (Milan: 5 Continents, 2007), 20–29, and León

Krempel, "Biographische und stilistische Notizen zu Frans Post," in *Frans Post (1612–1680): Maler des Verlorenen Paradieses,* ed. León Krempel (Petersberg: Michael Imhof, 2006), 19–28.

12. Caspar van Baerle [Caspar Barlaeus], *The History of Brazil Under the Governorship of Count Johan Maurits of Nassau, 1636–1644,* trans. Blanche T. van Berckel-Ebeling Koning (Gainesville: University Press of Florida, 2011), 313.

13. See Ulrike Gehring, "Painted Topographies: A Transdisciplinary Approach to Science and Technology in Seventeenth-Century Landscape Painting," in *Mapping Spaces: Networks of Knowledge in 17th Century Landscape Painting,* ed. Ulrike Gehring and Peter Weibel (Karlsruhe: ZKM and Center for Art and Media, 2014), 27–31.

14. See *Frans Post: Le Brésil à la cour de Louis XIV,* ed. Pedro Corrêa do Lago and Blaise Ducos (Milan: 5 Continents, 2005).

15. One of the numbers in the month on this painting appears to be missing. Corrêa do Lago suggests November as the most likely month (*Frans Post, 1612–1680,* 88).

16. Barlaeus, *History,* 121; Corrêa do Lago, *Frans Post, 1612–1680,* 88.

17. Corrêa do Lago, *Frans Post, 1612–1680,* 88.

18. On Post's later paintings and exoticism, see Benjamin Schmidt, "The 'Dutch Atlantic' and the Dubious Case of Frans Post," in *Dutch Atlantic Connections, 1680–1800: Linking Empires, Bridging Borders,* ed. Gert Oostindie and Jessica V. Roitman (Leiden: Brill, 2014), 249–72. On the Dutch market for curiosities, see Dániel Margócsy, *Commercial Visions: Science, Trade, and Visual Culture in the Dutch Golden Age* (Chicago: University of Chicago Press, 2014), and Harold J. Cook, *Matters of Exchange: Commerce, Medicine, and Science in the Dutch Golden Age* (New Haven, Conn.: Yale University Press, 2007).

19. David Freedberg, "Science, Commerce, and Art: Neglected Topics at the Junction of History and Art History," in *Art in History / History in Art: Studies in Seventeenth-Century Dutch Culture,* ed. David Freedberg and Jan de Vries (Santa Monica: Getty Center for the History of Art and the Humanities, 1991), 390.

20. Van de Boogaart, "Infernal Allies," 521.

21. Dante Martins Teixeira, "The 'Thierbuch' of Zacharias Wagener of Dresden (1614–1668) and the Oil Paintings of Albert Eckhout," in *Albert Eckhout volta ao Brasil / Albert Eckhout Returns to Brazil, 1644–2002,* ed. Barbara Berlowicz et al. (Copenhagen: Nationalmuseet, 2002), 176.

22. See Angela Vanhaelen's insightful essay, "Boredom's Threshold: Dutch Realism," *Art History* 35, no. 5 (November 2012): 1004–23.

23. Alois Riegl, *The Group Portraiture of Holland,* trans. Evelyn M. Kain and David Britt (Los Angeles: Getty Research Institute for the History of Art and the Humanities, 1999), 64. And see Vanhaelen, "Boredom's Threshold," 1005, 1013–17.

24. See Alois Riegl, "Die Stimmung als Inhalt der modernen Kunst," in *Die Graphischen Künste,* ed. Friedrich Dörnhöffer and Karl Masner (Vienna: Gesellschaft für Vervielfältigende Kunst, 1899), 47–56.

25. Erik Larsen, *Frans Post, interprète du Brésil* (Amsterdam: Colibris, 1962), 138–40. For a critique of Larsen's argument about the reversed telescope, see Peter J. P.

Whitehead, "Frans Post and the Reversed Galilean Telescope," *The Burlington Magazine* 128, no. 1004 (November 1986): 805–7.

26. See Gehring, "Painted Topographies," 87–89.

27. Recently two studies for the capybara, along with thirty-two additional animal studies by Post, were discovered in the Noord-Hollands Archief in Haarlem. See Alexander de Bruin, "Frans Post: Animals in Brazil," *Master Drawings* 54, no. 3 (October 2016–January 2017): 5–80.

28. J. H. Elliott, *The Old World and the New, 1449–1650* (Cambridge: Cambridge University Press, 1970), 23. Also see Liza Oliver, "Frans Post's Brazil: Fractures in Seventeenth-Century Dutch Colonial Landscape Paintings," *Dutch Crossing* 37, no. 3 (November 2013): 203–4; Corrêa do Lago, *Frans Post, 1612–1680,* 71; *Netherlandish Art in the Rijksmuseum: 1600–1700,* ed. Jan Piet Filedt Kok et al. (Amsterdam: Waanders, 2001), 158.

29. Souren Melikan, "Startling Originality of a Dutch Painter: Bold Landscapes from Journey to Brazil," *International Herald Tribune,* December 10, 2005; Corrêa do Lago, *Frans Post, 1612–1680,* 96, 104, 33; Ernst van den Boogaart, "A Well-Governed Colony: Frans Post's Illustrations in Caspar Barlaeus's History of Dutch Brazil," *The Rijksmuseum Bulletin* 59, no. 3 (2011), 243; and Joaquim de Sousa-Leão, *Frans Post: 1612–1680* (Amsterdam: A. L. van Gendt, 1973), 24.

30. Barlaeus, *History,* 72.

31. Corrêa do Lago, *Frans Post, 1612–1680,* 31.

32. See the summary of this tradition in Boudewijn Bakker, *Landscape and Religion from Van Eyck to Rembrandt,* trans. Diane Webb (London: Routledge, 2012), 202–4.

33. On Indian alliances, see Meuwese, *Brothers in Arms*; on WIC involvement in the slave trade, see Johannes Menne Postma, *The Dutch in the Atlantic Slave Trade, 1600–1815* (New York: Cambridge University Press, 1990), 1–24; on slave revolt in Brazil, see Stuart B. Schwartz, *Slaves, Peasants, and Rebels: Reconsidering Brazilian Slavery* (Urbana: University of Illinois Press, 1992), 103–36.

34. On the pacifying response to conflict in seventeenth-century Dutch art, see Svetlana Alpers, *The Vexations of Art: Velázquez and Others* (New Haven, Conn.: Yale University Press, 2005), 83–109.

35. Karel van Mander, *The Lives of the Illustrious Netherlandish and German Painters,* ed. Hessel Miedema, vol. l, trans. Jacqueline Pennial-Boer and Charles Ford (Doornspijk: Davaco, 1994), 50. Also see Walter Melion, *Shaping the Netherlandish Canon: Karel van Mander's Schilder-Boeck* (Chicago: The University of Chicago Press, 1991), 7, and Walter S. Gibson, *Pleasant Places: The Rustic Landscape from Bruegel to Ruisdael* (Berkeley: University of California Press, 2000), 68.

36. See Gehring, "Painted Topographies."

37. Lawrence Weschler, "Inventing Peace," *The New Yorker* 71, no. 37 (November 20, 1995): 57. Also see the discussion of this essay in Bryan Jay Wolf, *Vermeer and the Invention of Seeing* (Chicago: University of Chicago Press, 2001), 192–93.

38. For a recent reflection on the ways landscape resists the critical formulas of the art historian, see Jennifer Raab, "Landscape and the Risk of Metaphor," *American Art* 3, no. 2 (Summer 2017): 56–58.

39. On the early humanist as *orator,* see Michael Baxandall, *Giotto and the Orators: Humanist Observers of Painting in Italy and the Discovery of Pictorial Composition, 1350–1450* (Oxford: Clarendon, 1971), 1–4, and Hanna H. Gray, "Renaissance Humanism: The Pursuit of Eloquence," *Journal of the History of Ideas* 24, no. 4 (October–December 1963), 500.

40. Leon Battista Alberti, *On Painting,* trans. John R. Spencer (New Haven, Conn.: Yale University Press, 1966), 73–74; John R. Spencer, "Ut Rhetorica Pictura: A Study in Quattrocento Theory of Painting," *Journal of the Warburg and Courtauld Institutes* 20, no. 1–2 (January–June 1957), 33–34.

41. Alberti quoted in Anthony Grafton, *Worlds Made by Words: Scholarship and Community in the Modern West* (Cambridge, Mass.: Harvard University Press, 2009), 38. The quotation is from Alberti, *De re aedificatoria* 7.10. On Alberti and the *istoria,* see Grafton, *Worlds Made by Words,* 35–55.

42. On the San Zeno altarpiece and the kind of humanist ekphrasis that it might have elicited from the Renaissance viewer, see Keith Christiansen, "The Genius of Andrea Mantegna," *The Metropolitan Museum of Art Bulletin* 67, no. 2 (Fall 2009): 18–26.

43. Pliny the Elder, *Natural History,* vol. 9, *Books 33–35,* trans. H. Rackham, Loeb Classical Library 394 (Cambridge, Mass.: Harvard University Press, 1952), 336–37. On the meaning of the term *parergon* and its adoption by Renaissance commentators on landscape, see E. H. Gombrich, "The Renaissance Theory of Art and the Rise of Landscape," in *Norm and Form: Studies in the Art of the Renaissance* (Chicago: University of Chicago Press, 1966), 114–15, and Christopher S. Wood, *Albrecht Altdorfer and the Origins of Landscape* (London: Reaktion, 1993), 54–65.

44. Wood, *Albrecht Altdorfer,* 9.

45. Thomas Blount, *Glossographia* (London: printed by Thomas Newcomb, 1656), Y8r, quoted in Wood, *Albrecht Altdorfer,* 57.

46. Karel van Mander, *The Foundation of the Noble Free Art of Painting,* trans. Elizabeth A. Honig et al. (New Haven: E. A. Honig, 1985), 27. On van Mander's understanding of the relationship between history and landscape, see Melion, *Shaping the Netherlandish Canon,* 1–12; and Bakker, *Landscape and Religion,* 175–97.

47. Svetlana Alpers, *The Art of Describing: Dutch Art in the Seventeenth Century* (Chicago: University of Chicago Press, 1983), 159.

48. See Alpers's discussion of this painting in *Art of Describing,* 119–26, 165–68.

49. See, for example, Anthony Grafton and Thomas DaCosta Kaufmann, "Holland without Huizinga: Dutch Visual Culture in the Seventeenth Century," *Journal of Interdisciplinary History* 16, no. 2 (Autumn 1985): 255–65.

50. Grafton and Kaufmann, "Holland without Huizinga," 261–63.

51. Alpers, *Art of Describing,* xxii.

52. See, for example, John Barrell, *The Dark Side of the Landscape: The Rural Poor in English Painting, 1730–1840* (Cambridge: Cambridge University Press, 1980); David H. Solkin, *Richard Wilson: The Landscape of Reaction* (London: Tate Gallery, 1982); Ann Bermingham, *Landscape and Ideology: The English Rustic Tradition, 1740–1860* (Berkeley: University

of California Press, 1986); and Andrew Hemingway, *Landscape Imagery and Urban Culture in Early Nineteenth-Century Britain* (Cambridge: Cambridge University Press, 1992).

53. Barrell, *Dark Side of the Landscape,* 149. On the absorption of Constable's figures in the landscape, see Bermingham, *Landscape and Ideology,* 138–40.

54. For an overview of this historiography, see Bakker, *Landscape and Religion,* 199–229.

55. Julie Hochstrasser, "Remapping Dutch Art in Global Perspective: Other Points of View," in *Cultural Contact and the Making of European Art since the Age of Exploration,* ed. Mary D. Sheriff (Chapel Hill: University of North Carolina Press, 2010), 64.

56. Hochstrasser, "Remapping Dutch Art," 50. This "surface" reading, however, is itself questionable, since the Dutch colony in Brazil had come to an end in 1654. As Schmidt argues, Post's later Brazilian works are better interpreted through a discourse of exoticism than one of nationalistic pride ("The 'Dutch Atlantic'").

57. In June 1645, Brosterhuyzen wrote to Constantijn Huygens that he had begun etching Post's drawings (Boogaart, "A Well-Governed Colony," 238). Post's drawings are located in the British Museum: Prints and Drawings, 1928,0310.90. They are catalogued in Leonardo Dantas Silva, *Dutch Brazil: Frans Post, The British Museum Drawings* (Petrópolis: Editora Index, 2000).

58. Barlaeus, *History,* 44.

59. Barlaeus, *History,* 72.

60. Barlaeus, *History,* 72.

61. *Mauritius redux* is included at the end of Barlaeus's *Historia*: Caspar Barlaeus, *Rerum per octennium in Brasilia . . . historia* (Amsterdam: Joannes Blaeu, 1647), 334–40. On the poems by Barlaeus in celebration of Dutch military victories, see A. J. E. Harmsen, "Barlaeus's Description of the Dutch Colony in Brazil," in *Travel Fact and Travel Fiction: Studies on Fiction, Literary Tradition, Scholarly Discovery, and Observation in Travel Writing,* ed. Z. R. W. M. von Martels (New York: Brill, 1994), 161–63.

62. Barlaeus, *History,* 20. On Barlaeus's decidedly humanist perspective on Dutch Brazil, see Schmidt, *Innocence Abroad,* 254–57.

63. Anthony Grafton, *What Was History?: The Art of History in Early Modern Europe* (Cambridge: Cambridge University Press, 2007), 21.

64. Nicholas Wickenden, *G. J. Vossius and the Humanist Concept of History* (Assen: Van Gorcum, 1993), 23. On the relevance of Vossius's *Ars historica* to Barlaeus's *Historia,* see Harmsen, "Barlaeus's Description."

65. Wickenden, *G. J. Vossius,* 65.

66. Wickenden, *G. J. Vossius,* 211–12; Grafton, *What Was History?,* 45.

67. Gray, "Renaissance Humanism," 498. On the importance of eloquence in teaching at the Amsterdam Athenaeum, see Dirk van Miert, *Humanism in an Age of Science: The Amsterdam Athenaeum in the Golden Age, 1632–1704* (Boston: Brill, 2009).

68. ". . . Poesin vel aequet, vel vincat: sed etiam paria Historiae faciat." Gerardus Joannes Vossius, *De quatuor artibus popularibus: grammatistice, gymnastice, musice, et graphice* (Amsterdam: Joannes Bleau, 1650), 66–67. On the breadth and flexibility of the term "historia," see Grafton, *Worlds Made by Words,* 35–55.

69. Barlaeus, *History,* 161.

70. Barlaeus, *History,* 1 (quotation slightly modified).

71. Barlaeus, *History,* 100. The "ostriches" that the Dutch encountered in Brazil were rheas.

72. This occurs in a poem entitled "In tabulam oppositam" that explicates the meanings of the book's emblematic frontispiece, which shows four cherubs blowing the trumpets of Fame: "At quam, Fama, vides, lituos inflare tubasque, / Non vim, sed speciem, tanta loquentis habet" (Barlaeus, *Rerum per octennium* [unpaginated]).

73. Alberti, *On Painting,* 78.

74. In his essay "Why Look at Animals?," John Berger writes of the difference between meeting the look of an animal and meeting that of another human. The animal's "lack of common language, its silence, guarantees its distance, its distinctness, its exclusion, from and of man" (John Berger, *About Looking* [New York: Pantheon, 1980], 4).

3. MAGICAL PICTURES

1. Charles Brockden describes the event in a letter to Thomas Noble of July 21, 1745 (Milton J. Coalter Jr., *Gilbert Tennent, Son of Thunder: A Case Study of Continental Pietism's Impact on the First Great Awakening in the Middle Colonies* [New York: Greenwood, 1986], 125–26).

2. Coalter, *Gilbert Tennent,* 126.

3. Gilbert Tennent, *All Things Come Alike to All: A Sermon, On Eccles. IX. 1, 2 and 3 Verses. Occasioned by a Person's Being Struck by the Lightning and Thunder* (Philadelphia: printed by William Bradford, 1745), 40.

4. Benjamin Franklin, *New Experiments and Observations on Electricity* (London: D. Henry and R. Cave, 1754), 112.

5. The phrase "Prometheus of modern times" appears in Kant's essay from 1756: "Continued observations on the earthquakes that have been experienced for some time," trans. Olaf Reinhardt, in *The Cambridge Edition of the Works of Immanuel Kant: Natural Science,* ed. Eric Watkins (Cambridge: Cambridge University Press, 2012), 373. It should be noted that Kant's praise for Franklin is decidedly ambivalent (even though the literature on Franklin never notes this fact, despite the frequency with which the phrase is quoted). The full passage is monitory: in Kant's view, Promethean endeavors such as Franklin's ultimately lead man "to the humbling reminder, which is where he ought properly to start, that he is never anything more than a human being."

6. See Mary D. Sheriff, "Au Génie de Franklin: An Allegory by J.-H. Fragonard," *Proceedings of the American Philosophical Society* 127, no. 3 (June 1983): 180–93. There is a third portrait made during Franklin's lifetime that directly associates him with the lightning. Painted by Charles Willson Peale in 1789 and in the collection of the Philadelphia History Museum, the portrait shows an older Franklin who is seated, holding a lightning rod, with a bolt of lightning out the window. On the portraiture of Franklin, see also Brandon Frame Fortune and Deborah J. Warner, *Franklin & His Friends: Portraying the Man of Science in Eighteenth Century America* (Washington, D.C.: Smithsonian National Portrait

Gallery, 1999); Deborah Jean Warner, "Portrait Prints of Men of Science in Eighteenth-Century America," *Imprint* 25, no. 1 (Spring 2000), 26–33; Wayne Craven, "The American and British Portraits of Benjamin Franklin," in *Reappraising Benjamin Franklin: A Bicentennial Perspective,* ed. J. A. Leo Lemay (Newark: University of Delaware Press, 1993), 247–71; Richard Dorment, *British Painting in the Philadelphia Museum of Art: From the Seventeenth through the Nineteenth Century* (Philadelphia: Philadelphia Museum of Art, 1986), 38–44; and Charles Coleman Sellers, *Benjamin Franklin in Portraiture* (New Haven, Conn.: Yale University Press, 1962).

7. William T. Whitley, *Artists and their Friends in England, 1700–1799* (London: Medici Society, 1928), 375. The key sources on Chamberlin's life are Whitley, 83–84, and Edward Edwards, *Anecdotes of Painters who have Resided or been Born in England* (London: Leigh and Sotheby, 1808), 121–22.

8. On the circulation of the print, see Warner, "Portrait Prints," 27–28, and Fortune and Warner, *Franklin & His Friends, 77.*

9. Benjamin Franklin, Letter to Jonathan Williams of February 24, 1764, in *The Papers of Benjamin Franklin,* vol. 11, ed. Leonard W. Labaree (New Haven, Conn.: Yale University Press, 1967), 89.

10. James Delbourgo, *A Most Amazing Scene of Wonders: Electricity and Enlightenment in Early America* (Cambridge, Mass.: Harvard University Press, 2006), 16.

11. Ebenezer Kinnersley, "Notice is hereby given to the Curious," *The New York Gazette,* or *Weekly Post-Boy,* June 1, 1752.

12. Mircea Eliade, *Patterns in Comparative Religion* (New York: Sheed and Ward, 1958), 38.

13. Lucretius, *The Nature of Things,* trans. A. E. Stallings (London: Penguin, 2007), 187.

14. Psalm 77:17, in *The Bible: Authorized King James Version,* ed. Robert Carroll and Stephen Pricket (Oxford: Oxford University Press, 1997), 681. See also Pss. 18:14 and 144:6 and Zech. 9:14. For a medieval example of this iconography, see the thirteenth-century *Bible moralisée,* Oxford, Bodleian Library, MS 270b, fol. 132r: in one of the illustrated roundels on this page, God sends down lightning in the form of arrow heads onto the Saracens.

15. See the recent critical edition: Julius Wilhelm Zincgref, *Emblematum ethico-politica,* 2 vols., ed. Dieter Mertens and Theodor Verweyen (Tübingen: M. Niemeyer, 1993).

16. See Robert Blair St. George, *Conversing by Signs: Poetics of Implication in Colonial New England Culture* (Chapel Hill: University of North Carolina Press, 1998), 181–83, and David D. Hall, *Worlds of Wonder, Days of Judgment: Popular Religious Belief in Early New England* (New York: Alfred A. Knopf, 1989).

17. Cotton Mather, *The Christian Philosopher,* ed. Winton U. Solberg (Urbana: University of Illinois Press, 1994), 72. See also James Campbell, *Recovering Benjamin Franklin: An Exploration of a Life of Science and Service* (Peru, Ill.: Carus, 1999), 64.

18. John Adams quoted in I. Bernard Cohen, *Benjamin Franklin's Science* (Cambridge, Mass.: Harvard University Press, 1990), 153. On debates about conductors, see Cohen, 118–58, and Delbourgo, *Most Amazing Scene, 50–86.*

19. On the significance of Priestley's publication for the historiography of electricity, see Simon Schaffer, "The Consuming Flame: Electrical Showmen and Tory Mystics in the World of Goods," in *Consumption and the World of Goods,* ed. John Brewer and Roy Porter (London: Routledge, 1993), 512–15.

20. See Schaffer, "Consuming Flame," 512–15.

21. William Law, *Appeal to All that Doubt, or Disbelieve, the Truths of the Gospel* (London: printed for W. Innys, 1742), 163. The same passage is quoted in John Freke, *An Essay to Shew the Cause of Electricity* (London: printed from W. Innys, 1746), 14, and Schaffer, "Consuming Flame," 502.

22. On Freke's enthusiasm, see Schaffer, "Consuming Flame," 502–4. On the history of enthusiasm generally in early modern Europe, see Michael Heyd, *"Be Sober and Reasonable": The Critique of Enthusiasm in the Seventeenth and Early Eighteenth Centuries* (New York: Brill, 1995). On the significance of "exercised bodies" in the revivals of the Great Awakening, see Douglas L. Winiarski, *Darkness Falls on the Land of Light: Experiencing Religious Awakenings in Eighteenth-Century New England* (Chapel Hill: Omohundro Institute of Early American History and Culture and University of North Carolina Press, 2017).

23. Gilbert Tennent, *The Danger of an Unconverted Ministry* (Philadelphia: printed by Benjamin Franklin, 1740), 9, 10. On the significance of Tennent's sermon, see Thomas S. Kidd, *The Great Awakening: The Roots of Evangelical Christianity in Colonial America* (New Haven, Conn.: Yale University Press, 2007), 55–67; and Coalter, *Gilbert Tennent,* 64–67.

24. Richard Webster, *A History of the Presbyterian Church in America* (Philadelphia: Joseph M. Wilson, 1857), 471. Also see J. A. Leo Lemay, *Ebenezer Kinnersley: Franklin's Friend* (Philadelphia: University of Pennsylvania Press, 1964), 19–20, and Nina Reid-Maroney, *Philadelphia's Enlightenment, 1740–1800: Kingdom of Christ, Empire of Reason* (Westport, Conn.: Greenwood, 2001), 52–53.

25. Ebenezer Kinnersley, *Pennsylvania Gazette,* July 24, 1740, as quoted in Kidd, *The Great Awakening,* 66, and Lemay, *Ebenezer Kinnersley,* 20.

26. On Kinnersley's lectures see Lemay, *Ebenezer Kinnersley,* 62–87, and Reid-Maroney, *Philadelphia's Enlightenment,* 56–60.

27. On the *Venus Electrificata* see Delbourgo, *Most Amazing Scene,* 115–19. It is important to note that experimentalists could themselves be charged with enthusiasm (see Heyd, *Be Sober and Reasonable,* 144–64).

28. Franklin was the publisher of Whitefield's sermons and journals. On the friendship and collaboration between Franklin and Whitefield, see Frank Lambert, "Subscribing for Profits and Piety: The Friendship of Benjamin Franklin and George Whitefield," *The William and Mary Quarterly* 50, no. 3 (July 1993): 529–54.

29. On the ringing of church bells, see Cohen, *Benjamin Franklin's Science,* 119–25.

30. The experiment with the bells and cork balls is mentioned in the letter of April 18, 1754 (Franklin, *New Experiments and Observations,* 128–29).

31. Franklin quoted in Cohen, *Benjamin Franklin's Science,* 90. See also Delbourgo, *Most Amazing Scene,* 60.

32. J. A. Leo Lemay, *Life of Benjamin Franklin,* vol. 3, *Soldier, Scientist, and Politician, 1748–1757* (Philadelphia: University of Pennsylvania Press, 2009), 129; Joyce E. Chaplin, *The First Scientific American: Benjamin Franklin and the Pursuit of Genius* (New York: Basic, 2006), 138.

33. Fortune and Warner, *Franklin & His Friends,* 74.

34. Joseph Priestley, *History and Present State of Electricity* (1775), as quoted in Simon Schaffer, "Natural Philosophy and Public Spectacle in the Eighteenth Century," *History of Science* 21 (1983): 8.

35. Benjamin Franklin, *Experiments and Observations on Electricity* (London: E. Cave, 1751), 59–62.

36. Kinnersley, "Notice is hereby given."

37. William Watson, *Expériences et observations pour servir à l'explication de la nature et des propriétés de l'éctricité* (Paris: Sebastien Jorry, 1748), 140. On Watson's place in the London electrical community, see Schaffer, "Consuming Flame," 496–99.

38. Priestley quoted in Schaffer, "Natural Philosophy and Public Spectacle," 8.

39. Franklin, *Experiments and Observations,* 60.

40. Pieter van Musschenbroek, Letter to René-Antoine Réamur of January 20, 1746, as quoted in J. L. Heilbron, *Electricity in the 17th and 18th Centuries: A Study of Early Modern Physics* (Berkeley: University of California Press, 1979), 313.

41. William Watson, "A Sequel to the Experiments and Observations Tending to Illustrate the Nature and Properties of Electricity," *Philosophical Transactions* 44 (1746–1747): 715–16.

42. See Delbourgo, *Most Amazing Scene,* 14–15, 60.

43. This is true of the original painting, although Fisher's mezzotint does show Franklin's writing on the sheet.

44. Pliny, *Natural History,* vol. 9, *Books 33–35,* trans. H. Rackham, Loeb Classical Library 394 (Cambridge, Mass.: Harvard University Press, 1952), 333.

45. Erwin Panofsky, "Erasmus and the Visual Arts," *Journal of the Warburg and Courtauld Institutes* 32 (1969): 225.

46. Immanuel Kant, *Critique of the Power of Judgment,* ed. Paul Guyer, trans. Paul Guyer and Eric Matthews (Cambridge: Cambridge University Press, 2000), 144.

47. On Warburg's misinterpretation of the Hopi dances, see David Freedberg, "Warburg's Mask: A Study in Idolatry," in *Anthropologies of Art,* ed. Mariet Westermann (Williamstown, Mass.: Clark Institute, 2005), 3–25. On Warburg's mythic thought, see Joseph Mali, *Mythistory: The Making of a Modern Historiography* (Chicago: University of Chicago Press, 2003), 133–86.

48. Aby M. Warburg, *Images from the Region of the Pueblo Indians of North America,* trans. Michael P. Steinberg (Ithaca, N.Y.: Cornell University Press, 1995), 51.

49. Warburg, *Images,* 50. Warburg mentions Franklin in the company of the Wright brothers, "the modern Icarus" (Warburg, 54).

50. Max Weber, *The Protestant Ethic and the Spirit of Capitalism,* trans. Stephen Kalberg (Los Angeles: Roxbury, 2002), 14–18.

51. Warburg, *Images*, 53.

52. Warburg, *Images*, 17.

53. Smith's original mezzotint of 1714 showed George II as Prince of Wales. A crown was later added after he became king, and the print was often copied and reissued.

54. Franklin, *Experiments and Observations*, 27.

55. My brief account of Vaucanson's automaton relies on Jessica Riskin's discerning interpretation in "The Defecating Duck, or, The Ambiguous Origins of Artificial Life," *Critical Inquiry* 29, no. 4 (Summer 2003): 599–633. Voltaire is quoted in Riskin, 601. On the question of the authenticity of the duck's digestion, also see d'Alembert's entry on "Automaton" in the *Encyclopédie,* which notes of Vaucanson's duck that "the inventor does not pretend that this digestion is perfect, capable of producing blood and nutritional fluids to sustain the animal, and it would be churlish to criticize him for it" (Jean-Baptiste le Rond d'Alembert, "Automaton," in *The Encyclopedia of Diderot & d'Alembert Collaborative Translation Project,* trans. Nelly S. Hoyt and Thomas Cassirer [Ann Arbor: University of Michigan Library, 2003], hdl.handle.net/2027/spo.did2222.0000.140; originally published as "Automate," *Encyclopédie ou Dictionnaire raisonné des sciences, des arts et des métiers,* vol. 1 [Paris, 1751], 896–97).

56. Wendy Bellion, *Citizen Spectator: Art, Illusion, and Visual Perception in Early National America* (Chapel Hill: Omohundro Institute of Early American History and Culture and University of North Carolina Press, 2011). On the politics of Enlightenment entertainments, also see Delbourgo, *Most Amazing Scene,* 129–64, and Barbara Marie Stafford, *Artful Science: Enlightenment Entertainment and the Eclipse of Visual Education* (Cambridge, Mass.: MIT Press, 1996).

57. On the *Staircase Group,* see Bellion, *Citizen Spectator,* 63–111.

58. Franklin, *Experiments and Observations*, 28.

59. The most important of these early merchant accounts is Willem Bosman, *A New and Accurate Description of the Coast of Guinea* (London: printed for James Knapton, 1705). Bosman's text was first published in Dutch in 1703. On the development of the fetish in the early modern Atlantic, see the three essential articles by William Pietz: "The Problem of the Fetish, I," *Res: Anthropology and Aesthetics* 9 (Spring 1985): 5–17; "The Problem of the Fetish, II: The Origin of the Fetish," *Res: Anthropology and Aesthetics* 13 (Spring 1987): 23–45; and "The Problem of the Fetish, IIIa: Bosman's Guinea and the Enlightenment Theory of Fetishism," *Res: Anthropology and Aesthetics* 16 (Autumn 1988): 105–24. Also see W. J. T. Mitchell, *What Do Pictures Want?: The Lives and Loves of Images* (Chicago: University of Chicago Press, 2005), 145–68, 188–96.

60. Charles de Brosses, "On the Worship of the Fetish Gods: Or, A Parallel of the Ancient Religion of Egypt with the Present Religion of Nigritia," trans. Rosalind C. Morris and Daniel H. Leonard in *The Returns of Fetishism: Charles de Brosses and the Afterlives of an Idea* (Chicago: University of Chicago Press, 2017), 45. See also Rosalind C. Morris, "After de Brosses: Fetishism, Translation, Comparativism, Critique," in Morris and Leonard, 133–319.

61. Charles Blount, *The Miscellaneous Works* (London, 1695), 6. On imposture theory and anticlericalism in Enlightenment thought, see Peter Harrison, *"Religion" and the*

Religions in the English Enlightenment (Cambridge: Cambridge University Press, 1990), and S. J. Barnett, *Idol Temples and Crafty Priests: The Origins of Enlightenment Anticlericalism* (New York: St. Martin's Press, 1999).

62. See Bernard Le Bovier de Fontenelle, *The History of Oracles and the Cheats of the Pagan Priests* (London, 1688). On Fontenelle's *Histoire des oracles,* and on the Enlightenment critique of oracles more generally, see Eric Schmidt, *Hearing Things: Religion, Illusion, and the American Enlightenment* (Cambridge, Mass.: Harvard University Press, 2000), 78–101, and Jonathan I. Israel, *Radical Enlightenment: Philosophy and the Making of Modernity, 1650–1750* (Oxford: Oxford University Press, 2001), 359–74.

63. On Pinchbeck's "acoustic temple," see Schmidt, *Hearing Things,* 78–81, and Bellion, *Citizen Spectator,* 247–50.

64. Franklin, *Experiments and Observations,* 28.

65. T. H. Breen, "An Empire of Goods: The Anglicanization of Colonial America, 1690–1776," *Journal of British Studies* 25, no. 4 (October 1986): 467–99.

66. R. T. Haines Halsey, "Early Engravings in Colonial Houses," *The Metropolitan Museum of Art Bulletin* 19, no. 8 (August 1924): 198. On the popularity of imported engravings in the colonies also see Peter John Vivian Moore, "British Graphic Art, 1660–1735: An Atlantic Perspective" (PhD diss., York University, 2013). Moore stresses the importance of an Atlantic framework for understanding the popularity of the "British print."

67. On mezzotints and lacquered furniture, see Halsey, "Early Engravings," 200. On "painting on glass," see Moore, "British Graphic Art," 233, and Ann Massing, "From Print to Painting: The Technique of Glass Transfer Painting," *Print Quarterly* 6, no. 4 (December 1989): 383–93.

68. See David Alexander, "The Dublin Group: Irish Mezzotint Engravers in London, 1750–1775," *Quarterly Bulletin of the Irish Georgian Society* 16, no. 3 (July–September 1973): 72–93.

69. See Tim Clayton, "'Figures of Fame': Reynolds and the Printed Image," in *Joshua Reynolds: The Creation of Celebrity,* ed. Martin Postle (London: Tate, 2005), 49–59.

70. James Chelsum, *A History of the Art of Engraving in Mezzotinto, from its Origin to the Present Times* (Winchester: printed by J. Robbins, 1786), 4.

71. Joseph Roach, *It* (Ann Arbor: University of Michigan Press, 2007), 3.

72. See Warner, "Portrait Prints," 27–28.

73. Benjamin Franklin, Letter to Thomas-François Dalibard of September 22, 1769, in *The Papers of Benjamin Franklin,* vol. 16, ed. William B. Willcox (New Haven, Conn.: Yale University Press, 1972), 205.

4. AT THE MOUTH OF THE CAVE

1. Alois Riegl, "Die Stimmung als Inhalt der modernen Kunst," in *Die Graphischen Künste,* ed. Friedrich Dörnhöffer and Karl Masner (Vienna: Gesellschaft für Vervielfältigende Kunst, 1899), 47–48.

2. On Riegl's concept of *Stimmung,* see Moshe Barasch, *Theories of Art 3: From Impressionism to Kandinsky* (New York: Routledge, 2000), 155–60.

3. Riegl, "Die Stimmung," 54.

4. G. W. F. Hegel, *Aesthetics: Lectures on Fine Art,* vol. 1, trans. T. M. Knox (Oxford: Clarendon, 1975), 11.

5. For some recent reflections on the complexity of Hegel's statement, see Hans Belting, *The End of the History of Art?,* trans. Christopher S. Wood (Chicago: University of Chicago Press, 1987); Georges Didi-Huberman, *Confronting Images: Questioning the Ends of a Certain History of Art,* trans. John Goodman (University Park: Penn State University Press, 2005), 47–52; and Giorgio Agamben, *The Man Without Content,* trans. Georgia Albert (Stanford. Calif.: Stanford University Press, 1999), 52–58. As for Riegl, the dialectical relationship between *Nahsicht* and *Fernsicht* cannot be fully explained as a developmental history, since the concepts are tied to human perceptual faculties (vision and touch) that are not primarily historical. The relationship between the two becomes increasingly complex in Riegl's later work. See Margaret Iverson, *Alois Riegl: Art History and Theory* (Cambridge, Mass.: MIT Press, 1993), 10–14. On Riegl's difficult relationship to historicism, also see Diane Reynolds Cordileone, "The Advantages and Disadvantages of Art History to Life: Alois Riegl and Historicism," *Journal of Art Historiography* 3 (December 2010), arthistoriography.files.wordpress.com/2011/02/media_183170_en.pdf.

6. Bryan Jay Wolf, *Romantic Re-Vision: Culture and Consciousness in Nineteenth-Century American Painting and Literature* (Chicago: University of Chicago Press, 1982), 195.

7. Alan Wallach, "The Word from Yale," *Art History* 10, no. 2 (June 1987): 256–57.

8. See, for example, Angela Miller, *The Empire of the Eye: Landscape Representation and American Cultural Politics, 1825–1875* (Ithaca, N.Y.: Cornell University Press), 1993; Alan Wallach, "Making a Picture of the View from Mount Holyoke," in *American Iconology: New Approaches to Nineteenth-century Art and Literature,* ed. David C. Miller (New Haven, Conn.: Yale University Press, 1995), 80–91; Alan Wallach, "Wadsworth's Tower: An Episode in the History of American Landscape Vision," *American Art* 10, no. 3 (Autumn 1996): 8–27; Kenneth Myers, *The Catskills: Painters, Writers, and Tourists in the Mountains, 1820–1895* (Yonkers, N.Y.: Hudson River Museum of Westchester, 1988); Myers, "Art and Commerce in Jacksonian America: The Steamboat Albany Collection," *Art Bulletin* 82, no. 3 (September 2000): 503–28; Rebecca Bedell, *The Anatomy of Nature: Geology and American Landscape Painting, 1825–1875* (Princeton, N.J.: Princeton University Press, 2001); and David Bjelajac, "Thomas Cole's Oxbow and the American Zion Divided," *American Art* 20, no. 1 (Spring 2006): 61–83.

9. See *Thomas Cole: Landscape into History,* ed. William H. Truettner and Alan Wallach (New Haven, Conn.: Yale University Press, 1994). The book's subtitle is, of course, a response to Kenneth Clark's *Landscape into Art* (London: J. Murray, 1949).

10. Reprinted in Ellwood C. Parry III, *The Art of Thomas Cole: Ambition and Imagination* (Newark: University of Delaware Press, 1988), 25–26.

11. Thomas Cole, Letter to Daniel Wadsworth of November 20, 1826, in *The Correspondence of Thomas Cole and Daniel Wadsworth,* ed. J. Bard McNulty (Hartford: Connecticut Historical Society, 1983), 4. The painting was later engraved and published in John

Howard Hinton, *The History and Topography of the United States,* vol. 2 (London: Simpkin & Marshall, 1832).

12. James Fenimore Cooper, *The Pioneers* (New York: Bantam, 1993), 374.

13. See Edward S. Casey, *Representing Place: Landscape Painting and Maps* (Minneapolis: University of Minnesota Press, 2002), 56–73. Myers has also emphasized the participatory aspect of Cole's *Kaaterskill Falls,* contrasting the painting to Cole's picturesque *Lake with Dead Trees* (1825), which Myers interprets as its pendant: "*Kaaterskill Falls* denies the viewer this kind of physical and interpretive distance in order to draw him or her into a less mediated encounter with the scene" (*Catskills,* 44).

14. Historians of American art began telling Trumbull's discovery story during Cole's own lifetime. The same day he purchased the original canvas of *Kaaterskill Falls,* Trumbull showed Cole's landscapes to the playwright and historian William Dunlap, who purchased one for himself. It was Dunlap, writing under the pseudonym "American," who authored the original *New-York Evening Post* article and nine years later retold that story in his *History of the Rise and Progress of the Arts of Design in the United States,* ed. Alexander Wyckoff, vol. 3 (New York: George F. Scott, 1965), 149–50.

15. Myers reads the Indian standing on the cliff as he reads the falls themselves, as elements through which "the individual momentarily forgets his or her apartness from the observed scene and experiences it *as if* directly" (*Catskills,* 44). While I largely agree with Myers's compelling interpretation of the painting, I would also qualify it by arguing that the Indian invites an optical identification that stands in contrast to, or rather as a sublimation of, the fuller sensory involvement that Cole invites in the foreground.

16. Cooper, *Pioneers,* 374. The platform at the top of the falls was built sometime between 1823 and 1825, when Cole made a sketch of Kaaterskill Falls that includes it (Myers, *Catskills,* 42 and 83n56, and Tracie Felker, "First Impressions: Thomas Cole's Drawings of His 1825 Trip up the Hudson River," *The American Art Journal* 24, no. 1/2 [1992]: 76).

17. Thomas Cole, *The Collected Essays and Prose Sketches,* ed. Marshall Tymn (St. Paul, Minn.: John Colet Press, 1980), 3.

18. Cole, *Collected Essays and Prose Sketches,* 12.

19. For the allegory of the cave, see Plato, *Republic* 514a–517a, trans. G. M. A. Grube, rev. C. D. C. Reeve (Indianapolis, Ind.: Hackett, 1992). For a recent consideration of the links between the figure of the cave and image-making, see Mark A. Cheetham and Elizabeth D. Harvey, "Obscure Imaginings: Visual Culture and the Anatomy of Caves," *Journal of Visual Culture* 1, no. 1 (April 2002): 105–26. For a discussion of the figure of the cave in American romantic literature, see Clark Griffith, "Caves and Cave Dwellers: The Study of a Romantic Image," *Journal of English and Germanic Philology* 62, no. 3 (July 1963): 551–68.

20. Cole, *Collected Essays and Prose Sketches,* 101.

21. See Louis Legrand Noble, *The Life and Works of Thomas Cole,* ed. Elliot S. Vesell (Hensonville, N.Y.: Black Dome, 1997), 214.

22. Thomas Cole, Letter to Daniel Wadsworth of April 23, 1828, in McNulty, *Correspondence of Thomas Cole and Daniel Wadsworth,* 38.

23. On Wall's view, see John K. Howat, "A Picturesque Site in the Catskills: The Kaaterskill Falls as Painted by William Guy Wall," *Honolulu Academy of Arts Journal* 1 (1974): 16–29.

24. Cole as quoted in Noble, *Life and Works of Thomas Cole,* 259.

25. One finds a persistent doubling back between sound and sight throughout Cole's work, as exemplified in a journal entry of 1834 describing an idea for a piano that "might be constructed by which color could be played" (Noble, *Life and Words of Thomas Cole,* 141). While one could attribute Cole's idea to a general romantic interest in synaesthesia, it nevertheless speaks to his refusal to dissociate vision from other forms of bodily experience. On the history of the "ocular harpsichord," see Thomas L. Hankins and Robert J. Silverman, *Instruments and the Imagination* (Princeton, N.J.: Princeton University Press, 1995), 72–85.

26. Another early painting by Cole that shares this composition is *The Subsiding of the Waters of the Deluge* (1829, National Museum of American Art), which corresponds closely in its structure to the drawing of *Elijah at the Mouth of the Cave.*

27. 1 Kings 19:13, in *The Bible: Authorized King James Version,* ed. Robert Carroll and Stephen Pricket (Oxford: Oxford University Press, 1997), 439.

28. Cole, *Collected Essays and Prose Sketches,* 12.

29. See Michel de Certeau, "Quotations of Voices," in *The Practice of Everyday Life,* trans. Steven Rendall (Berkeley: University of California Press, 1984), 154–64.

30. Some scholars have already observed links between the clamor of Cole's art and the clamor of revivalism. Bryan Wolf, for example, notes that Cole's *The Bewilderment* echoes in its "language of bewilderment and release the rhetoric of contemporary revivalist sermons" (*Romantic Re-Vision,* 219), while Barbara Novak has observed how the operatic qualities of certain nineteenth-century American landscapes remind one "of the noisy conversions of the evangelical revival especially prominent in the upstate New York area that spawned so many Hudson River painters: shouting, biting, groaning, etc." (*Nature and Culture: American Landscape and Painting, 1825–1875,* 3rd ed. [Oxford: Oxford University Press, 2007], 32).

31. The sketchbook is housed in the New York State Library, Albany (Thomas Cole Papers, VC10635), but the list of paintings has been published in *Annual II / Baltimore Museum of Art: Studies on Thomas Cole, An American Romanticist,* 1967, 82–100.

32. An important early account of the revivals in the "western country" is Theophilus Armenius, "Account of the Rise and Progress of the Work of God in the Western Country," *The Methodist Magazine* 2 (1819): 184–87, 221–24, 272–74, 304–8, 349–53, 393–96, 434–39.

33. See Nathan O. Hatch, *The Democratization of American Christianity* (New Haven, Conn.: Yale University Press, 1989).

34. George Whitefield, *Some Remarks on a Pamphlet, Entituled The Enthusiasm of Methodists and Papists Compar'd* (Philadelphia: W. Bradford, 1749), 10.

35. On Wesley and Whitefield as field preachers, see Ian Maddock, *Men of One Book: A Comparison of Two Methodist Preachers, John Wesley and George Whitefield* (Cambridge: Lutterworth, 2012), 36–69.

36. On the origins of the camp meeting, see Charles A. Johnson, *The Frontier Camp Meeting: Religion's Harvest Time* (Dallas, Tex.: Southern Methodist University Press, 1955).

37. On the Great Awakening as a transatlantic mobilization of the common people, see Peter Linebaugh and Marcus Rediker, *The Many-Headed Hydra: Sailors, Slaves, Commoners, and the Hidden History of the Revolutionary Atlantic* (Boston: Beacon, 2000), 190–93. On the translatlantic aspects of revivalism, also see Richard Carwardine, *Transatlantic Revivalism: Popular Evangelicalism in Britain and America, 1790–1865* (Westport, Conn.: Greenwood, 1978).

38. On revivalism as an antimarket force in the early republic, see Charles Sellers, *The Market Revolution: Jacksonian America, 1815–1846* (Oxford: Oxford University Press, 1991). On English Methodism as a disciplinary and regressive social force, see E. P. Thompson, *The Making of the English Working Class*, rev. ed. (Harmondsworth, UK: Penguin, 1980). For a counter to Thompson that emphasizes the flexible and adaptable nature of the Methodist revivals, see David Hempton, *The Religion of the People: Methodism and Popular Religion, c. 1750–1900* (London: Routledge, 1996). On the democratizing impulse in the revivals, see Hatch, *Democratization of American Christianity.*

39. On antirevivalism, see *Antirevivalism in Antebellum America: A Collection of Religious Voices*, ed. James D. Bratt (New Brunswick, N.J.: Rutgers University Press, 2006).

40. See J. Musgrave, *Origin of Methodism in Bolton* (Bolton, Mass.: printed by H. Bradbury, 1865).

41. Noble, *Life and Works of Thomas Cole*, 5.

42. Camp meetings were regularly held in the vicinity of Cole's home in Steubenville, Ohio, as is apparent in the journal of Francis Asbury (1745–1816), first bishop of the American Methodist Church, who stopped regularly at Steubenville during his annual journeys along the Ohio River between 1803 and 1815. See Francis Asbury, *The Heart of Asbury's Journal*, ed. Ezra Squier Tipple (New York: Eaton & Mains, 1904), 642, 694. One of the oldest continuous camp meetings in the United States, which began in 1818, is at Hollow Rock, less the twenty miles north of Steubenville (Eleanor L. Smith, *Hollow Rock: A History*, 2nd ed. (Toronto, Ohio: Hollow Rock Camp Meeting, 2011).

43. Cole made his first trip to the Adirondacks in 1826, which inspired his *Scene from "Last of the Mohicans"* (1827; Wadsworth Atheneum). His first trip to Niagara Falls, in 1829, resulted in his *Distant View of Niagara Falls* (1830; Art Institute of Chicago); see John H. Conlin, "Thomas Cole in Western New York," *Western New York Heritage* 10, no. 3 (Fall 2007): 46–48. On the burned-over district, see Whitney R. Cross, *The Burned-over District: The Social and Intellectual History of Enthusiastic Religion in Western New York, 1800–1850* (Ithaca, N.Y.: Cornell University Press, 1950).

44. J. Milbert, *Picturesque Itinerary of the Hudson River and the Peripheral Parts of North America*, trans. Constance D. Sherman (Ridgweood, N.J.: Gregg Press, 1968), 59. On Milbert's travels, see Constance D. Sherman, "A French Explorer in the Hudson River

Valley," *The New-York Historical Society Quarterly* 45, no. 3 (July 1961): 255–80. For another picturesque view of a camp meeting similar in composition to Cole's, see the lithograph *Sacramental Scene in a Western Forest,* in Joseph Smith, *Old Redstone, or, Historical Sketches of Western Presbyterianism* (Philadelphia: Lippincott and Grambo, 1854).

45. Frances Trollope, *Domestic Manners of the Americans,* ed. Donald Smalley (New York: Alfred A. Knopf, 1949), 171–72. Trollope travelled in America from 1827 to 1831 and published *Domestic Manners of the Americans* in 1832.

46. Trollope, *Domestic Manners,* 168.

47. Frederick Marryat, *A Diary in America, With Remarks on Its Institutions,* ed. Sydney Jackman (New York: Alfred A. Knopf, 1962), 239–43.

48. For a recent consideration of Cole's suspicion of the mob in relation to *The Course of Empire: Destruction* (1836), see Ross Barrett, "Violent Prophecies: Thomas Cole, Republican Aesthetics, and the Political Jeremiad," *American Art* 27, no. 1 (Spring 2013): 25–49.

49. Cole, *Collected Essays and Prose Sketches,* 5.

50. Bjelajac has similarly linked Cole's *St. John in the Wilderness* to contemporary revivalist scenes like Rider's; see David Bjelajac, *American Art: A Cultural History* (New York: Abrams, 2001), 194.

51. Charles Grandison Finney, *Sermons on Important Subjects,* 3rd ed. (New York: John S. Taylor, 1836), 21.

52. Edmund Burke himself had made this connection in the "Sound and Loudness" section of his *Philosophical Enquiry into the Origin of our Ideas of the Sublime and Beautiful,* ed. Adam Phillips (Oxford: Oxford University Press, 1990), 75–76.

53. James B. Finley, *Autobiography of Rev. James B. Finley, or, Pioneer Life in the West,* ed. W. P. Strickland (Cincinnati, Ohio: Cranston and Curts, 1853), 166. David E. Nye discusses the relationship between the sublime and religious revivals in nineteenth-century America in *American Technological Sublime* (Cambridge, Mass.: MIT Press, 1994), 28–29.

54. F. A. Cox and J. Hoby, *The Baptists in America; A Narrative of the Deputation from the Baptist Union in England, to the United States and Canada* (New York: Leavitt and Lord, 1836), 208–9.

55. On the importance of landscape for the evangelical movement and its relevance to Cole's art, see Jerome Tharaud, "Evangelical Space: *The Oxbow,* Religious Print, and the Moral Landscape in America," *American Art* 28, no. 3 (Fall 2014): 52–75.

56. Samuel H. Monk, *The Sublime: A Study of Critical Theories in XVIII-Century England* (New York: Modern Language Association of America, 1935), 235.

57. Perry Miller, *Nature's Nation* (Cambridge, Mass.: Harvard University Press, 1967), 153. For a recent analysis of the transcendentalists' appeal to nature in relation to antebellum class conflict, see Lance Newman, *Our Common Dwelling: Henry Thoreau, Transcendentalism, and the Class Politics of Nature* (New York: Palgrave Macmillan, 2005).

58. See Eric Schmidt, *Hearing Things: Religion, Illusion, and the American Enlightenment* (Cambridge, Mass.: Harvard University Press, 2000), 66–69.

59. Miller, *Nature's Nation*, 84.

60. Alan Wallach, "Thomas Cole and the Aristocracy," in *Reading American Art*, ed. Marianne Doezema and Elizabeth Milroy (New Haven, Conn.: Yale University Press, 1998), 102. On Cole and the dissenting tradition, see Alan Peter Wallach, "The Ideal American Artist and the Dissenting Tradition: A Study of Thomas Cole's Popular Reputation" (PhD diss., Columbia University, 1973), 98–189.

61. Mark Noll makes these distinctions within the evangelical movement in terms of "formalists" and "antiformalists" (*America's God: From Jonathan Edwards to Abraham Lincoln* [Oxford: Oxford University Press, 2002], 175–76). For a discussion of the revivalist movement in relation to Cole, see Christine Stansell and Sean Wilentz, "Cole's America: An Introduction," in Truettner and Wallach, *Thomas Cole*, 11–12.

62. Wallach, "Thomas Cole and the Aristocracy," 82–84.

63. Alan Wallach, "Thomas Cole: Landscape and the Course of American Empire," in Truettner and Wallach, *Thomas Cole*, 42; Angela Miller, "Thomas Cole and Jacksonian America: *The Course of Empire* as Political Allegory," *Prospects* 14 (October 1989): 75–76. For a recent survey of the transatlantic context that shaped Cole's critical attitude toward Jacksonian America, see Tim Barringer, "Thomas Cole's Atlantic Crossings," in Elizabeth Mankin Kornhauser and Tim Barringer, *Thomas Cole's Journey: Atlantic Crossings* (New York: Metropolitan Museum of Art, 2018), 19–61.

64. Thomas Cole, Journal entry for November 6, 1834, in *The Collected Essays and Prose Sketches*, 124; and see Miller, "Thomas Cole and Jacksonian America," 76.

65. See Russ Patrick Reeves, "Countering Revivalism and Revitalizing Protestantism: High Church, Confessional, and Romantic Critiques of Second Great Awakening Revivalism, 1835 to 1852" (PhD diss., University of Iowa, 2005), 100–105.

66. Cole's involvement in St. Luke's included designing a new church after the old one burned down in 1839, and also painting a *trompe l'oeil* window in the new church (Parry, *Art of Thomas Cole*, 242–43). Cole's increasing involvement with high-church Episcopalianism is also suggested by his contributions in 1846 to discussions on art in the high-church Episcopal weekly, *The Churchman*. For the Noble quote see *Life and Works of Thomas Cole*, 33–34.

67. The painting was commissioned by Jonathan Sturges as a gift for Bryant, in appreciation of his eulogy (Barbara Ball Buff, "Kindred Spirits, 1849," in *American Paradise: The World of the Hudson River School*, ed. John K. Howat [New York: Metropolitan Museum of Art, 1987], 108–10). On the painting, also see Linda S. Ferber, "Asher B. Durand, American Landscape Painter," in *Kindred Spirits: Asher B. Durand and the American Landscape*, ed. Linda S. Ferber (New York: Brooklyn Museum, 2007), 158–61.

68. William Cullen Bryant, *Funeral Oration, Occasioned by the Death of Thomas Cole* (New York: D. Appleton, 1848), 26. On Bryant, Cole, and the sister arts, see Donald Ringe, "Kindred Spirits: Bryant and Cole," *American Quarterly* 6, no. 3 (Autum 1954): 233–44.

69. On the relation of Durand's *Kindred Spirits* to Cole's early sublime landscapes, see Bryan Wolf, "All the World's a Code: Art and Ideology in Nineteenth-Century American Painting," *Art Journal* 44, no. 4 (Winter 1984): 328–30.

5. DANCING FOR THE KINETOGRAPH

1. For an account of the opening at 1155 Broadway, see Gordon Hendricks, *The Kinetoscope: America's First Commercially Successful Motion Picture Exhibitor* (New York: Beginnings of the American Film, 1966), 56–60. On the early history and commercial exploitation of the kinetoscope, also see Dickson and Dickson, *History of the Kinetograph* (1895); Ray Phillips, *Edison's Kinetoscope and Its Films: A History to 1896* (Westport, Conn.: Greenwood, 1997); and Charles Musser, *Before the Nickelodeon: Edwin S. Porter and the Edison Manufacturing Company* (Berkeley: University of California Press, 1991).

2. Musser, *Before the Nickelodeon,* 50; Charles Musser, *Edison Motion Pictures, 1890–1900: An Annotated Filmography* (Gemona del Friuli, Italy: Le Giornate del Cinema Muto, 1997), 125–29; Sandra K. Sagala, *Buffalo Bill on the Silver Screen: The Films of William F. Cody* (Norman: University of Oklahoma Press, 2013), 19–21. For descriptions of the events at the Black Maria, as well as the names of all those present, see "Dancing for the Kinetograph," *The Sun* (New York), September 25, 1894; "Red Men Again Conquered," *New York Herald,* September 25, 1894; "War Dances Before It," *The New York Press,* September 25, 1894; and "Before the Kinetograph," *Newark Daily Advertiser,* September 24, 1894, repr. in Musser, *Edison Motion Pictures,* 128.

3. Niagara had not yet been filmed in 1895, but this was clearly planned. By the time the 1900 Edison Films catalog was published, there were twelve films in its "waterfalls" series, including several Niagara subjects, as well as Kaaterskill Falls (titled "Waterfall in the Catskills" in the catalog); see *Edison Films: Complete Catalogue,* no. 94 (March 1900): 47–48. Although the dances filmed by Dickson were not performed before a mountainous landscape and Indian village, as in the title page scene, these background elements do reproduce the scenery of the Wild West show's canvas backdrops, in front of which dances were performed for audiences in the grandstands (L. G. Moses, *Wild West Shows and the Images of American Indians, 1883–1933* [Albuquerque: University of New Mexico Press, 1996], 34–35).

4. "War Dances Before It."

5. The boys are Johnny Burke No Neck and Seven Up, and according to an article in *The Chicago Tribune* that was published when the Indians employed by Buffalo Bill were passing through on their way to Brooklyn, they were ten and eight years old, respectively, in May 1894 ("For Bill's Big Show," *The Chicago Tribune,* May 4, 1894).

6. Tom Gunning, "The Cinema of Attraction: Early Film, Its Spectator, and the Avant-Garde," *Wide Angle* 8, no. 3 (1986): 63–70.

7. "Red Men Again Conquered."

8. Warburg, *Images from the Region of the Pueblo Indians,* 53.

9. "Red Men Again Conquered."

10. Ralph E. Friar and Natasha A. Friar, *The Only Good Indian: The Hollywood Gospel* (New York: Drama Book Specialists, 1972), 70. On the persistence of the Hollywood Indian, also see John E. O'Connor, *The Hollywood Indian: Stereotypes of Native Americans in Films* (Trenton: New Jersey State Museum, 1980), and *Hollywood's Indian: The Portrayal of*

the Native American in Film, ed. Peter C. Rollins and John E. O'Connor (Lexington: University Press of Kentucky, 2011).

11. Edison quoted in George M. Smith, "Edison's Latest Invention," *The Saint Paul Daily Globe,* April 8, 1894, 18.

12. "Red Men Again Conquered."

13. On press coverage, see Christina Klein, "'Everything of Interest in the Late Pine Ridge War Are Held by Us for Sale': Popular Culture and Wounded Knee," *The Western Historical Quarterly* 25, no. 1 (Spring 1994): 45–68, and Rani-Henrik Andersson, *The Lakota Ghost Dance of 1890* (Lincoln: University of Nebraska Press, 2008), 192–250.

14. There seems to be some confusion about the film titles in recent scholarship. Musser (*Edison Motion Pictures,* 125–26) identifies the war dance as *Sioux Ghost Dance* and the other as *Buffalo Dance,* and these are the titles under which the two films are now generally known. However, the title *Buffalo Dance* does not appear in early film catalogs; the earliest use of that title appears to be Hendricks's 1966 *The Kinetoscope.* The only title under which either film could have been sold is *Sioux Ghost Dance,* and as far as I have been able to determine, there is no evidence that allows us to say definitively which film that was.

15. James Mooney, *The Ghost-Dance Religion and the Sioux Outbreak of 1890* (Lincoln: University of Nebraska Press, 1991), 777, 780–81. The scholarly literature on the Ghost dance is extensive. I have relied in particular on Mooney, *Ghost-Dance Religion;* Raymond J. DeMallie, "The Lakota Ghost Dance: An Ethnohistorical Account," *The Pacific Historical Review* 51, no. 4 (November 1982): 385–405; Andersson, *Lakota Ghost Dance;* and Sam A. Maddra, *Hostiles?: The Lakota Ghost Dance and Buffalo Bill's Wild West* (Norman: University of Oklahoma Press, 2006).

16. See Mooney, *Ghost-Dance Religion,* Plate CIX, and Evan M. Maurer, *Visions of the People: A Pictorial History of Plains Indian Life* (Minneapolis: Minneapolis Institute of Arts, 1992), 168–69.

17. On the integration of the Ghost Dance with traditional Lakota religion, see DeMallie, "Lakota Ghost Dance."

18. Recent scholarship has discredited the long-held view that the Ghost Dance was given a militaristic cast among the Lakota (DeMallie, "Lakota Ghost Dance," and Maddra, *Hostiles?,* 27–44).

19. See Maddra, *Hostiles?,* 132–33. He was named after John M. Burke, the general manager of Buffalo Bill's Wild West, and Chief No Neck, a regular performer in the show.

20. On the banning of weapons during the dance, see Mooney, *Ghost-Dance Religion,* 788. Andersson also argues that there "is no evidence that the Lakotas carried arms during the ghost dance ceremonies" (*Lakota Ghost Dance,* 65). The program for the Wild West show states explicitly that the music for the Ghost Dance was not accompanied by a drum (*Buffalo Bill's Wild West and Congress of Rough Riders of the World: Historical Sketches & Programme (1894)* [New York: Fless & Ridge, 1894], 40).

21. *Catalogue: Edison and International Photographic Films* (New York: Maguire and Baucus, April 1897), 8.

22. "Before the Kinetograph;" "War Dances Before It."

23. "Indians Ready to Fight," *The New York Times,* November 22, 1890.

24. "Short Bull's Narrative (Dictated c. 1906)," in Maddra, *Hostiles?,* 208.

25. General Nelson A. Miles, quoted in Moses, *Wild West Shows,* 110. On the release of the Fort Sheridan Ghost Dancers to Cody, also see Maddra, *Hostiles?,* 57–62.

26. Cody had originally been summoned to Pine Ridge by General Miles (also pictured in the poster), and a photograph from January 1891 showing Cody and Miles on horseback viewing a "hostile Indian camp" is likely the source for the poster (Denver Public Library, Salsbury collection, Buffalo Bill's Wild West Show, NS-56).

27. Andersson, *Lakota Ghost Dance,* 249–50.

28. Lieutenant Marion P. Maus, "The New Indian Messiah," *Harper's Weekly* 34, no. 1772 (December 6, 1890): 947.

29. *Historical Sketches & Programme (1894),* 39–40. Cody refers to Wounded Knee as "an unlooked-for accident" on 48. On the program's refusal to pronounce on the meaning of the Ghost Dance, see Louis S. Warren, *Buffalo Bill's America: William Cody and the Wild West Show* (New York: Alfred A. Knopf, 2005), 384–85.

30. *Buffalo Bill's Wild West and Congress of Rough Riders of the World: Historical Sketches & Programme (1893)* (Chicago: The Blakely Printing Company, 1893), 44. On the source material for the program, see Karen A. Bearor, "The Illustrated American and the Lakota Ghost Dance," *American Periodicals: A Journal of History & Criticism* 21, no. 2 (2011): 143–63.

31. Maddra, *Hostiles?,* 131. Cody did ultimately enact Wounded Knee, but on the screen rather than in the Wild West show. *The Indian Wars,* filmed in 1913, included a reenactment of the "battle" on site, which proved controversial. Only about two minutes of the film survive, and these do not include the Wounded Knee episode. See Andrea I. Paul, "Buffalo Bill and Wounded Knee: The Movie," *Nebraska History* 71 (Winter 1990): 182–90, and Sagala, *Buffalo Bill on the Silver Screen.*

32. See Maddra, *Hostiles?.*

33. Alain Michaud, *Aby Warburg and the Image in Motion,* trans. Sophie Hawkes (New York: Zone, 2004), 62–66. Alison Griffiths also emphasizes the importance of the displacement of the dancers from their original context in the Wild West show, as well as their "provocative visual address to the spectator" (*Wondrous Difference: Cinema, Anthropology, & Turn-of-the-Century Visual Culture* [New York: Columbia University Press, 2002], 174–76).

34. Dickson and Dickson, *History of the Kinetograph,* 16.

35. Most kinetoscopes were installed in phonograph parlors. See Altman, *Silent Film Sound* (New York: Columbia University Press, 2004), 80.

36. Musser, *Before the Nickelodeon,* 29.

37. Dickson and Dickson, *History of the Kinetograph,* 18.

38. On this film and recent efforts to restore synchronization, see Patrick Loughney, "Domitor Witnesses the First Complete Public Presentation of the [Dickson Experimental Sound Film] in the Twentieth Century," in *The Sounds of Early Cinema,* ed. Richard Abel and Rick Altman (Bloomington: Indiana University Press, 1998), 215–19.

39. Raff and Gammon, "Announcement: Reduction in Price of Kinetoscopes and Kinetophones" (1895), 1.

40. See Hendricks, *Kinetoscope*, 118–25; Musser, *Before the Nickelodeon*, 53–56; and Altman, *Silent Film Sound*, 78–83. James Lastra usefully complicates the meaning of "synchronization" in early film (*Sound Technology and the American Cinema: Perception, Representation, Modernity* [New York: Columbia University Press, 2000], 94–95), although at this earliest stage of commercial film in 1894, it is clear that Edison and Dickson were seeking point-by-point synchronization.

41. Tom Gunning, "Doing for the Eye What the Phonograph Does for the Ear," in Abel and Altman, *The Sounds of Early Cinema*, 13–31.

42. See Roland Gelatt, *The Fabulous Phonograph, 1877–1977* (New York: Collier, 1977), 107–9.

43. Jonathan Crary, *Techniques of the Observer: On Vision and Modernity in the Nineteenth Century* (Cambridge, Mass.: MIT Press, 1990).

44. Dickson and Dickson, *History of the Kinetograph*, 4.

45. Dickson and Dickson, *History of the Kinetograph*, 4. Also see "Edison and the Kinetograph" (reprint of article that appeared in *The Montreal Daily Star*, April 20, 1895), *Film History* 11, no. 4 (1999): 404–8.

46. As Noël Burch writes, the kinetoscope's lack of synchronous sound produced "an intolerable contradiction in the context of these aspirations to the faithful reproduction of Life" (*Life to Those Shadows,* trans. Ben Brewster [Berkeley: University of California Press, 1990], 33).

47. Jonathan Crary, *Suspensions of Perception: Attention, Spectacle, and Modern Culture* (Cambridge, Mass.: MIT Press, 1999), 31–33.

48. James Mooney, Letter to John Wesley Powell of July 8, 1893, National Anthropological Archives, Smithsonian Institution, Bureau of American Ethnology Records, Box 109 (Letters Received 1888–1906), Folder: Mooney 1893.

49. W. J. McGee, Letter to James Mooney of July 29, 1893, National Anthropological Archives, Smithsonian Institution, Bureau of American Ethnology Records, Box 17 (Letterbooks), Letterbook U. The physicist was Charles K. Wead, who later published an article on "The Study of Primitive Music" in *American Anthropologist*, n.s., 2, no. 1 (January 1900): 75–79.

50. The twelve zinc master discs are housed in the Library of Congress (AFS 14034–14045, Archive of Folk Culture, American Folklife Center, Library of Congress). James R. Smart has proposed that Mooney sang the songs himself, but given Mooney's concern for authenticity, it is more likely that he hired a native singer, and indeed, in the Bureau of American Ethnology Records, there is a sheet signed by Mooney with cost estimates for travel, including a request for funds "to bring back an Indian singer to procure the notation of dance and medicin songs" (Smart, "Emile Berliner and Nineteenth-Century Disc Recordings," *The Quarterly Journal of the Library of Congress* 37, nos. 3–4 [Summer–Fall 1980]: 431; James Mooney, "Estimates," undated, National Anthropological Archives, Smithsonian Institution, Bureau of American Ethnology Records, Box 109 (Letters

Received 1888–1906), Folder: Mooney Misc. At least one of the gramophone discs strangely has "Chas. Mooney" inscribed on it. While Smart has proposed that this refers to Mooney's brother, Charles, this cannot be the case, since Mooney did not have a brother. The most likely explanation is an error by the individual in Berliner's studio who inscribed the disc.

51. Frans Boas, "On Alternating Sounds," *American Anthropologist* 2, no. 1 (1889): 47–54. On Boas's essay and its significance for phonographic research in turn-of-the-century American ethnography, see Brian Hochman, *Savage Preservation: The Ethnographic Origins of Modern Media Technology* (Minneapolis: University of Minnesota Press, 2014), 87–109. On late nineteenth-century salvage ethnography and the phonograph, also see Jonathan Sterne, *The Audible Past: Cultural Origins of Sound Reproduction* (Durham, N.C.: Duke University Press, 2003), 311–25.

52. Lorraine Daston and Peter Galison, *Objectivity* (New York: Zone, 2007), 115–90. Also see Hochman, *Savage Preservation,* 102–3.

53. Lida Rose McCabe, "The 'Indian Man,'" *The Chicago Daily Inter-Ocean,* August 20, 1893. On Mooney at the World's Columbian Exposition, see L. G. Moses, *The Indian Man: A Biography of James Mooney* (Lincoln: University of Nebraska Press, 1984), 74–80.

54. Mooney, *Ghost-Dance Religion,* 777.

55. Mooney, *Ghost-Dance Religion,* 654.

56. In his acknowledgements, Mooney thanks Berliner for recording and "Professors John Philip Sousa and F. W. V. Gaisberg for arranging the Indian Music" (*Ghost-Dance Religion,* 655).

57. Mooney, *Ghost-Dance Religion,* 657.

58. J. W. Powell, *Fourteenth Annual Report of the Bureau of Ethnology* (Washington: Government Printing Office, 1896), LX.

59. Mooney, *Ghost-Dance Religion,* 1065.

60. Michael Elliott, *The Culture Concept: Writing and Difference in the Age of Realism* (Minneapolis: University of Minnesota Press, 2002), 116. Elliott argues convincingly that Mooney's dedication to textual reproduction "makes it possible to apprehend more than the discrete data he uncovers in the texts" (117).

61. Mooney, *Ghost-Dance Religion,* 1102.

62. Mooney, *Ghost-Dance Religion,* 808–9, 654.

63. See Raymond J. DeMallie's introduction in Mooney, *Ghost-Dance Religion,* xvi, and Alice Beck Kehoe, *The Ghost Dance: Ethnohistory and Revitalization* (Fort Worth, Tex.: Holt, Rinehart and Winston, 1989), 41–50.

64. U.S. Senate, *Letter from the Secretary of the Interior in Response to Senate Resolution of June 1, 1892, Transmitting Certain Papers and Giving Information Relative to Certain Contracts Made with Indians, and the Relation of Agents or Attorneys to the Same,* January 5, 1893, 52nd Congress, 2nd Session, S. Ex. Doc. 18, 686–694. On depredations, see William T. Hagan, "United States Indian Policies, 1860–1900," in *Handbook of North American Indians,* vol. 4, *History of Indian-White Relations,* ed. Wilcomb E. Washburn (Washington, D.C.: Smithsonian Institution, 1988), 63–64. On Short Bull's narratives, see Maddra, *Hostiles?,* 35–44.

65. The Kinetoscope films were part of the installation "American Identities: A New Look," September 12, 2001, through February 28, 2016, Brooklyn Museum.

66. Frank Norris, *McTeague: A Story of San Francisco* (New York: Vintage, 1990), 77. Norris clearly had in mind a projecting kinetoscope (a phantoscope or vitascope), as McTeague and his companions all watched at the same time. After the popularity of the peephole kinetoscope waned, *Sioux Ghost Dance* continued to be seen in such projections. An advertisement for "Phantoscope pictures" in *The Indianapolis Journal,* September 16, 1896, lists "Sioux ghost dance" as one of the features being shown.

Index

M I C H A E L G A U D I O is professor of art history at the University of Minnesota. He is the author of *Engraving the Savage: The New World and Techniques of Civilization* (Minnesota, 2008) and *The Bible and the Printed Image in Early Modern England: Little Gidding and the Pursuit of Scriptural Harmony*.